SACRED ART IN EAST AND WEST

SACRED ART IN EAST AND WEST

Its Principles and Methods

TITUS BURCKHARDT

Translated by Lord Northbourne

PERENNIAL BOOKS LTD
Pates Manor, Bedfont, Middlesex

Published in France under the title
Princip et Methodes de l'Art Sacré
by Paul Derain, Lyon, 1958

First UK Edition 1967
Second Impression 1976

ISBN 0 900588 11 X

Printed and bound in Great Britain

CONTENTS

ILLUSTRATIONS

IN THE TEXT

INTRODUCTION

WHEN historians of art apply the term "sacred art" to any and every work that has a religious subject, they are forgetting that art is essentially form. An art cannot properly be called "sacred" solely on the grounds that its subjects originate in a spiritual truth; its formal language also must bear witness to a similar origin. Such is by no means the case with a religious art like that of the Renaissance or of the Baroque period, which is in no way distinct, so far as style is concerned, from the fundamentally profane art of that era; neither the subjects which it borrows, in a wholly exterior and as it were literary manner, from religion, nor the devotional feelings with which it is permeated in appropriate cases, nor even the nobility of soul which sometimes finds expression in it, suffice to confer on it a sacred character. No art merits that epithet unless its forms themselves reflect the spiritual vision characteristic of a particular religion.

Every form is the vehicle of a given quality of being. The religious subject of a work of art may be as it were superimposed, it may have no relation to the formal "language" of the work, as is demonstrated by Christian art since the Renaissance; there are therefore essentially profane works of art with a sacred theme, but on the other hand there exists no sacred work of art which is profane in form, for there is a rigorous analogy between form and spirit. A spiritual vision necessarily finds its expression in a particular formal language; if that language is lacking, with the result that a so-called sacred art borrows its forms from some kind of profane art, then it can only be because a spiritual vision of things is also lacking.

It is useless to try to excuse the Protean style of a religious art, or its indefinite and ill-defined character, on grounds of the universality of dogma or the freedom of the spirit. Granted that spirituality in itself is independent of forms, this in no way implies that it can be expressed and transmitted by any and every sort of form. Through its qualitative essence form has a place in

the sensible order analogous to that of truth in the intellectual order; this is the significance of the Greek notion of *eidos*. Just as a mental form such as a dogma or a doctrine can be the adequate, albeit limited, reflection of a Divine Truth, so can a sensible form retrace a truth or a reality which transcends both the plane of sensible forms and the plane of thought.

Every sacred art is therefore founded on a science of forms, or in other words, on the symbolism inherent in forms. It must be borne in mind that a symbol is not merely a conventional sign. It manifests its archetype by virtue of a definite ontological law; as Coomaraswamy has observed, a symbol *is* in a certain sense that to which it gives expression. For this very reason traditional symbolism is never without beauty : according to the spiritual view of the world, the beauty of an object is nothing but the transparency of its existential envelopes; an art worthy of the name is beautiful because it is true.

It is neither possible nor even useful that every artist or craftsman engaged in sacred art should be conscious of the Divine Law inherent in forms; he will know only certain aspects of it, or certain applications that arise within the limits of the rules of his craft; these rules will enable him to paint an icon, to fashion a sacred vessel or to practise calligraphy in a liturgically valid manner, without its being necessary for him to know the ultimate significance of the symbols he is working with. It is tradition that transmits the sacred models and the working rules, and thereby guarantees the spiritual validity of the forms. Tradition has within itself a secret force which is communicated to an entire civilization and determines even arts and crafts the immediate objects of which include nothing particularly sacred. This force creates the style of a traditional civilization; a style that could never be imitated from outside is perpetuated without difficulty, in a quasi-organic manner, by the power of the spirit that animates it and by nothing else.

One of the most tenacious of typically modern prejudices is the one that sets itself up against the impersonal and objective rules of an art, for fear that they should stifle creative genius. In reality no work exists that is traditional, and therefore "bound" by changeless principles, which does not give sensible expression to a certain creative joy of the soul; whereas modern individualism has produced, apart from a few works of genius which are

nevertheless spiritually barren, all the ugliness—the endless and despairing ugliness—of the forms which permeate the "ordinary life" of our times.

One of the fundamental conditions of happiness is to know that everything that one does has a meaning in eternity; but who in these days can still conceive of a civilization within which all vital manifestations would be developed "in the likeness of Heaven"?[1] In a theocentric society the humblest activity participates in this heavenly benediction. The words of a street singer heard by the author in Morocco are worth quoting here. The singer was asked why the little Arab guitar which he used to accompany his chanting of legends had only two strings. He gave this answer: "To add a third string to this instrument would be to take the first step towards heresy. When God created the soul of Adam it did not want to enter into his body, and circled like a bird round about its cage. Then God commanded the angels to play on the two strings that are called the male and the female, and the soul, thinking that the melody resided in the instrument—which is the body—entered it and remained within it. For this reason two strings, which are always called the male and the female, are enough to deliver the soul from the body."

This legend holds more meaning than appears at first sight, for it summarizes the whole traditional doctrine of sacred art. The ultimate objective of sacred art is not the evocation of feelings nor the communication of impressions; it is a symbol, and as such it finds simple and primordial means sufficient; it could not in any case be anything more than allusive, its real object being ineffable. It is of angelic origin, because its models reflect supra-formal realities. It recapitulates the creation—the "Divine Art"—in parables, thus demonstrating the symbolical nature of the world, and delivering the human spirit from its attachment to crude and ephemeral "facts".

The angelic origin of art is explicitly formulated by the Hindu tradition. According to the *Aitareya Brāhmana* every work of art in the world is achieved by imitation of the art of the *devas*, "whether it be an elephant in terra-cotta, a bronze object, an article of clothing, a gold ornament or a mule-cart". The *devas* correspond to the angels. Christian legends attributing an angelic origin to certain miraculous images embody the same idea.

The *devas* are nothing more nor less than particular functions of the universal Spirit, permanent expressions of the Will of God. The doctrine common to traditional civilizations prescribes that sacred art must imitate the Divine Art, but it must be clearly understood that this in no way implies that the complete Divine creation, the world such as we see it, should be copied, for such would be pure pretension; a literal "naturalism" is foreign to sacred art. What must be copied is the way in which the Divine Spirit works. Its laws must be transposed into the restricted domain in which man works as man, that is to say, into artisanship.

<p style="text-align:center">* * *</p>

In no traditional doctrine does the idea of the Divine Art play so fundamental a part as in the Hindu doctrine. For *Māyā* is not only the mysterious Divine Power which causes the world to appear to exist outside the Divine Reality, so that it is from her, from *Māyā*, that all duality and all illusion spring : she is also in her positive aspect the Divine Art which produces all form. In principle she is not other than the possibility contained in the Infinite of limiting Itself, as the object of Its own "vision", without Its infinity being thereby limited. Thus God manifests Himself in the world, yet equally He does not so manifest Himself; He expresses Himself and at the same time keeps silence.

Just as the Absolute objectivises, by virtue of its *Māyā*, certain aspects of Itself, or certain possibilities contained in Itself, and determines them by a distinctive vision, so does the artist realize in his work certain aspects of himself; he projects them as it were outside his undifferentiated being. And to the extent that his objectivation reflects the secret depths of his being, it will take on a purely symbolical character, and at the same time the artist will become more and more conscious of the abyss dividing the form, reflector of his essence, from what that essence really is in its timeless plenitude. The creative artist knows this : this form is myself, nevertheless I am infinitely more than it, for the Essence remains the pure Knower, the witness which no form can compass; but he also knows that it is God who expresses Himself through his work, so that the work in its turn surpasses the feeble and fallible *ego* of the man.

Herein lies the analogy between Divine Art and human art :

in the realization of oneself by objectivation. If this objectivation is to have spiritual significance and not to be merely a vague introversion, its means of expression must spring from an essential vision. In other words, it must not be the "I", that root of illusion and of ignorance of oneself, which arbitrarily chooses those means; they must be borrowed from tradition, from the formal and "objective" revelation of the supreme Being, Who is the "Self" of all beings.

<div align="center">* * *</div>

From the Christian point of view God is similarly "artist" in the most exalted sense of the word, because He created man "in His own image" (Genesis i. 27). And moreover since the image comprises not only a likeness to its model, but also a quasi-absolute unlikeness, it could not but become corrupted. The divine reflection in man was troubled by the fall of Adam; the mirror was tarnished; but nevertheless man could not be completely cast aside; for while the creature is subject to its own limitations, the Divine Plenitude on the other hand is not subject to limitation of any kind, and this amounts to saying that the said limitations cannot be in any real sense opposed to the Divine Plenitude, which is manifested as limitless Love. The very limitlessness of that Love demands that God, "pronouncing" Himself as Eternal Word, should descend into this world, and as it were assume the perishable outlines of the image—human nature—so as to restore to it its original beauty.

In Christianity the divine image *par excellence* is the human form of the Christ; thus it comes about that Christian art has but one purpose : the transfiguration of man, and of the world which depends on man, by their participation in the Christ.

<div align="center">* * *</div>

That which the Christian view of things grasps by means of a sort of loving concentration on the Word incarnate in Jesus Christ, is transposed in the Islamic view into the universal and the impersonal. In Islam the Divine Art—and according to the Koran God is "artist" (*musawwir*)—is in the first place the manifestation of the Divine Unity in the beauty and regularity of the cosmos. Unity is reflected in the harmony of the multiple, in order and in equilibrium; beauty has all these aspects within

itself. To start from the beauty of the world and arrive at Unity —that is wisdom. For this reason Islamic thought necessarily attaches art to wisdom; in the eyes of a Muslim, art is essentially founded on wisdom, or on science, the function of science being the formulation of wisdom in temporal terms. The purpose of art is to enable the human environment, the world in so far as it is moulded by man, to participate in the order that manifests most directly the Divine Unity. Art clarifies the world; it helps the spirit to detach itself from the disturbing multitude of things so that it may climb again towards the Infinite Unity.

* * *

According to the Taoist view of things the Divine Art is essentially the art of transformation : the whole of nature is ceaselessly being transformed, always in accordance with the laws of the cycle; its contrasts revolve round a single centre which always eludes apprehension. Nevertheless anyone who understands this circular movement is thereby enabled to recognize the centre which is its essence. The purpose of art is to conform to this cosmic rhythm. The most simple formula states that mastery in art consists in the capacity to trace a perfect circle in a single movement, and thus to identify oneself implicitly with its centre, while that centre remains unspecified as such.

* * *

In so far as it is possible to transpose the notion of "Divine Art" into Buddhism, which avoids all personification of the Absolute, it can be applied to the beauty of the Buddha, miraculous and mentally unfathomable as it is. Whereas no doctrine concerned with God can escape, as far as its formulation is concerned, from the illusory character of mental processes, which attribute their own limits to the limitless and their own conjectural forms to the formless, the beauty of the Buddha radiates a state of being beyond the power of thought to define. This beauty is reflected in the beauty of the lotus : it is perpetuated ritually in the painted or modelled image of the Buddha.

* * *

In one way or another all these fundamental aspects of sacred art can be found, in varying proportions, in each of the five

great traditions just mentioned, for there is not one of them that does not possess in its essentials all the fullness of Divine Truth and Grace, so that in principle it would be capable of manifesting every possible form of spirituality. Nevertheless, since each religion is necessarily dominated by a particular point of view which determines its spiritual "economy", its artistic manifestations, being naturally collective and not isolated, will reflect this point of view and this economy each in its own style. It is moreover in the nature of form to be unable to express anything without excluding something, because form delimits what it expresses, excluding thereby some aspects of its own universal archetype. This law is naturally applicable at every level of formal manifestation, and not to art alone; the various Divine Revelations on which the different religions are founded are also mutually exclusive when attention is directed to their formal contours only, rather than to their Divine Essence which is one. Here again the analogy between "Divine Art" and human art becomes apparent.

Attention will be confined in the present work to the art of the five great traditions already named, Hinduism, Christianity, Islam, Buddhism and Taoism, since the artistic rules appropriate to each are not only deducible from existing works, but are also confirmed by canonical writings and by the example of living masters. Within this framework it will only be possible to concentrate on a few aspects of each art, chosen as specially typical, the subject as a whole being inexhaustible. Hindu art will be considered first, as its methods have shown the greatest continuity through the ages; by taking it as an example one can show the connection between the arts of medieval civilizations and those of much more ancient civilizations. Christian art will occupy the most space, because of its importance for European readers; but it would be impossible to describe all its modalities. The third place will be accorded to Islamic art, because there exists in many respects a polarity between it and Christian art. As for the art of the Far East, the Buddhist and the Taoist, it must suffice to define some of their aspects, chosen as characteristic yet clearly distinguished from those of the arts dealt with earlier; the comparisons drawn will then serve to indicate the great variety of traditional expression.

The reader will have understood that no sacred art exists

which does not depend on some aspect or other of metaphysic. The science of metaphysic is itself limitless, like its object which is infinite, so that it will not be possible to specify all the relationships which link together the different metaphysical doctrines. It will therefore be best to refer the reader to other books which set out as it were the premises on which this book is based; the books in question make accessible the essence of the traditional doctrines of the East and of the medieval West in a language that can be understood by a modern European. In this connection the first to be named must be the works of René Guénon,[2] of Frithjof Schuon[3] and of Ananda Coomaraswamy.[4] In addition, and as being concerned with the sacred art of particular traditions, the book by Stella Kramrisch on the Hindu temple,[5] the studies of Daisetz Teitaro Suzuki on Zen Buddhism, and the book by Eugen Herrigel (Bungaku Hakushi) on the knightly art of archery in Zen.[6] Other books will be mentioned in their place, and traditional sources will be quoted, as occasion demands.

NOTES

1. "Do you not know, O Asclepius, that Egypt is the image of Heaven and that it is the projection here below of the whole ordering of Heavenly things?" (*Hermes Trismegistus*, from the French translation of L. Ménard.)

2. *Introduction générale à l'Etude des Doctrines Hindoues*, Paris, Editions Véga 3e édition, 1939: translation—"Introduction to the Study of the Hindu Doctrines" by Marco Pallis, Luzac, London, 1945. *L'Homme et son Devenir selon le Vêdânta*, Paris 4e édition, Editions Traditionelles, 1952: translation—"Man and his Becoming according to the Vedānta" by Richard Nicholson, Luzac, London, 1945. *Le Symbolisme de la Croix*, Paris, Editions Véga 4e édition, 1952: translation—"Symbolism of the Cross" by Angus Macnab, Luzac, London, 1958. *Le Règne de la Quantité et les Signes du Temps*, Paris, Gallimard, 4e édition, 1950: translation—"The Reign of Quantity and the Signs of the Times" by Lord Northbourne, Luzac, London, 1953. *La Grande Triade*, Paris, Gallimard, 2e édition, 1957.

3. *De l'Unité transcendante des Religions*, Paris, Gallimard, 1948: translation—"The Transcendent Unity of Religions" by Peter Townsend, Faber, London, 1953. *L'Œil du Cœur*, Paris, Gallimard, 1950. *Perspectives spirituelles et Faits humains*, Paris, Cahiers du Sud, 1953: translation—"Spiritual Perspectives and Human Facts" by D. M. Matheson,

Faber, London, 1954. *Castes et Races*, Lyon, Derain, 1957. *Stations de la Sagesse,* Paris, Buchet Chastel-Corrêa, 1958: translation—"Stations of Wisdom" by G. E. H. Palmer, Murray, London, 1961. *Sentiers de Gnose,* Paris, La Colombe, 1957: translation—"Gnosis" by G. E. H. Palmer, Murray, London, 1959. *Language of the Self,* a translation by D. M. Matheson and Marco Pallis published in English by Ganesh, Madras, India, 1959. *Comprendre l'Islam*, Paris, Gallimard, 1961: translation—"Understanding Islam" by D. M. Matheson, Allen and Unwin, London, 1963. *Light on the Ancient Worlds*, a translation by Lord Northbourne published in English by Perennial Books, London, 1965.

4. *The Transformation of Nature in Art,* Cambridge, Mass., U.S.A., Harvard University Press, 1934. Reprint: Dover, New York [1956]. *Elements of Buddhist Iconography, ditto,* 1935. *Hinduism and Buddhism,* The Philosophical Library, New York, U.S.A.

5. *The Hindu Temple,* Calcutta, University of Calcutta, 1946.

6. *Zen in the Art of Archery,* translated from the German by R. F. C. Hull, Routledge and Kegan Paul, London, 1953.

Chapter I

THE GENESIS OF THE HINDU TEMPLE (pl. I)

I

AMONG settled peoples the sacred art *par excellence* is the building of a sanctuary, in which the Divine Spirit, invisibly present in the universe, will "dwell" in a direct and as it were "personal" sense.[1] Spiritually speaking, a sanctuary is always situated at the centre of the world, and it is this that makes it a *sacratum* in the true sense of the word : in such a place man is protected from the indefinity of space and time, since it is "here" and "now" that God is present to man. This is expressed in the design of the temple; its emphasis on the cardinal directions co-ordinates space in relation to its centre. The design is a synthesis of the world : that which is in ceaseless movement within the universe is transposed by sacred architecture into permanent form. In the cosmos time prevails over space; on the other hand in the construction of the temple time is as it were transmuted into space : the great rhythms of the visible cosmos, symbolizing the principial aspects of an existence disjointed and dispersed by becoming, are reassembled and stabilized in the geometry of the building. The temple thus represents, through its regular and unalterable form, the completion of the world, the timeless aspect or final state of the world, wherein all things are at rest in the equilibrium that precedes their reintegration into the undivided unity of Being. The sanctuary prefigures the final transfiguration of the world—a transfiguration symbolized in Christianity by the "Heavenly Jerusalem"—and for this reason alone it is filled with the Divine Peace (*shekhina* in Hebrew, *shānti* in Sanskrit).

Similarly the Divine Peace descends into a soul whose every modality or every content—analogous to those of the world—reposes in an equilibrium both simple and rich, and comparable in its qualitative unity to the regular form of a sanctuary.

The edification of a sanctuary, like that of a soul, has also an aspect of sacrifice. The powers of the soul must be withdrawn

from the world if it is to become a receptacle of Grace, and for exactly analogous reasons the materials for the construction of a temple must be withdrawn from all profane use and must be offered to the Divinity. We shall see that this sacrifice is necessary as a compensation for the "divine sacrifice" which is at the origin of the world. In every sacrifice the substance sacrificed undergoes a qualitative transformation, in the sense of its being assimilated to a divine model. This is no less evident in the building of a sanctuary, and in this connection a well-known example may be cited, that of the building of the Temple at Jerusalem by Solomon in accordance with the plan revealed to David.

The completion of the world prefigured in the temple is symbolized in the rectangular form of the temple, a form essentially opposed to the circular form of a world driven onward by the cosmic movement. Whereas the spherical form of the sky is indefinite and is not accessible to any kind of measurement, the rectangular or cubical form of a sacred edifice expresses a positive and immutable law, and that is why all sacred achitecture, whatever may be the tradition to which it belongs, can be seen as a development of the fundamental theme of the transformation of the circle into the square. In the genesis of the Hindu Temple the development of this theme is particularly clearly seen, with all the richness of its metaphysical and spiritual content.

Before pursuing this matter further it must be made clear that the relation between these two fundamental symbols, the circle and the square or the sphere and the cube, may carry different meanings according to the plane of reference. If the circle is taken as the symbol of the undivided unity of the Principle, the square will signify its first and changeless determination, the universal Law or Norm : and in this case the circle will indicate a reality superior to that suggested by the square. The same is true if the circle is related to the heavens, the movement of which it reproduces, and the square to the earth, the solid and relatively inert state of which it recapitulates; the circle will then be to the square as the active is to the passive, or as life is to the body, for it is the heavens that engender actively, while the earth conceives and gives birth passively. It is however possible to envisage an inversion of this hierarchy : if the square

is considered in its metaphysical significance, as the symbol of principial immutability, which in its turn contains and resolves within itself all cosmic antinomies, and if the circle is correspondingly considered in relation to its cosmic model, which is endless movement, then the square will represent a reality superior to that represented by the circle; for the permanent and immutable nature of the Principle transcends the celestial or cosmic activity, which is relatively exterior to the Principle itself.[2] This last symbolical relationship between the circle and the square predominates in the sacred architecture of India. This is both because the quality that belongs specially to architecture is stability—it is through its stability that architecture reflects the Divine Perfection most directly—and also because the point of view in question is essentially inherent in the Hindu spirit. The Hindu spirit is in fact always inclined to transpose terrestrial and cosmic realities, divergent though they be, into the non-separative and static plenitude of the Divine Essence. This spiritual transfiguration is accompanied in sacred architecture by an inversely analogous symbolism, wherein the great "measures" of time, the various cycles, are "crystallized" in the fundamental square of the temple.[3] We shall see later how this square is arrived at by the fixation of the principal movements of the heavens. In any case the symbolical predominance of the square over the circle in sacred architecture does not exclude, either in India or elsewhere, manifestations of an inverse relation between the two symbols, wherever such inversion becomes appropriate in view of the analogy between the various constructional elements and the corresponding parts of the universe.

The "crystallization" of all cosmic realities in a geometrical symbol, which is like an inverted image of the timeless, is prefigured in the Hindu tradition by the construction of the Vedic altar. Its cubical shape, built up from bricks laid in several courses, represents the "body" of *Prajāpati*,[4] the total cosmic being. The *devas*[5] immolated this primordial being at the beginning of the world; his disjointed limbs, which constitute the multiple aspects or parts of the cosmos,[6] have to be symbolically reassembled.

Prajāpati is the Principle in its manifested aspect; this aspect includes the totality of the world, and appears as if fragmented by the diversity and changeability of the world. Seen in this

way *Prajāpati* is as it were torn by time; he is identified with
solar cycle, the year, also with the lunar cycle, the month, but
above all with the universal cycle, or with the totality of all
cosmic cycles. In his Essence he is not other than *Purusha*, the
immutable and indivisible Essence of man and of the universe;
according to the *Rig-Veda* (X.90) it is *Purusha* whom the *devas*
sacrificed at the beginning of the world, in order to constitute
the various parts of the universe and the different kinds of living
beings. This must not be understood as "pantheism", for *Purusha*
is not divided in himself, nor is he "localized" in ephemeral
beings; it is only his manifested and apparent form that is sacri-
ficed, while his eternal nature remains as it ever was, so that he
is at the same time the victim, the sacrifice and the goal of the
sacrifice. As for the *devas*, they represent divine aspects, or more
exactly modalities or functions of the Divine Act or Intellect
(*Buddhi* corresponding to the *Logos*). Multiplicity is not in the
nature of God but in the nature of the world; it is none the less
prefigured principially by the distinctions that can be made
between the various aspects or functions of the Divine, and it is
these aspects or functions that "sacrifice" God in manifesting
Him in separate mode.[7]

Thenceforward every sacrifice reproduces and in some degree
compensates the pre-temporal sacrifice of the *devas*; the unity
of the total being is symbolically and spiritually reconstituted
by the rite. The officiant identifies himself with the altar which
he has built in the likeness of the universe and to the measure-
ments of his own body; he identifies himself also with the sacri-
ficial animal, which replaces him by its possession of certain
qualities;[8] and finally his spirit is identified with the fire which
reintegrates the offering in principial illimitation.[9] The man, the
altar, the holocaust and the fire are alike *Prajāpati*, who is him-
self the Divine Essence.

The analogy between the universe and the sacrificial altar is
expressed in the number and the arrangement of the bricks of
which it is built. The analogy between the altar and the man is
expressed in the proportions of the altar, which are derived
from the measurements of the human body. The side of the base
corresponds to the stretch of a man with arms extended, the
bricks are a foot long, the navel (*nābhi*) of the altar is a span
square. In addition, the "golden man", a schematic figure of a

man which must be walled into the altar with the head turned to the East—the holocaust being always in this position—indicates the analogy between man and the sacrificial victim. We shall see later on that these same symbolical features are implicit in the construction of a temple.

II

The altar exists before the temple. In other words the art of building an altar is more ancient and more universal than is sacred architecture properly so called, for altars are used both by nomadic and by settled peoples, whereas temples exist only among the latter. The primitive sanctuary is the sacred area surrounding the altar; the rites employed for consecrating and delimiting this area were later transposed to the founding of a temple (*templum* in Latin originally meant the sacred precinct set apart for the *contemplation* of the cosmos). There are many indications to support the conclusion that these rites constitute a primordial inheritance linking together the two great currents of nomadic and settled peoples, in other respects so different in their styles of living.[10]

A particularly eloquent testimony to this primordial legacy is presented by the following quotation from a priest and sage belonging to the nomadic Sioux Indians, Hehaka Sapa (Black Elk). He describes the consecration of a fire altar thus : "Taking the axe, he (the officiant) pointed it towards the six directions, and then struck the ground to the West. Repeating the same movement he struck the ground to the North, then in the same way to the East and to the South; then he raised the axe skywards and struck the ground twice in the centre for the earth, and then twice for the Great Spirit. Having done this, he scratched the soil and, with a stick which he had purified in the smoke and offered to the six directions, he drew a line running from the West to the centre, then from the East to the centre, then from the North to the centre and finally from the South to the centre; then he offered the stick to the heavens and touched the centre, and to the earth and touched the centre. In this way the altar was made; in the manner described, we fixed in this place the centre of the world, and this centre, which in reality is everywhere, is the dwelling-place of the Great Spirit."[11]

As this example shows, the consecration of the altar consists in the evocation of the relationships which connect the principal aspects of the universe with its centre. These aspects are: heaven, which in its generative activity is opposed to the earth, the passive and maternal principle, and the four directions or "winds", whose forces determine the cycle of the day and the changes of the seasons; they correspond to as many powers or aspects of the Universal Spirit.[12]

Whereas the normal shape of a temple is rectangular, the nomadic altar such as has been described is not square in outline, even though its origin is the quaternary of the celestial regions. This is explained by the "style" appropriate to the nomadic life; to nomads buildings that are rectangular in shape express the fixation of death.[13] Nomadic sanctuaries, made like tents or cabins of live branches, are generally round;[14] their model is the dome of the sky. Similarly nomadic encampments are arranged in circular form, and the same practice is sometimes found in the cities of nomadic peoples who have become sedentary, like the Parthians. Thus it is that the cosmic polarity of the circle and the square is reflected in the contrast between nomadic and sedentary peoples: the former recognize their ideal in the dynamic and limitless nature of the circle, whereas the latter see theirs in the static character and the regularity of the square.[15] But apart from these differences of style the conception of the sanctuary remains the same; whether it be built of solid materials like the temples of sedentary peoples, or whether it be no more than a *sacratum* established temporarily like the nomadic altar, it is always situated at the centre of the world. Hehaka Sapa says of this centre that it is the dwelling place of the Great Spirit, and that it is in reality everywhere; that is why a symbolical point of reference is sufficient for its realization.

The ubiquity of the spiritual centre also finds an expression in the sensible order in the fact that the directions of space, which diverge in accordance with the motionless axes of the starry sky, converge in the same way on every point situated on the earth; the visual axes of two terrestrial observers looking at the same star are in fact practically parallel, whatever may be the geographical distance separating them. In other words, there is no "perspective" from the point of view of the starry sky: its centre is everywhere, for its vault—the universal temple

—is measureless. Similarly, anyone watching the sun rising or setting over a surface of water sees the golden path of the rays reflected in the water leading straight towards him. If he moves, the path of light follows him; but every other observer sees the path leading no less directly to himself. These facts have a profound significance.[16]

III

The basic plan of the temple is derived from the procedure of its orientation, which is a rite in the proper sense of the word, for it connects the form of the sanctuary with that of the universe, which in this case is the expression of the divine norm. A pillar is set up in the place chosen for the building of the temple, and a circle is traced round it. The pillar serves as gnomon, and its shadow thrown on to the circle marks, by its extreme positions in the morning and in the evening, two points that are connected by an East-West axis (figs. 1 and 2). These two points are taken as centres for marking out, with a cord used as a compass, two circles that intersect to form the "fish" which gives the North-South axis (fig. 2).[17]

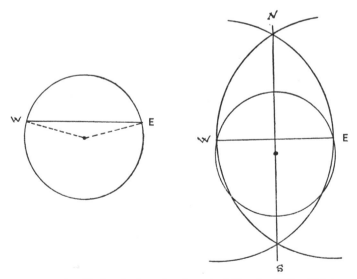

Figs. 1 and 2. Circles of orientation, from the Māuasāva Shilpa-Shāstra

The intersections of other circles, centred on the four ends of the axes thus obtained, afford the means of establishing the four corners of a square; this square then appears as the "quadrature" of the solar cycle, of which the circle round the gnomon is the direct representation (fig. 3).[18]

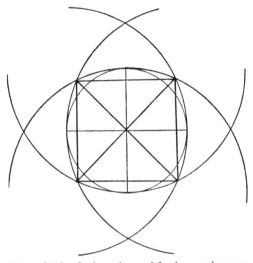

Fig. 3. Circle of orientation and fundamental square

The rite of orientation is universal in its range. We know that it was used in the most diverse civilizations: it is mentioned in ancient Chinese books, and Vitruvius tells us that the Romans established the *cardo* and the *decumanus* of their cities in this way, after consulting the augurs on the place to be chosen; there are also numerous indications that the same procedure was used by the builders of medieval Europe. The reader will have noticed that the three phases of this rite correspond to three fundamental geometrical figures: the circle, image of the solar cycle, the cross formed by the cardinal axes and the square derived from it. These are the symbols of the Far Eastern Great Triad, Heaven-Man-Earth: Man (fig. 4) appears in this hierarchy as the intermediary between Heaven and Earth, the active principle and the passive principle, just as the cross of the cardinal axes is the intermediary between the limitless cycle of the heavens and the terrestrial "square".

Fig. 4. Chinese ideogram of the Great Triad: Heaven-Man-Earth

According to the Hindu tradition the square obtained by the rite of orientation, which summarizes and circumscribes the plan of the temple, is the *Vāstu-Purusha-mandala,* that is to say the symbol of *Purusha,* in so far as he is immanent in existence (*vastu*), or the spatial symbol of *Purusha. Purusha* is pictured in the shape of a man stretched out in the fundamental square, in the position of the victim in the Vedic sacrifice: his head is to the East, his feet to the West, and his two hands touch the North-east and South-east corners of the square.[19] He is none other than the primordial victim, the total being, whom the *devas* sacrificed at the beginning of the world and who is thus "incarnated" in the cosmos, the temple being the crystalline image of the cosmos. "*Purusha* (the unconditioned essence) is by himself the whole world, the past and the future. From him was born *Virāj* (the cosmic Intelligence), and from *Virāj* was born *Purusha* (in his aspect as prototype of man)" (*Rig-Veda,* X. 90, 5). In its limitative and as it were "arrested" form the geometrical diagram of the temple, the *mandala,* corresponds to the earth; but in its qualitative form it is an expression of *Virāj,* the cosmic intelligence; and finally in its transcendent essence it is none other than *Purusha,* the Essence of all beings.

IV

The fundamental diagram of the temple is thus a symbol of the Divine Presence in the world; but from a complementary point of view it is also an image of existence, brutish and "*asūric*",[20] but overcome and transfigured by the *devas*.[21] These two aspects are in any case indissolubly linked together: without the "seal" impressed on it by the Divine Spirit, "matter" would have no intelligible form, and without the "matter" that receives

the divine "seal" and so to speak delimits it, no kind of manifestation would be possible. According to the *Brihat-Samhita* (LII. 2-3) there was formerly, at the beginning of the present cycle, an undefinable and unintelligible thing which "obstructed the heavens and the earth". Seeing this, the *devas* suddenly seized it, and laid it on the ground face downwards, and established themselves on it in the positions they were in when they seized it, *Brahmā* filled it with *devas*[22] and called it *Vāstupurusha*. This obscure thing, having no intelligible form, is nothing but existence (*vastu*) in its tenebrous root, in so far as it is opposed to the Light of the Essence, of which the *devas* are as it were rays. Through the victory which the *devas* win over undifferentiated existence it receives a form; chaotic in itself, it becomes the support of distinct qualities, and the *devas* in their turn obtain a support of manifestation. From this point of view the stability of the temple comes from the direction "existence" (*vastu*), and rites are addressed to *Vāstupurusha* to secure the stability of the building: the patron (*kāraka*) of the temple, its builder or its donor, identifies himself with the *asūra* who became a victim of the gods and who supports the form of the temple.

Thus the *Vāstu-Purusha-mandala* is conceived from two different and apparently opposed points of view. The Hindu spirit never loses sight of the duality of the root of all things, for things proceed at once from the infinite Beauty and from the existential obscurity that veils it, this obscurity being in its turn a mysterious function of the Infinite, for it is nothing other than the universal plastic power, *Prakriti,* or the *Shakti*[23] that clothes beings with limited forms. Hindu art does no more than imitate the work of the *Shakti*. The *Shakti* is directly present in architecture and sculpture: a cosmic power, generous like the earth and mysterious like the serpent, appears to flow through the most insignificant of forms, it fills them with its plastic tension, while itself it is obedient to the incorruptible geometry of the Spirit. It is the *Shakti* that dances on the motionless body of *Shiva,* who represents Divinity in its aspect as transformer of the cosmos.

According to the point of view chosen, the victim incorporated in the *mandala* will represent either *Purusha,* the universal Essence, or the *asūra* overcome by the *devas*. If it is *Purusha* who is seen in the victim, the point of view carries with

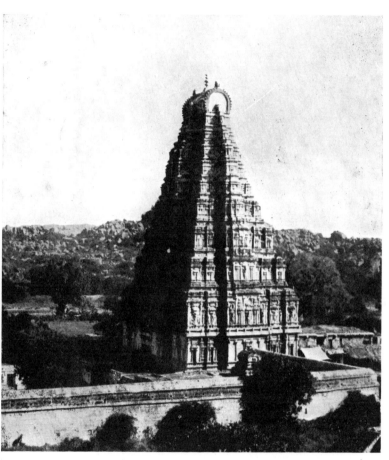

Plate I. Temple of Hampi, near Madras

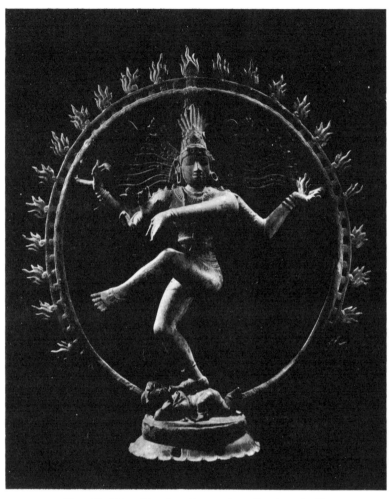

Plate II. Shiva Dancing. Bronze from Southern India

it an illusion, for the Divine Essence which as it were "descends" into the forms of the world is not in reality subject to their limitations, on the other hand, its "incorporation"—or what appears to be such—is the prototype of all sacrifice, by inverse analogy. It is however only the passive nature of existence that can really *undergo* the sacrifice, it is that nature, and not the Essence, which is *transformed,* so that from this point of view it is not *Purusha* who is imprisoned in the plan of the temple as sacrificial victim, but the *asūra* divinized by his sacrifice.

The symbolism of the *Vāstu-Purusha* is found among peoples who are not attached by any historical link to the Hindu world. For instance, the Osages, a tribe of the plains of North America, look upon the ritual arrangement of their camp as "the form and the spirit of a perfect man" who faces the East in times of peace; ". . . in him is found the centre, or the innermost place, the common symbol of which is the fire that burns in the middle of the medicine-lodge.[24] The important thing is that the encampment, arranged in a "camp-circle", is a picture of the whole cosmos: the half of the tribe which is situated to the Northward represents Heaven, while the other half living on the South side symbolizes the Earth. The fact that the ritual bounds of the area are in this case in the shape of a circle and not, as in the case of a temple, a square or a rectangle, is explained by the "style" of the nomadic life, and in no way invalidates the analogy in question. The assimilation of the form of the temple to that of the human body is moreover to some extent paralleled in the sacred calumet which itself was "a sort of corporeal type of that ideal man who becomes the gnomon of the sensible universe . . ."[25]

The same symbolism is found elsewhere in the idea that a durable building must be founded on a living being: hence the practice of walling a sacrificial victim into the foundations. In some cases it is the shadow of a living man that is "caught" and symbolically incorporated into the building.[26] Such things are doubtless distant echoes of the rite of the stabilization of the temple (*Vastushānti*), or of the idea of a victim at once divine and human incorporated into the temple of the world. An analogous conception namely that of the Christian temple as the body of the Divine Man, will be described later.

V

The *Vāstu-Purusha-mandala,* the outline of which is derived from the rite of orientation, is subdivided into a number of lesser squares; they form a network within which the foundations of the building are laid out. The analogy between the cosmos and the plan of the temple is carried right through into the plan of the internal arrangements, in which each lesser square corresponds to one of the phases of the great cosmic cycles and to the *deva* who rules over it. Only the central area, consisting of one or several lesser squares, is symbolically situated outside the cosmic order: it is the *Bramāsthana,* the place where *Brahmā* dwells. Over this central area the "chamber of the embryo" (*Garbhagriha*) is erected, in the form of a cube; it will hold the symbol of the Divinity to whom the temple is consecrated.

There are 32 types of *Vāstu-Purusha-mandala,* distinguished by the number of their lesser squares. These types are divided into two groups, those with an odd number of lesser squares, and those with an even number of internal divisions. The first series is developed from the fundamental *mandala* of nine squares which is more particularly a symbol of the earth (*Prithivī*) or of the terrestrial environment; the central square corresponds to the centre of this world and the eight peripheral squares to the cardinal regions and the four intermediate regions of space; it could be said to represent the Rose of the Winds with eight directions in a square form (fig. 5). As for the *mandalas* with an even number of divisions, their central feature is a block of four squares (fig. 6): it constitutes the symbol of *Shiva,* Divinity in its aspect of transformer. We have seen that the quaternary

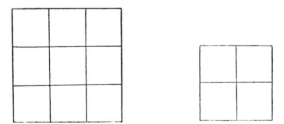

Figs. 5 and 6. Mandalas of nine and of four divisions

rhythm, of which this *mandala* is as it were the spatial fixation, expresses the principle of time; it may be looked on as the "static" form of the cosmic wheel with four spokes, or divided into its four phases. It will be observed that this type of *mandala* has no central square, the "centre" of time being the eternal present.

There are two *mandalas* that are specially favoured for the symbolical plan of the temple, one with 64 lesser squares and one with 81. It should be noted that the numbers 64 and 81 are sub-multiples of the fundamental cyclical number 25920, the number of years comprised in a complete precession of the equinoxes: $64 \times 81 \times 5 = 25920$. The factor 5 corresponds to the cycle of five lunar-solar years (*samvatsara*). The precession of the equinoxes is the ultimate measure of the cosmos, and in itself it is only measurable in terms of lesser cycles. Each of these mandalas thus represents an "abbreviation" of the universe conceived as the "sum" of all the cosmic cycles.[27]

It has already been indicated that the central "field" of the *mandala* represents the *Brahmāsthana*, the "station" of *Brahmā;* in the *mandala* of 64 squares it occupies four central squares, in the *mandala* of 81 squares, nine. In this field is erected the chamber of the centre, which houses the symbol of the titular divinity of the temple and is analogous to the "golden embryo" (*Hiranyagarbha*), the luminous germ of the cosmos (figs. 7 and 8).

The squares surrounding the *Brahmāsthana*, with the exception of those at the outer edges of the *mandala*, are assigned to

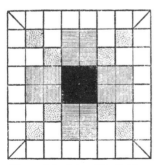

Fig. 7. Mandala of 64 divisions,
after Stella Kramrisch

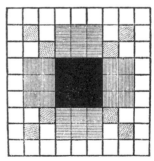

Fig. 8. Mandala of 81 divisions
after Stella Kramrisch

the twelve solar divinities (*Adityas*), whose number is reduced essentially to eight, since eight of them make up hierogamic couples. Thus the divine powers radiating from the station of *Brahmā* diverge along the eight principal directions of space. The eight directions again are associated with the eight planets of the Hindu system (the five planets properly so called, the sun, the moon and the demon of the eclipse (*Rāhu*). As for the outside squares, they represent the lunar cycle : in the *mandala* of 64 squares the border of 28 divisions corresponds to the 28 lunar mansions; in the *mandala* of 81 squares the "domains" of the four guardians of the cardinal regions are added. In both cases the cycle of the border is dominated by the 32 regents of the universe (*Padadevatās*) who are reflected in the qualities of space. Their hierarchy is derived from the quaternary division of space, expanded in the series 4—8—16—32; in the *mandala* of 64 squares four pairs of the said regents occupy the corners of the principal square.[28] The difference between the two mandalas of 64 and of 81 squares is thus essentially the same as that which distinguishes the two simplest *mandalas*, respectively dedicated to *Prithivī* and to *Shiva*, or to the principle of extension and the principle of time. The first named marks the cross of the cardinal axes by bands of squares, the second indicates it only by lines.

Regarded as a cosmological diagram the *Vāstu-Purusha-mandala* fixes and co-ordinates the cycles of the sun and of the moon;[29] the divergent rhythms of these two fundamental cycles could be said to reflect the infinitely varied theme of becoming. In a certain sense the world endures for as long as the sun and the moon, the "male" and the "female", are not united; that is to say, for as long as their respective cycles do not coincide. The two types of *mandala* are like two complementary figurations of the resolution of the two cycles into a single timeless order. Through this cosmological aspect the *Vāstu-Purusha-mandala* reflects the hierarchy of the divine functions. The various "aspects" of Being, as well as the diverse functions of the Universal Spirit, the cosmic manifestation of Being, can indeed be conceived as so many directions comprised in the totality of space, or as so many "facets" of a regular polygon, their symmetry betraying the unity of their common principle. That

is why the *Vāstu-Purusha-mandala* is also the seal of *Virāj*, the cosmic intelligence issuing from the supreme *Purusha*.[30]

An effective transformation of the cosmic cycles, or more precisely of the celestial movements, into crystalline form is also found in the symbolism of the sacred city. The mandala *par excellence* containing 64 squares is compared with the unconquerable city of the gods (*Ayodhyā*) which is described in the *Rāmayāna* as a square with eight compartments on each side. This city holds in its centre the abode of God (*Brahmapura*), just as the plan of the temple contains the *Brahmāsthana*. In Christianity also the changeless and celestial synthesis of the cosmos is symbolized as a city, the Heavenly Jerusalem; its bounds are held up by twelve pillars and are square, and in its centre dwells the Divine Lamb.[31] According to the Fathers of the Church the Heavenly Jerusalem is the prototype of the Christian temple.[32]

VI

We have seen that the construction of a temple is the expression of a cosmology. It carries as well an "alchemical" significance, in so far as it is the support of an inward realization in the artist himself. This "alchemical" significance first becomes apparent in the rite of orientation, which may be compared to a procedure of "crystallization" or of "coagulation". The indefinite cycle of the heavens is "fixed" or "coagulated" in the fundamental square, with the cross of the cardinal axes as connecting link; the cross thus plays the part of a crystallizing principle. If the world, carried onwards by the indefinite cyclical movement of the heavens, is in a sense analogous to the soul in its state of passivity and unconscious of its own essential reality, the discriminating cross is then the spirit, or more exactly the spiritual act, and the square is the body "transmuted" by this operation and henceforth the receptacle and the vehicle of a new and superior consciousness. The body is then the alchemical "salt" that unites the active and the passive, the spirit and the soul.

From another point of view the "alchemical" significance of the construction of the temple springs from the symbolism of the *Purusha* incorporated in the building and considered in this

case in its micro-cosmic aspect. This aspect is based more particularly on the *mandala* of 81 squares, which corresponds to the subtle body of *Purusha*, represented therein as a man lying face downwards[33] with his head towards the East. In a general way, discounting any anthropomorphic figuration, the lines that make up the geometrical diagram of the *Vāstu-Purusha-mandala* are identified with the measures of *Prāna*, the vital breath of *Vāstu-Purusha*. The principal axes and diagonals denote the principal subtle currents of his body; their intersections are the sensitive points or vital nodes (*marmas*), which must not be incorporated into the foundations of a wall, a pillar or a doorway. The exact coincidence of the axes of several buildings, such as those of a temple and its dependencies, must be avoided for similar reasons. Any transgression of this rule will be the cause of trouble in the organism of the donor of the temple, who is regarded as its real builder (*kāraka*) and is identified in the rites of foundation with *Purusha*, the sacrificial victim incorporated in the building.

A consequence of this law is that certain architectural elements are slightly displaced with respect to the rigorous symmetry of the design. The geometrical symbolism of the building as a whole is not thereby obscured; on the contrary, it retains its character as principial form while avoiding confusion with the purely material form of the temple. This brings into special prominence the extent of the difference between the traditional conception of "measure" and regularity, and the conception which finds its expression in modern science and industry; for what has been said about Hindu architecture is equally valid in principle for every traditional art or craft, whatever may be its religious foundation. The surfaces and the angles of a Romanesque church for example are always found to be inexact when strict measurements are applied to them, but the unity of the whole imposes itself all the more concisely: it could be said that the regularity of the building is released from the bonds of mechanical control in order to become reintegrated in the intelligible. Most modern constructions on the contrary can show only a purely "additive" unity, while they present a regularity in their detail that is "inhuman"—because it is apparently absolute—as if it were a question, not of "reproducing" the transcendent model using the means available to man, but of "replacing"

it by a sort of magic copy in complete conformity with it, which implies a Luciferian confusion between the material form and the ideal or "abstract" form. Because of this, modern buildings present an inversion of the normal relationship between essential forms and contingent forms, the result of which is a sort of visual inactivity incompatible with the sensitiveness—one would like to say with the "initiable substance"—of the contemplative artist. This is the danger that is forestalled in Hindu architecture by prohibiting the "obstruction" of the subtle currents of the sacred building.

The corporeal form of the temple must be distinguished from its subtle life, woven of *Prāna*, just as *Prāna* is distinguished from its own intellectual essence, which is *Virāj*. Together these three existential degrees represent the total manifestation of *Purusha*, the Divine Essence immanent in the cosmos.

In other words, the temple has a spirit, a soul and a body, like man and like the universe. The Vedic sacrificer identifies himself spiritually with the altar, which he builds to the measure of his body and thereby also to the measure of the universe of which the altar is a model; in exactly the same way the architect of the temple identifies himself with the building and with that which it represents; thus each phase of the architectural task is equally a phase of spiritual realization. The artist confers upon his work something of his own vital force; in exchange he participates in the transformation which that force undergoes by virtue of the sacramental and implicitly universal nature of the work. It is in this connection that the idea of *Purusha* incorporated into the building acquires a direct spiritual import.

VII

The base of the temple does not necessarily cover the whole extent of the *mandala*. The foundation walls are usually built in part inside and in part outside the square of the *mandala*, in such a way as to emphasize the cross of the cardinal axes or the star of the eight directions. This flexibility in the contour of the temple stresses its resemblance to the polar mountain (*Meru*). The lower part of the temple is more or less cubical and carries a series of diminishing storeys, giving a pyramidial effect. The pyramid is crowned by a conspicuous cupola, pierced by a

vertical axis, the "axis of the world", which is considered as passing through the body of the temple, starting at the centre of *Garbhagriha*, the cavern-sanctuary in the heart of the almost completely solid building (fig. 9).

Fig. 9. Foundations of a Hindu Temple, after Stella Kramrisch

The axis of the world corresponds to the transcendent reality of *Purusha*, the Essence that passes through all the planes of existence, linking their respective centres with unconditioned Being, situated symbolically at the highest point of the axis, clear of the pyramid of existence, the likeness of which is the temple with its many storeys.[34] This axis is represented in the Vedic altar by a channel of air which passes through three courses of bricks and ends beneath at the "golden man" (*hiranyapurusha*) immured in the altar. The axis is represented in this case by a void; this is because it is not only the motionless principle around which the cosmos revolves, but also the way which leads out of the world towards the Infinite.

The Hindu temple carries a sort of massive cupola (*sikhara*) from which the end of the axis projects. This cupola, which is sometimes like a thick disc in shape, corresponds naturally to the dome of the sky; it is the symbol of the supra-formal world.

The Hindu temple—which must not be confused with the buildings that surround it, the halls and the pavilions of the gates —has usually no windows lighting the sanctuary, which communicates with the outer world only through the passage leading to the entrance. Instead, the outer walls are generally ornamented with niches which enclose carved images of the *devas*, as if they were solid windows through which the Divinity present

in the sanctuary shows himself to the worshippers who are accomplishing the ritual circumambulation of the temple. As a general rule the central chamber of the temple, situated over the *Brahmāsthana*, contains only the symbol of the Divinity, all other figurative representations being dispersed over the vestibule and the outer walls. Thus the Unique Divinity is manifested on the outside only in anthropomorphic and multiple forms, which become visible to the pilgrims in the course of their progress round the mass of the sacred building with its promontories and its ravines.[35]

In the rite of circumambulation the architectural and plastic symbolism of the temple, which "fixes" the cosmic cycles, becomes itself the object of cyclical experience: the temple is then the axis of the world around which the beings subject to the round of existence (*Samsāra*) revolve; it is the entire cosmos in its aspect of immutable and divine Law.

VIII

Hindu architecture tends to envelop its verticals in compact masses with prolix outlines; on the other hand it emphasizes the horizontal lines as if they were sheets of water. This is because the vertical corresponds to the ontological unity, the essence, which is interior and transcendent, whereas the horizontal symbolizes the existential plane. The repetition of the horizontal, with the help of a massive construction in superimposed layers, suggests the indefinite multitude of the degrees of existence, their indefinity being in a sense the reflection in manifestation of the Divine Infinity. Hinduism is as it were haunted by nostalgia for the Infinite, which it envisages both in the absolute, in its aspect as undifferentiated plenitude, and in the relative, as the inexhaustible richness of the possibilities of manifestation, the latter point of view being effaced in the former. This is the spiritual foundation of that pluralism of forms which confers on Hindu art, despite the simplicity of its basic themes, something of the exuberant nature of a virgin forest.

This same pluralism is strongly marked in the carving of figures; in the statues of *devas* with multiple limbs, in the combinations of human with animal shapes, in all the protean profusion that oscillates—in the eyes of the West—between beauty

and monstrosity. In fact such transformation of the human body, which seems to make it almost like a multiform organism such as a plant or marine animal, have as their object the "dissolution" of all affirmation of the individual in a universal and indefinite rhythm; this rhythm is the play (*līlā*) of the Infinite manifesting itself through the inexhaustible power of its *Māyā*.

Māyā represents the productive or maternal aspect of the Infinite, and its power is equivocal in itself : it is generous in its fundamental maternal aspect, producing ephemeral beings and protecting them, and compensating all disequilibria in its boundless amplitude; but it is also cruel in its magic, which draws them into the inexorable round of the existence. Its dual nature is symbolized in the iconography of the Hindu temple by the protean mask of the *Kāla-mukha* or *Kirtti-murkha* which crowns the arches of the doorways and niches (fig. 10). This mask looks

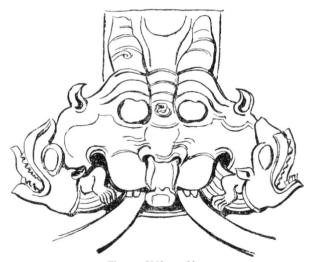

Fig. 10. Kāla-mukha

something like a lion and something like a marine monster. It has no lower jaw, as if it were a skull hung up as a trophy, but its features are none the less animated by an intense life; its nostrils fiercely suck in the air, while its mouth spits forth dolphins (*makaras*) and garlands which hang between the abutments of the arches. It is the "glorious" and terrible face of the

Divinity considered as the source of life and death. The divine enigma, cause of this world at once real and unreal, is hidden behind this Gorgon's mask: in manifesting this world the Absolute reveals Itself and hides Itself at the same time; It endows beings with existence, but at the same time deprives them of the vision of Itself.[36]

In other places the two aspects of the divine *Māyā* are represented separately: the lionesses or leogryphs which prance along the pillars and niches symbolize her terrible aspect, while the young women of celestial beauty incarnate her beneficent aspect.

Hindu art far surpasses Greek art in its exaltation of feminine beauty. The spiritual ideal of Greek art, progressively lowered towards a purely human ideal, is the *cosmos* as opposed to the indefinity of the *chaos*, and therefore the beauty of the male body, with its decisively articulated proportions; the supple and unified beauty of the feminine body, its richness here simple and there complex, like that of the sea, is missed by Greek art, at least on the intellectual plane. Hellenism remains closed to the recognition of the Infinite, which it confuses with the indefinite; not having the conception of the Transcendent Infinity, it catches no glimpse of it on the "prakritic" plane, that is to say, as the inexhaustible ocean of forms. It is not until the period of its decadence that Greek art becomes open to the "irrational" beauty of the feminine body, by which it is drawn away from its *ethos*. In Hindu art on the contrary the feminine body appears as a spontaneous and innocent manifestation of the universal rhythm, like a wave of the primordial ocean or a flower of the tree of the world.

Something of this innocent beauty also surrounds the representations of sexual union which adorn Hindu temples. In their most profound significance they express the state of spiritual union, the fusion of subject and object, of the interior and the exterior in ecstatic trance (*samadhi*). At the same time they symbolize the complementarism of the cosmic poles, the active and the passive; the passional and equivocal aspect of these representations is thus effaced in a universal vision.

Hindu sculpture assimilates without effort, and without losing its spiritual unity, means which elsewhere would lead to naturalism. It transmutes even sensuality by saturating it with spiritual awareness, expressed in the plastic tension of the surfaces

which, like those of a bell, seem to be designed to make a sound
that is pure. This quality in the work is the fruit of a ritual
method, which consists in the sculptor touching the surface of
his own body, from the head to the feet, with the aim of raising
the clarity of his consciousness right up to the extreme limits of
psycho-physical life, with a view to its integration in the spirit.[37]

On the other hand bodily consciousness, directly reflected in
the sculpture of figures, is transmuted by the sacred dance. The
Hindu sculptor must know the rules of the ritual dance, for it
is the first of the figurative arts, since it works with man himself.
Sculpture is thus attached to two radically different arts : through
the technique of the craft it is related to architecture, which is
essentially static and transforms time into space, whereas the
dance transforms space into time, by absorbing it into the con-
tinuity of the rhythm. It is therefore not surprising that these
two poles of Hindu art, sculpture and dancing, should together
have engendered what is perhaps the most perfect fruit of Hindu
art, the image of *Shiva* dancing (pl. II).

The dance of *Shiva* expresses at once the production, the
conservation and the destruction of the world, considered as
phases of the permanent activity of God. *Shiva* is the "Lord of
the Dance" (*Natarājā*). He himself revealed the principles of the
sacred dance to the sage Bharatamuni, who codified them in the
Bharata-Nātya-Shāstra.[38]

The static laws of sculpture and the rhythm of the dance are
combined to perfection in the classic statue of *Shiva* dancing.
The movement is conceived as a rotation round a motionless
axis; by its decomposition into four typical gestures, following
one another like phases, it reposes so to speak in its own ampli-
tude; it is in no way rigid, but its rhythm is held in a static
formula, like the ripples of a liquid in a vessel; time is integrated
in the timeless. The limbs of the god are arranged in such a way
that the worshipper who sees the statue from in front seizes all
the forms at a glance : they are contained within the plane of
the flaming circle, symbol of *Prakriti*, but their spatial poly-
valence is in no way impaired thereby. On the contrary, from
whatever side one contemplates the statue, its static equilibrium
remains perfect, like that of a tree outspread in space. The plastic
precision of the detail is in tune with the uninterrupted continuity
of the gestures.

Shiva dances on the vanquished demon of chaotic matter. In his outermost right hand he holds the drum, the beat of which corresponds to the creative act. By the gesture of his uplifted hand he announces peace, protecting what he has created. His lowered hand points to the foot which is lifted from the ground, in sign of deliverance. In his outermost left hand he carries the flame which will destroy the world.[39]

Images of *Shiva* dancing show sometimes the attributes of a god, sometimes those of an ascetic, or of both together, for God is beyond all forms, and He assumes form only that He may become his own victim.

NOTES

1. In primitive civilizations every dwelling is regarded as an image of the cosmos, for the house or the tent "contains" and "envelops" man on the model of the great world. This notion has survived in the language of the most diverse peoples, who speak of the "vault" or the "tent" of the sky, and of its "summit" to signify the pole. When a building is a sanctuary the analogy between it and the cosmos becomes reciprocal, because the Divine Spirit "inhabits" the sanctuary just as It "inhabits" the universe. On the other hand the Spirit contains the universe, so that the analogy is also valid in an inverse sense.

2. This view of things corresponds to the Vedantin point of view, which attributes dynamism to the passive substance, the *Shakti*, while the active Essence remains motionless.

3. Similarly the design of the Christian temple symbolizes the transmutation of the present "age" into a future "age": the sacred edifice represents the Heavenly Jerusalem, the shape of which is also square.

4. The reader to whom the Hindu terms used in this chapter are unfamiliar need not try to memorize those that are enclosed in parentheses. The inclusion of the latter is necessary both for the sake of accuracy, since in most cases no short form of words in English can be exactly equivalent to the Hindu term, and also in order to facilitate reference to other works dealing with the Hindu tradition.

5. According to the terminology of the monotheistic religions the *devas* correspond to the angels, in so far as the latter represent divine aspects.

6. This recalls the dismemberment of the body of Osiris in the Egyptian myth.

7. The myth of the immolation of *Prajāpati* by the *devas* is analogous to the Sufic doctrine according to which God manifested the multiple universe by virtue of His multiple Names, the diversity of the world being as it were "necessitated" by the Names. The analogy in question becomes still more striking when it is said that God manifests Himself in

the world by virtue of His Names. See the author's book: *Introduction aux doctrines ésotériques de l'Islam,* Lyon, Derain, 1955, and his translation of the *Sagesse des Prophètes (Fuçûç al-Hikām)* of Muhyi-d-din ibn 'Arabī, Paris, Albin Michel, 1955.

8. Although man is superior to the animal by virtue of his celestial "mandate", the animal shows a relative superiority to man in so far as man has lost his primordial nature, for the animal does not fall away in the same way from its cosmic norm. The sacrifice of an animal in place of a man is ritually justified only by the existence of a kind of qualitative compensation.

9. Union with the Divine Essence always comprises, as phases or aspects of a single spiritual act, the reintegration of all the positive aspects of the world—or of their interior equivalents—in a symbolical "hearth", the sacrifice of the soul in its limited aspect and its transformation by the fire of the Spirit.

10. The patriarchs of the nomadic people of Israel built altars under the open sky, from unworked stones. When Solomon built the temple in Jerusalem, thereby consecrating the sedentary condition of the people, the stones were worked without the use of iron tools, in memory of the manner of building the primitive altar.

11. Cf. Hehaka Sapa, *Les Rites secrets des Indiens Sioux,* texts collected by Joseph Epes Brown, Paris, Payot, 1953, p. 22.

12. See *ibid.,* Introduction by Frithjof Schuon

13. "Everything the Power of the World does is done in a circle. The sky is round, and I have heard that the earth is round like a ball, and so are all the stars. The wind, in its greatest power, whirls. Birds make their nests in circles, for theirs is the same religion as ours. Our tepees were round like the nests of birds, and these were always set in a circle, the nation's hoop, a nest of many nests, where the Great Spirit meant for us to hatch our children." (Hehaka Sapa in *Black Elk Speaks,* related by John Neihardt, New York, William Morrow, 1932, p. 198.

14. The same is the case with the prehistoric sanctuaries called "cromlechs", in which the circle of upright stones reproduces the cyclical divisions of the heavens.

15. Sometimes the static perfection of the square or the cube is combined with the dynamic symbolism of the circle. Such is the case with the Kaaba, which is the centre of a rite of circumambulation, and is without doubt one of the oldest of sanctuaries. It has been many times rebuilt, but its shape, which is that of a slightly irregular cube, has not been altered in historical times. The four corners *(arkān)* of the Kaaba are oriented towards the cardinal regions of the sky. The rite of circumambulation *(tawāf)* is a part of the pilgrimage to the Kaaba and was simply perpetuated by Islam. It expresses with precision the relationship existing between the sanctuary and the celestial movement. It is accomplished seven times, to correspond with the number of the celestial spheres, three times at racing speed and four times at walking pace.

According to legend the Kaaba was first built by an angel, or by

Seth, son of Adam. It was then in the shape of a pyramid; the deluge destroyed it; Abraham rebuilt it in the shape of a cube (*ka'bah*). It is situated on the axis of the world, its prototype is in the heavens, where the angels perform the *tawāf* around it. Still according to legend, the Divine Presence (*sakīnah*) appeared in the form of a serpent which led Abraham to the place where he must build the Kaaba; the serpent coiled itself round the building. This recalls in a striking way the Hindu symbolism of the serpent (*Ananta* or *Shesa*), which moves round the precinct of the temple.

We shall see later that the Hindu temple is also the centre of a rite of circumambulation.

16. In this connection the Hindu symbolism of the *sushumnā* may be recalled, the ray which joins every being to the spiritual sun.

17. The motive of the fish formed by the intersection of two circles, as well as the pattern of the triple fish formed by three intersecting circles, are found in the decorative art of various peoples, notably in Egyptian art, and in the Merovingian and Romanesque arts.

18. See *Mānasāra-Shilpa-Shāstra*, Sanscrit text edited and summarized in English by P. K. Acharya, Oxford University Press [1934].

19. In the building of the Vedic altar, *Agni-Prajāpati* as sacrificial victim is represented with the face turned towards the sky. The crucifix incorporated, according to Honorius d'Autun, in the plan of a cathedral is in the same position.

20. The *asuras* are the conscious—and therefore in a sense personal—manifestations of *tamas*, the "descending" tendency of existence. Cf. René Guénon, *Le Symbolisme de la Croix*, Paris, Véga, 1957.

21. A westerner would speak of "brute matter" transformed into pure symbol by Divine or angelic inspiration. The Hindu idea of existence (*vastu*) implies to some extent this conception of "brute matter", but it goes much farther, existence being conceived as the metaphysical principle of separativity.

22. This is the transformation from chaos to cosmos, the *fiat lux*, whereby the earth "without form and void" is filled with reflections of the divine.

23. *Prakriti* is the passive complement of *Purusha,* and the *Shakti* is the dynamic aspect of *Prakriti.*

24. Cf. Hartley Burr Alexander, *L'Art et la Philosophie des Indiens de l'Amerique du Nord*, Paris, Ernest Leroux, 1926.

25. Cf. *ibid.*

26. This custom is still found in Rumanian folk-lore.

27. In the solstitial rite of the "sun-dance" the Arapaho Indians build a great lodge, in the middle of which stands the sacred tree, representing the axis of the world. The lodge is constructed of twenty-eight pillars erected in a circle, and sustaining the rafters of the roof which meet the tree in the centre. On the other hand the lodge of the Crow Indians is open above, while the space surrounding the central tree is divided into twelve sections in which the dancers take their places. In both cases the form of the sanctuary is related to two cycles, that of the sun, and that

of the moon. In the first case the lunar cycle is represented by the twenty-eight pillars of the enclosure, corresponding to the twenty-eight lunar mansions; in the second case it is represented by the twelve months.

The rites accompanying the erection of the tree for the "sun-dance" show striking analogies with the Hindu rites connected with the erection of the sacrificial post, which is also the axis of the world and the cosmic tree.

28. In certain cosmological diagrams met with in Islamic esoterism, the phases of the celestial cycles are ruled over by angels, who in their turn manifest Divine Names. On this subject see the author's study: *Une clé spirituelle de l'astrologie musulmane*, Paris, Editions Traditionnelles, 1950.

29. It is worthy of note that the traditional diagram of the horoscope, representing the ecliptic, is also square.

30. The directions of space correspond very naturally to the Divine Aspects or Qualities, for they are the result of the polarization with respect to a given centre of a space that as such is limitless and undifferentiated. The centre chosen then corresponds to the "germ" of the world. It may be observed in passing that the "magic square", which serves to "coagulate" subtle forces for the performance of a predetermined operation, is a distant derivative of the *Vāstu-Purusha-mandala*.

31. Attention must be called in passing to the astonishing phonetic and semantic analogy between, on the one hand, *agnus* and *ignis*, and on the other, *ignis* and *Agni*; and in addition, to the analogy between the English word "ram" and the *Ram*, whose name in Hindu symbolism is a sacred word corresponding to fire, and is represented as a ram.

32. The altar then corresponds to the centre of the Heavenly Jerusalem, the centre occupied by the Lamb.

The terrestrial symbol of *Purusha*, the *Vāstu-Purusha-mandala,* is at the same time the plan of the temple, of the city, and of the palace in which a consecrated king lives. It also defines the place of the throne, around which are represented in certain cases the 32 gods (*Padadevatās*), acolytes of *Indra*, who denote the 4 × 8 directions of space.

The reader will have noticed that the *mandala* of eight times eight squares corresponds to a chess-board. The game of chess, which comes from India, where it is played by the noble and warrior castes, is an application of the symbolism inherent in the *Vāstu-Purushu-mandala* See the author's study: *Le symbolisme du jeu des échecs*, in *Etudes Traditionnelles*, Paris, October–November 1954.

33. This position corresponds to the "asuric" aspect of the victim incorporated in the *mandala*.

34. See René Guénon, *Le Symbolisme de la Croix, op. cit.*

35. Cf. Stella Kramrisch, *The Hindu Temple*, Calcutta, University of Calcutta, 1946. In all matters concerning the relation between the symbolism of the Hindu altar and of the Hindu temple the author has consulted this excellent work, which has drawn abundantly on the *shastras* of sacred art, and refers to the writings of Ananda K. Coomaraswamy.

36. The *Kāla-mukha* is also the face of *Rāhu*, the demon of the

eclipse. Cf. Ananda K. Coomaraswamy, *The Face of Glory.* (Swayamâ-trinnâ: *Janua Coeli*, in Zalmoxsis, II, 1939.)

37. This is not unrelated to the meaning of "fixation" in alchemy.

38. The "celestial" origin of the Hindu dance is indirectly proved by its spatial extension through the centuries. In a form adapted to Buddhism it has influenced the choreographic style of Tibet and of all Eastern Asia, including Japan; in Java it survived the conversion of the island to Islam; and through the medium of tzigane dancing it seems even to have set its seal on Spanish dancing.

39. Cf. Ananda K. Coomaraswamy, *The Dance of Shiva,* London, Peter Owen, 1958. (Also: New York, Farrar, Straus, 1957.)

THE FOUNDATIONS OF CHRISTIAN ART

I

THE mysteries of Christianity were revealed in the heart of a world that was both chaotic and pagan. Its "light shone in the darkness" but was never able to transform completely the environment of its expansion. It is for this reason that Christian art, compared with that of the age-long civilizations of the East, is curiously discontinuous, both in its style and in its spiritual quality. We shall see later how Islamic art succeeded in realizing a certain degree of formal homogeneity only by rejecting out of hand the artistic heritage of the Graeco-Roman world, at least in the domains of painting and sculpture. The problem did not present itself in the same way to Christianity : Christian thought, with its emphasis on the person of the Saviour, demanded a figurative art, so that Christianity was unable to set aside the artistic heritage of antiquity; but in adopting it, Christianity assimilated some germs of naturalism in the anti-spiritual sense of the word. Despite the long process of assimilation which that heritage underwent in the course of centuries, its latent naturalism never failed to break through every time there was a weakening of spiritual consciousness, even well before the Renaissance, when the definite break with tradition took place.[1] Whereas the art of the traditional civilizations of the East cannot properly be said to be split into sacred art and profane art, since sacred models inspire even its popular expressions, the Christian world has always known, side by side with an art that is sacred in the strict sense of the word, a religious art using more or less "worldly" forms.

The art that springs from a genuinely Christian inspiration is derived from certain images of the Christ and of the Virgin that have a miraculous origin. The craft traditions continue alongside it, and they become Christian by adoption; they are none the less sacred in character, in the sense that their creative methods

embody a primordial wisdom that responds spontaneously to the spiritual truths of Christianity. These two currents, the traditional art of icon painting and the craft traditions, together with certain liturgical music evolved from a Pythagorean inheritance, are the only elements in Christian civilization that deserve to be called "sacred art".

The tradition of the sacred image, the "true icon" (*vera icon*) is essentially theological, and its origins are at once historical and miraculous, in conformity with the particular nature of Christianity; more will be said about this later. It is not at all surprising that the filiation of this art should be lost to our eyes in the obscurity of the pre-Constantinian period, since the origin of so many traditions that are recognized as apostolic is similarly lost in the same relative obscurity. Certain reservations were doubtless made during the earlier centuries of Christianity about figurative art, reservations conditioned both by the Judaic influence and by the contrast with the ancient paganism; for as long as the oral tradition was alive everywhere and Christianity had not yet come into the full light of day, the figuration of Christian truths in art can only have played a very occasional part, and then for special reasons. But later on, when social freedom on the one hand and the needs of the collectivity on the other encouraged religious art or even made it necessary, it would have been very strange if the tradition, with all its spiritual vitality, had not endowed this possibility of manifestation with all the spirituality that is compatible with its nature.

As for the craft tradition, with its pre-Christian roots, it is above all cosmological, for the work of the craftsman imitates quite naturally the formation of the cosmos out of chaos; its vision of the world is therefore not immediately connected with the Christian revelation, Christian language not being *a priori* cosmological. But the integration of the craft symbolism into Christianity was nevertheless a vital necessity, for the Church had need of plastic arts in order to clothe itself with visible forms, and it could not appropriate to itself the crafts without taking into account the spiritual possibilities they contain. Furthermore, the craft symbolism was a factor of equilibrium in the psychic and spiritual economy of the Christian "city"; it compensated so to speak the unilateral pressure of Christian morality, fundamentally ascetic as it is, by manifesting divine truths in a light that is

relatively non-moral and in any case non-volitive: it sets up against the sermon which insists on what must be done by one who would become holy, a vision of the cosmos which is holy through its beauty;[2] it makes men participate naturally and almost involuntarily in the world of holiness. By the very fact that Christianity cleansed the craft inheritance of the factitious accretions imposed on it by Graeco-Roman naturalism, drunk as it was with human glories, it released the perennial elements retained in that inheritance, elements that re-enact the laws of the cosmos.[3]

The point of junction between the purely Christian tradition, which is theological in essence, and pre-Christian cosmology can be clearly discerned in the Christian signs in the Catacombs, and particularly in the monogram in the form of a wheel with six or eight spokes. It is well known that this monogram, the use of which dates from the earliest times, is made up of the Greek letters χ and ρ (Chi and Rho), either alone or combined with a cross. When this sign is inscribed in a circle it clearly assumes the form of the cosmic wheel; sometimes it is replaced by a plain cross inscribed in a circle. There can be no doubt about the solar nature of the last mentioned sign: in some Christian inscriptions in the Catacombs the circle emits rays having hands, an element derived from the solar emblems of ancient Egypt. Furthermore through the loop of the ρ which adorns the vertical axis like a polar star, the monogram combined with the cross shows a relationship to the looped cross, the Egyptian *ankh* (fig. 11).

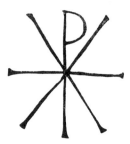

Fig. 11. The Christic monogram from the Catacombs, after Oskar Beyer

The wheel with eight spokes formed by the combination

of the monogram and the cross, is analogous to the "rose of the winds", the diagram of the four cardinal directions and the four intermediate directions of the heavens.

A fact that must never be lost sight of is that to the ancients as well as to the people of the Middle Ages physical space, envisaged in its totality, is always the objectivation of "spiritual space". In truth it is nothing else, because its logical homogeneity resides as much in the spirit of the knower as in physical reality.

The monogram of the Christ is very often placed between the letters alpha and omega, symbolizing the beginning and the end (fig. 12). The combination of the cross, the monogram and the

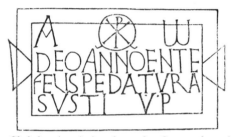

Fig. 12. Palaeo-Christian inscription from the Catacombs, with the Christic monogram between the Alpha and Omega. The solar circle of the monogram has "hands of light", following an Egyptian design. After Oskar Beyer

circle signify the Christ as spiritual synthesis of the universe. He is the all, He is the beginning, the end and the timeless centre; He is the "victorious" and "invincible" sun (*sol invictus*); His Cross rules the cosmos,[4] it judges the cosmos. Because of this the monogram is also the sign of victory. The Emperor Constantine, whose position as supreme monarch in itself symbolized the *sol invictus*, inscribed this sign on his standard, thereby announcing that the cosmic purpose of the Roman Empire was fulfilled in the Christ.

The Christ is also likened to the *sol invictus* in the liturgy, and the orientation of the altar confirms this assimilation. The liturgy, like many of the ancient mysteries, recapitulates the drama of the divine sacrifice in conformity with the general significance of the regions of space and the cyclical measures of time. The cosmic image of the Word is the sun.

The integration into Christianity of the craft traditions, with

all their cosmological outlook, had been providentially prepared for by the institution of the solar calendar by Julius Caesar,[5] who had drawn inspiration from Egyptian science; also by the trans-position of the Julian calendar and of the principal solar feasts into the Christian liturgical year. It must never be forgotten that reference to the cosmic cycles is fundamental in the craft tradi-tions and especially in architecture, as we have seen in the case of the building of a temple; this operation indeed gives the impression of a real "crystallization" of the celestial cycles. The significance of the directions of space cannot be dissociated from that of the phases of the solar cycle; this is a principle common to ancient architecture and to the liturgy.

Christian architecture perpetuates the fundamental diagram of the cross inscribed in the circle. It is significant that this design is at the same time the symbol of the Christ and the synthesis of the cosmos. The circle represents the totality of space, and there-fore also the totality of existence, and at the same time the celestial cycle, the natural divisions of which are indicated by the cross of the cardinal axes and are projected into the rectangular shape of the temple. The plan of a church emphasizes the form of the cross, and it corresponds not only to the specifically Christian meaning of the cross, but also to its cosmological role in pre-Christian architecture. The cross of the cardinal axes is the mediating element between the circle of the sky and the square of the earth : and it is the Christian perspective in par-ticular that gives first place to the part played by the Divine Mediator.

II

The symbolism of the Christian temple rests on the analogy between the temple and the body of the Christ, in accordance with the following words from the Gospel : "Jesus answered and said unto them, Destroy this temple and in three days I will raise it up. Then said the Jews, Forty and six years was this temple in building, and wilt thou rear it up in three days? But he spake of the temple of his body" (John ii. 19-21).

The temple of Solomon, replaced before the Christian era by the temple of Zorobabel, was the dwelling-place of the *Shekhina,* the Divine Presence on earth. According to the Jewish tradition

this Presence withdrew from the earth after the fall of Adam, but returned to inhabit the bodies of the patriarchs. Later on Moses prepared for it a movable dwelling in the tabernacle, and, in a more general sense, in the body of the purified people of Israel.[6] Solomon built for it a fixed habitation, in accordance with the plan revealed to his father David: "Thus spake Solomon, The Lord said that he would dwell in the thick darkness. I have surely built thee an house to dwell in, a settled place for thee to abid in for ever" (1 Kings viii. 12, 13). "And now, O God of Israel, let thy word, I pray thee, be verified, which thou spakest unto thy servant David my father. But will God indeed dwell on the earth? Behold the heaven and heaven of heavens cannot contain thee; how much less this house that I have builded" (*ibid.*, 26 and 27). "Now when Solomon had made an end of praying, the fire came down from heaven, and consumed the burnt offering and the sacrifices; and the glory of the Lord filled the house. And the priests could not enter into the house of the Lord, because the glory of the Lord had filled the Lord's house" (2 Chron. vii. 1 and 2).

The temple of Solomon was to be replaced by the body of the Christ:[7] when He died on the Cross the curtain before the holy of holies in the temple was rent: The body of the Christ is also the Church in its aspect as the communion of saints: the symbol of this Church is the Christian temple.

The Fathers of the Church say that the sacred building represents first and foremost the Christ as Divinity manifested on earth; at the same time it represents the universe built up of substances visible and invisible, and finally, man and his various "parts".[8] According to some of the Fathers the holy of holies is an image of the Spirit, the nave is an image of reason, and the symbol of the altar summarizes both,[9] according to others the holy of holies, that is to say the choir or the apse, represents the soul, while the nave is analogous to the body, and the altar to the heart.[10]

Some medieval liturgists, such as Durant de Mende and Honorius d'Autun, compare the plan of the cathedral to the form of the Crucified: His head corresponds to the apse with its axis to the East, His outstretched arms are the transepts, His torso and legs are at rest in the nave, His heart lies at the principal altar. This interpretation recalls the Hindu symbolism

of *Purusha* incorporated in the plan of the temple, in both cases the Man-God incarnated in the sacred building is the holocaust who reconciles Heaven with earth. It is conceivable that the Christian interpretation of the plan of the temple is an adaptation to the Christian perspective of a symbolism much more ancient than Christianity; but it is equally possible, and perhaps more probable, that two analogous spiritual conceptions were born independently one of the other.

It will be observed that the Hindu symbolism expresses the divine manifestataion in a generalized way. The *Vāstu-Purusha-mandala* is a diagram of the relation Spirit-matter or essence-substance, whereas the Christian parable of the temple envisages in particular the "descent" of the Word in human form. The metaphysical principle is the same but the sacred messages differ.

According to the teaching of the Fathers the incarnation of the Word as such is a sacrifice, not only by virtue of the Passion, but more especially because the Divinity is brought to an extreme of "humiliation" by the descent into a human and terrestrial form. It is true that God as God, in His eternal Essence, does not undergo the sacrifice; however, since the suffering of the Divine Man would not carry is real significance were it not for the presence of the Divine Nature in Him, the burden of the sacrifice does nevertheless in a certain sense fall in the end on God, whose infinite love embraces both the "height" and the "depth". Similarly in the Hindu doctrine, *Purusha* as Supreme Being cannot be subject to the limitations of the world in which and through which He manifests Himself; none the less, He can be regarded as taking on those limitations, because they are contained as possibilities in His own infinity.

These considerations are not taking us away from our subject. They are helpful towards an understanding of how close is the linkage that joins the meaning of the temple as body of the Divine Man with its cosmological meaning, for the cosmos represents in its most general significance the "body" of the revealed Divinity. It is at this point that the initiatic doctrine of the ancient "freemasons" meets Christology.

It has already been shown how the analogy between the constitution of the cosmos and that of the building is established by the procedure of orientation. We have seen too that the circle of the gnomon, which was the means of finding the East-West

and North-South axes, represented also the directing circle from which all the measurements of the building were deduced. It is known that the proportions of a church were usually derived from the harmonious division of a great circle, that is to say, its division into five or into ten. This Pythagorean method, which the Christian builders had probably inherited from the *collegia fabrorum*,[11] was employed not only in the horizontal plane but also in a vertical plane,[12] so that the body of the building was as it were inscribed in an imaginary sphere. The symbolism thus produced is very rich and very adequate to the requirements of the situation : the crystal of the sacred building is coagulated out of the indefinite sphere of the cosmos. This sphere is also like an image of the universal nature of the Word, whose concrete and terrestrial form is the temple (fig. 13).

Fig. 13. Examples of the proportions of Mediaeval churches, after Ernst Moessel

Division into ten parts does not fit in with the purely geo-metrical nature of the circle, for the compass divides it into six and into twelve; it corresponds however to the cycle, of which it indicates the successively decreasing phases, according to the formula $4 + 3 + 2 + 1 = 10$. This method of establishing the pro-portions of a building therefore partakes of the nature of time, so that it is not misleading to say that the proportions of a medieval cathedral reflect a cosmic rhythm. Moreover, propor-tion is in space what rhythm is in time, and in this connection

it is significant that harmonious proportion is derived from the circle, the most direct image of the celestial cycle. In this way the natural continuity of the circle is to a certain extent introduced into the architectural order, the unity of which becomes to that extent non-rational, and not comprehensible within the limits of the purely quantitative order.

The fact that a sacred edifice is an image of the cosmos implies *a fortiori* that it is an image of Being and its possibilities, which are as it were "externalized" or "objectivized" in the cosmic edifice. The geometrical plan of the building therefore symbolizes the "Divine Plan". At the same time it represents the doctrine, which each artisan collaborating in the work of construction could conceive and interpret within the limits of his particular art; it was a doctrine at once secret and open.

Like the cosmos the temple is produced out of chaos. The building materials, wood, brick or stone, correspond to the *hyle* or *materia prima*, the plastic substance of the world. The mason dressing a stone sees in it the *materia* which will participate in the perfection of the world only to the extent that it takes on a *forma* determined by the Spirit.

The tools used to shape the crude materials accordingly symbolize the divine "instruments" which "fashion" the cosmos out of the undifferentiated and amorphous *materia prima*. In this connection it is worth recalling the fact that in the most diverse mythologies, tools are identified with divine attributes; this explains why the initiatic transmission in the craft initiations was closely linked with the care of the tools of the craft. It can therefore be said that the tool is greater than the artist, in the sense that its symbolism goes beyond the individual as such; it is like an outward sign of the spiritual faculty linking the man to his divine prototype, the *Logos*. Moreover tools are analogous to weapons, which are also often treated as divine attributes.[13]

Thus the tools of the sculptor, the mallet and chisel, are in the likeness of the "cosmic agencies" which differentiate primordial matter, represented in this case by the unworked stone. The complementarism of the chisel and the stone necessarily reappears elsewhere and in other forms in most traditional crafts, if not in all. The plough works the soil[14] as the chisel works the stone, and in a similar way and in a principial sense, the pen "transforms" the paper;[15] the instru-

ment that cuts or shapes always appears as the agent of a male principle which acts on a female material. The chisel corresponds very evidently to a faculty of distinction or discrimination; active with respect to the stone, it becomes passive in its turn when it is considered in connection with the mallet, to the "impulsion" of which it is subject. In its initiatic and "operative" application the chisel symbolizes a distinctive knowledge and the mallet a spiritual will that "actualizes" or "stimulates" that knowledge. Here the cognitive faculty is situated below the volitive faculty, and this seems at first sight to contradict the normal hierarchy, but the apparent reversal is explained by the fact that the principial relation, in which knowledge has precedence over will, necessarily undergoes a metaphysical inversion in the "practical" domain. It is moreover the right hand that wields the mallet and the left that guides the chisel. Pure principial knowledge, which could be called "doctrinal"—and the "discernment" in question is no more than its practical or "methodical" application—does not intervene "actively", or shall we say "directly", in the work of spiritual realization but orders it in conformity with changeless truths. This transcendent knowledge is symbolized in the spiritual method of the stone carver by the various measuring instruments, such as the plumb-line, the level, the square and the compass, images of the changeless archetypes which preside over all the phases of the work.[16]

By analogy with certain craft initiations that still exist today in the East, it may be supposed that the rhythmical activity of the stone-carver was sometimes combined with the invocation, voiced or silent, of a divine name. In such a case the name, considered as a symbol of the creating and transforming Word, would be like a gift bequeathed to the craft by the Jewish or Christian tradition.

What has just been said about the work of the carver makes it clear that the initiatic teaching transmitted in the craft corporations must have been "visual" rather than "verbal" or "theoretical". The practical application of elementary geometrical principles alone must have awakened spontaneously some "presentiments" of metaphysical realities in artisans with a gift for contemplation. The use of measuring instruments, regarded as spiritual "keys", would then help towards an understanding of the ineluctable rigour of the universal laws, first in the

"natural" order, through the observation of the laws of statics, and then in the "supernatural" order, by an intuition, through the said laws, of their universal archetypes : presupposing always that the "logical" laws, which are derived from the rules of geometry and of statics, had not up to that time been arbitrarily enclosed within the limits of the notion of matter to such an extent that confusion with the inertia of the "non-spiritual" could arise.

Conceived in this way, the work of the artisan becomes a rite; nevertheless, if it is really to have the quality of a rite it must have some attachment to a source of Grace. The link that unites the symbolical act with its divine prototype must become the channel of a spiritual influence, so that it may bring about an intimate "transmutation" of the consciousness; it is indeed known that the craft initiation comprised a quasi-sacramental act of spiritual affiliation.

The goal of a realization attained by way of art or artisanship was "mastery", that is to say a perfect and spontaneous command of the art, a mastery in practice coinciding with a state of interior liberty and veracity. This is the state that Dante symbolizes as the earthly paradise situated on the summit of the mountain of purgatory. When he arrived at the threshold of this paradise, Virgil said to Dante : "Henceforth expect no more my words nor my counsel, for your judgement is free, upright and sound, and it would be a fault not to obey it; I declare thee also master of thyself, with the crown and the mitre."[17] Virgil personifies the pre-Christian wisdom that guides Dante through the psychic worlds to the centre of the human state, the Edenic state from which begins the ascent to the "heavens", symbols of supra-formal states. The ascent of the mountain of purgatory corresponds to the realisation of what were called in antiquity the "Lesser Mysteries", while the climb to the celestial spheres corresponds to a knowledge of the "Greater Mysteries". The symbolism used by Dante is mentioned simply because it gives a very clear idea of the range of a cosmological initiation such as a craft initiation.[18]

It is important not to lose sight of the fact that in the eyes of every artist or artisan taking part in the building of a church, the theory was visibly being made manifest by the building as a whole, reflecting as it did the cosmos or the Divine plan. Mastery

therefore consisted in a conscious participation in the plan of the "Great Architect of the Universe". It is this plan that is revealed in the synthesis of all the proportions of the temple; it co-ordinates the aspirations of all who take part in the work of the cosmos.

It could be said in quite a general way that the intellectual ele-ment in the method was manifested in the regular shape that had to be conferred on stone. For *forma* in the Aristotelian sense plays the part of "essence"; it is *forma* that recapitulates in a certain sense the essential qualities of a being or of an object, and is thus opposed to *materia*. In the initiatic application of this idea, the geometrical models represent aspects of spiritual truth, while the stone is the soul of the artist. The work done on the stone, consisting in the removal of all that is superfluous and in conferring a "quality" on something that is still no more than a crude "quantity", corresponds to the development of the virtues, which in the human soul are the supports and at the same time the fruits of spiritual knowledge. According to Durandus de Mende, the stone "trimmed to a rectangle and polished" re-presents the soul of a holy and steadfast man who will be built into the wall of the spiritual temple by the hand of the Divine Architect.[19] According to another parable, the soul is changed from a crude stone, irregular and opaque, into a precious stone, penetrated by the Divine Light which it reflects through its facets.

III

Forma and *materia* were familiar terms in medieval thought; they have been intentionally chosen here to designate the poles of a work of art. Aristotle, who referred the nature of every being or object to these two basic principles, used the artistic procedure for the purposes of his demonstrations, for the two principles in question are not *a priori* logical determinations, they are something more. Thought does not deduce them but pre-supposes them; their conception is not essentially founded on rational analysis, but on intellectual intuition, the normal support of which is not argument but the symbol; the clearest symbol of this ontological complementarism is precisely the relation be-tween the model or the idea (*eidos*) which pre-exists in the mind

of the artist, and the material, be it wood, clay, stone or metal, that is to receive the imprint of that idea. Without the example of plastic material, ontological *materia* or *hyle* cannot be conceived, for it is not measurable nor definable; it is "amorphous", not only in the relative sense in which the material of a craft is "amorphous" or crude, but also in a radical sense, for it is without intelligibility of any kind until it is joined to a *forma*. Correspondingly, although *forma* may be up to a point conceivable as such, it is nevertheless not imaginable apart from its union with *materia*, which determines it by lending it an "extension" either subtle or quantitative. In short, although the two ontological principles, once they have been recognized, are intellectually evident, it is no less true that the concrete symbolism provided by the work of the artist or craftsman cannot be dispensed with for their demonstration. Moreover, since the range of the symbolism extends far beyond the domain of reason, one must conclude that Aristotle borrowed the notions of *eidos* and *hyle,* translated by the Latins into *forma* and *materia,* from a real tradition, that is to say, from a method of teaching derived at once from doctrine and from Divine art.

It is also worthy of note that the Greek word *hyle* literally means wood; wood is in fact the principal material used in the crafts of archaic civilizations. In certain Asiatic traditions, notably in Hindu and Tibetan symbolism, wood is also regarded as a "tangible" equivalent of the *"materia prima"*, the universal plastic substance.

The example of art, taken by Aristotle as a conceptual starting point, is only fully valid if the reference is to traditional art, wherein the model, which by analogy plays the part of "formal" principle, is truly the expression of an essence, that is to say of a synthesis of transcendent qualities. In the practice of any such art this qualitative essence is embodied in a symbolical formulation susceptible of many "material" applications. According to the material receiving the imprint of the model, the model will reveal either more or less of its intrinsic qualities, just as the essential form of a being is either more or less in evidence according to the plastic capacity of its *materia*. On the other hand, it is form that brings out the particular nature of a material, and in this connection also traditional art is more truthful than a naturalistic or illusionist art, which tends to dissimulate the

natural characteristics of plastic materials. Let us recall once more that the relation *forma-materia* is such that *forma* becomes measurable only through its combination with *materia*, whereas *materia* is intelligible only by virtue of *forma*.

Individual existence is always woven of *forma* and *materia*, simply because the polarity they represent has its foundation in Being itself. Indeed *materia* proceeds from *materia prima*, the universal passive substance, while *forma* corresponds to the active pole of Being, the essence: when essence is referred to in connection with a particular being, it represents the archetype of that being, its permanent possibility in the Spirit or in God. It is true that Aristotle does not make this last transposition; he does not relate *forma* back to its metacosmic principle, no doubt because he consciously limits himself to the domain accessible to his method of demonstration; this domain is characterized by the possibility of a coincidence within it of ontological and logical laws. Nevertheless Aristotle's axioms, for example hylemorphic complementarism, presuppose a metacosmic background, such as medieval thought discerned quite naturally in the Platonic point of view. The doctrines of Plato and of Aristotle contradict one another on the rational plane alone; if one understands the myths of Plato, they cover the aspect of reality to which Aristotle confines his attention. Those who represent the highest development of the Middle Ages were therefore right in subordinating the perspective of Aristotle to that of Plato.[20]

Whether one accepts the doctrine of Plato in its characteristic dialectical form, or whether one feels obliged to reject it, it is impossible from the Christian point of view to deny that the essential possibilities of all things are eternally contained in the Divine Word, the Logos. For "all things were made" by the Word (John i. 3), and in It alone—or through It—are all things known, since It is the "true Light, that lighteth every man that cometh into the world" (*ibid.* i. 9, 10). Therefore the light of the intellect does not belong to us, it belongs to the omnipresent Word; and this light contains essentially the qualities of knowable things, for the innermost reality of the cognitive act is quality, and quality is "form", understood in the Peripatetic sense of the word. "The form of a thing, says Boethius, is like a light by which that thing is known."[21] This is the eminently

spiritual significance of hylemorphism : the "forms" of things, their qualitative essences, are in themselves transcendent; they can be found at all levels of existence; it is their coincidence with this or that material—or with some modality of the *materia prima*—which delimits them and reduces them to their more or less ephemeral "traces".

Boethius has just been quoted; in the Middle Ages he was one of the great masters of art, and it was he who handed on the Pythagorean idea of art.[22] His treatise on the *quadrivium* is more than a mere exposition of the minor arts—arithmetic, geometry, music and astronomy—it presents a real science of form, and it would be a mistake not to recognize the extent of its applicability to the plastic arts. In Boethius' eyes all the formal orders are "demonstrations" of the ontological Unity. His arithmetic represents not so much a method of calculation as a science of number, and he does not see number *a priori* as a quantity, but as a qualitative determination of unity, like the Pythagorean numbers themselves, which are analogous to the Platonic "ideas" : duality, the ternary, the quaternary, the quinary, etc., represent so many aspects of Unity. That which links the numbers together is essentially proportion, which in its turn is a qualitative expression of Unity; the quantitative aspect of numbers is merely their material "development".

The qualitative unity of number is more evident in geometry than in arithmetic, for quantitative criteria are not really sufficient to distinguish between two figures such as the triangle and the square, each of which has its unique and so to speak inimitable quality.

Proportion is in space what harmony is in the realm of sound. The analogy subsisting between these two orders is demonstrated by the use of the monocord, the string of which produces sounds that vary according to the length of its vibrating part.

Arithmetic, geometry and music correspond to the three existential conditions of number, space and time. Astronomy, which is essentially a science of cosmic rhythms, comprehends all these domains.

It may be noted that the astronomy of Boethius has been lost. His geometry as we know it has many gaps; perhaps we should only see in it a sort of summary of a science which must have undergone a considerable development in the workshops of the

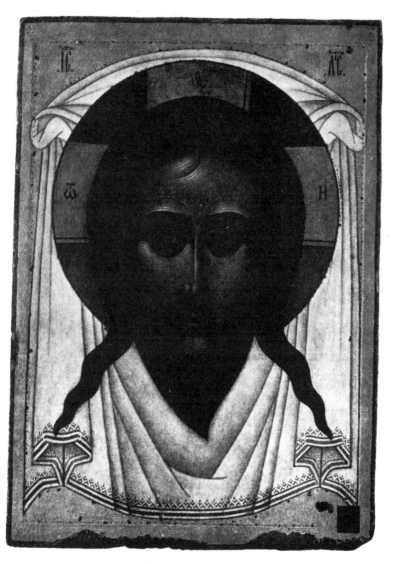

Plate III. Mandilion

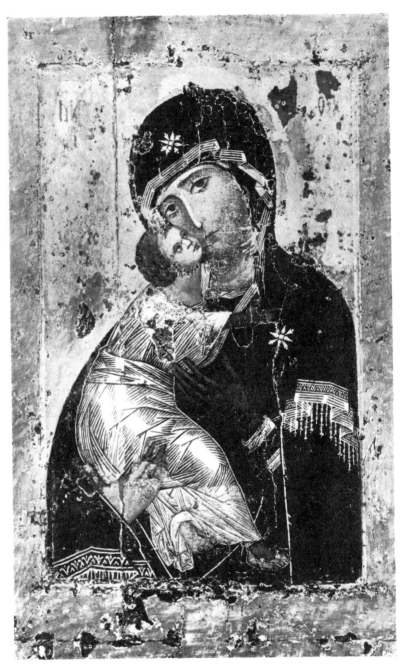

Plate IV. The Holy Virgin of Vladimir

medieval builders, not to mention the cosmological speculations which accompanied it.

Whereas modern empirical science considers first of all the quantitative aspect of things, while detaching it as far as possible from all its qualitative connotations, traditional science contemplates qualities independently of their quantitative associations. The world is like a fabric made up of a warp and a weft. The threads of the weft, normally horizontal, symbolize *materia* or, more immediately, such causal relations as are rationally controllable and quantitatively definable; the vertical threads of the warp correspond to *formae*, that is to say to the qualitative essences of things.[23] The science and the art of the modern period are developed in the horizontal plane of the "material" weft; the science and the art of the Middle Ages on the other hand are related to the vertical plane of the transcendent warp.

IV

The sacred art of Christianity constitutes the normal setting of the liturgy, of which it is an amplification in the fields of sound and of sight. Like the non-sacramental liturgy, its purpose is to prepare and to bring out the effects of the means of grace instituted by the Christ Himself. When Grace is in question no environment can be "neutral" it will always be for or against the spiritual influence; whatever does not "assemble" must inevitably "disperse".

It is quite useless to invoke "evangelical poverty" in order to justify the absence or the rejection of a sacred art. True enough, when the Mass was still celebrated in caverns or catacombs, sacred art was superfluous, at least in the form of plastic art; but from the time when sanctuaries began to be built they had to be subject to the rules of an art conscioius of spiritual laws. Not a single primitive or medieval church in fact exists, poor though it be, the forms of which do not bear witness to a consciousness of that kind,[24] whereas every non-traditional environment is encumbered with forms that are empty and false. Simplicity is in itself one of the marks of tradition, whenever it is not just the simplicity of virgin nature.

The liturgy itself can be thought of as a work of art comprising several degrees of inspiration. Its centre, the Eucharistic

sacrifice, belongs to the order of Divine Art; through it is accomplished the most perfect and the most mysterious of transformations. Spreading outwards from this centre or kernel, like an inspired but necessarily fragmentary commentary, is the liturgy, founded on usages consecrated by the Apostles and the Fathers of the Church. In this connection, the great variety of liturgical usages, such as existed in the Latin Church before the Council of Trent, in no way hid the organic unity of the work, but on the other hand emphasized its internal unicity, the divinely spontaneous nature of the plan and its character as art in the highest sense of the word; it is for this very reason that art properly so called was all the more easily integrated with the liturgy.

It is by virtue of certain objective and universal laws that the architectural environment perpetuates the radiancy of the Eucharistic sacrifice. Sentiment, however noble its impulse, can never create such an environment, for affectivity is subject to the reactions engendered by reactions, it is wholly dynamic, and cannot apprehend directly or with any certainty the qualities of space and time which correspond quite naturally to the eternal laws of the Spirit. It is impossible to be engaged in architecture without becoming implicitly engaged in cosmology.

The liturgy does not determine the architectural order alone, it also regulates the disposition of sacred images according to the general symbolism of the regions of space and the liturgical significance of left and right.

It is in the Eastern Orthodox Church that images are most directly integrated with the liturgical drama. They adorn more particularly the iconostasis, the barrier that divides the Holy of Holies—the place of the Eucharistic sacrifice enacted under the eyes of the priests alone—from the nave to which the majority of the faithful have access. According to the Greek Fathers the iconostasis is the symbol of the limit that separates the world of the senses from the spiritual world, and that is why the sacred images appear on that barrier, just as the Divine Truths which reason cannot directly apprehend are reflected in the form of symbols in the imaginative faculty, which is intermediate between the intellect and the sensorial faculties.

The plan of Byzantine Churches is distinguished by a division into a choir (*adyton*) to which the priests, with their attendant deacons and acolytes, alone are admitted, and a nave (*naos*)

which shelters the rest of the community. The choir is relatively small; it does not form a single unit with the nave which holds without respect to persons the whole crowd of believers standing with the iconostasis in their full view. The iconostasis has three doors, by which the officiants go in and out as they announce the various phases of the divine drama. The deacons use the lateral doors; only the priest at special moments such as the carrying of the consecrated elements or the book of the Gospels may pass through the Royal Door, the central one, which is thus made an image of the solar or Divine door.[25] The *naos* is usually more or less concentric in shape, a shape that corresponds to the contemplative character of the Eastern Church : space is as it were gathered in on itself, while still expressing the limitlessness of the circle or the sphere (fig. 14).

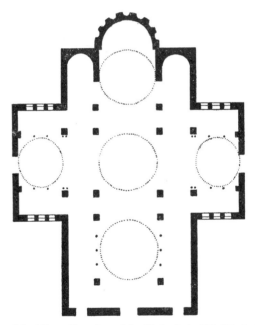

Fig. 14. The original Byzantine plan of the Cathedral of St. Mark, Venice, after Ferdinand Forlati

The Latin liturgy on the other hand tends to differentiate architectural space according to the cross formed by the axes,

and thus to communicate to it something of the nature of move-
ment. In Romanesque architecture the nave gets progressively
longer; it is the way of pilgrimage to the altar, to the Holy Land,
to Paradise; the transept too is developed more and more ex-
tensively. Later on Gothic architecture emphasizes to the utmost
extent the vertical axis, and ends by absorbing the horizontal
development into one great leap towards Heaven. The various
branches of the cross are gradually incorporated into a vast nave,
with perforated partitions and diaphanous outer walls.

The crypt and the cave are the models of Latin sanctuaries
at the height of the Middle Ages; these sanctuaries are concen-
trated on the Holy of Holies, the vaulted apse, enclosing the altar
as the heart holds the Divine Mystery; their light is the light of
the candles on the altar, as the soul is illumined from within.

Gothic cathedrals realize a different aspect of the mystical
body of the Church, or of the body of man sanctified, namely
his transfiguration by the light of Grace. So diaphanous a condi-
tion in architecture only became possible with the differentiation
of structural elements into ribs and membranes, the ribs assum-
ing the static function and the membranes that of clothing. Here
there is in a certain sense a passage from the static condition of
the mineral world to that of the vegetable world; it is not for
nothing that gothic vaulting recalls the calyces of flowers. There
is also the fact that a "diaphanous" architecture would not be
possible without the art of the glazier, whose windows make the
outer walls transparent while safeguarding the intimacy of the
sanctuary. The light broken up by stained glass is no longer
that of the crudity of the outer world, it is the light of hope and
beatitude. At the same time the colour of the glass has itself be-
come light, or more exactly, the light of day reveals its inward
richness through the transparent and sparkling colour of the
glass; so the Divine Light, which as such is blinding, is attenuated
and becomes Grace when it is refracted in the soul. The art of
staining glass conforms closely to the Christian genius, for colour
corresponds to love, as form corresponds to knowledge. The
differentiation of the one and only light by the many-coloured
substances of the windows recalls the ontology of the Divine
Light as expounded by a St. Bonaventure or a Dante.

The dominant colour of the window is blue, the blue of the
depth and the peace of the sky. Red, yellow and green are used

sparingly, and thereby seem all the more precious; they suggest stars or flowers or jewels, or drops of the blood of Jesus. The predominance of blue in medieval windows produces a light that is serene and soft.

In the pictography of the great cathedral windows the events of the Old and New Testaments are reduced to their simplest formulation, and are enclosed within a geometrical framework. They thus appear as prototypes eternally contained within the Divine Light; light is crystallized. Nothing is more joyous than this art; how remote it is from the sombre and tormented imagery of some Baroque churches!

Considered as a craft the art of staining glass is one of a group of techniques having as their aim the transformation of materials, namely, metallurgy, enamelling and the preparation of paints and dyes, including liquid gold. These techniques are all interconnected through a common craft inheritance which goes back in part as far as ancient Egypt, with alchemy as its spiritual complement; the crude material is the image of the soul which must be transformed by the Spirit. The transmutation of lead into gold in alchemy seems to involve a break of natural laws, but this is because it expresses in the language of the artisan the transformation, at once natural and supernatural, of the soul. The transmutation is natural because the soul is predisposed towards it, and supernatural because the real nature of the soul, or its true equilibrium, is in the Spirit, just as the real nature of lead is gold. But the passage from one to the other, from lead to gold, or from the unstable and disunited *ego* to its incorruptible and single essence, is only possible by some sort of miracle.

The noblest manual craft put to the service of the Church is that of the goldsmith, for his is the craft that fashions the sacred vessels and ritual instruments. There is something solar in this art, gold being related to the sun; and therefore the utensils created by the goldsmith manifest the solar aspect of the liturgy. The various hieratic forms of the cross, for example, represent so many modalities of the divine radiance; the divine centre reveals itself in the dark space that is the world (fig. 15).[26]

All arts founded on a craft tradition work to a geometrical or chromatic plan, which cannot be separated from the material processes of the craft, but retain none the less their character as symbolical "keys" that can open up the cosmic dimension of

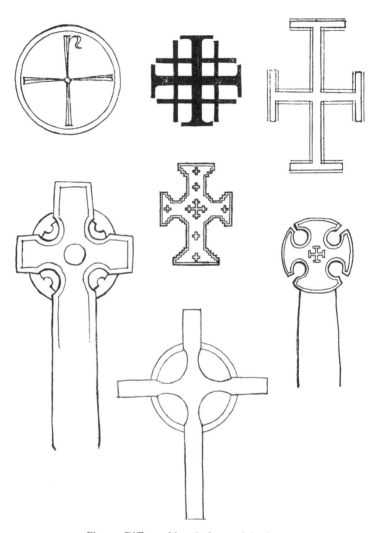

Fig. 15. Different hieratic forms of the Cross

each phase of the work.[27] An art of this kind is therefore necessarily "abstract" through the very fact that it is "concrete" in its processes; the designs at its disposal will depend for their proper application both on expert craftsmanship and on intuition, but they will be transposable at need into a figurative language, which will retain something of the "archaic" style of the creations of craftsmanship. This is what happens in the art of staining glass, and the same is the case with Romanesque sculpture, which is derived directly from the art of the mason; it keeps the technique and the rules of composition of that art, while reproducing at the same time models derived from the icon.

V

The tradition of the sacred image is related to established prototypes which have a historical aspect. It comprises a doctrine, that is to say, a dogmatic definition of the sacred image, and an artistic method which allows the prototype to be reproduced in a manner conformable to its meaning. The artistic method in its turn presupposes a spiritual discipline.

Among the prototypes generally handed down in Christian art, the most important is the *acheiropoietos* ("not made by human hands") image of the Christ on the *Mandilion*. It is said that the Christ gave His image, miraculously imprinted on a piece of fabric, to the messengers of the King of Edessa, Abgar, who had asked Him for His portrait. The *Mandilion* had been preserved at Constantinople until it disappeared when the town was pillaged by the Latin Crusaders (pl. III).[28]

Another prototype, no less important, is the image of the Virgin attributed to St. Luke; it is preserved in numerous Byzantine replicas (pl. IV).

Latin Christianity too possesses models consecrated by tradition, such as for example the Holy Countenance (*Volto Santo*) of Lucca, which is a crucifix carved in wood, Syrian in style, attributed by legend to Nicodemus the disciple of Christ.

Attributions such as these naturally cannot be proved historically; perhaps they ought not to be taken literally, but should be interpreted as having the function of confirming the authority of the traditional sources in question. As for the usual traditional representation of the Christ, its authenticity is confirmed by a

thousand years of Christian art, and this alone is a powerful argument in favour of that authenticity, for, unless reality is denied to everything of that order, it must be admitted that the Spirit present in the tradition as a whole would soon have eliminated a false physical representation of the Saviour. The representations of the Christ on certain sarcophagi of the period of Roman decadence evidently prove nothing to the contrary, any more than do the naturalistic portraits of the Renaissance, for the latter are no longer within the Christian tradition, while the former had not yet entered it. It may also be noted that the imprint preserved on the Holy Shroud of Turin, the details of which have only been made clearly visible by modern methods of investigation, resembles in a striking way, so far as characteristic details are concerned, the *acheiropoietos* image.[29]

The above remarks on the traditional icon of the Saviour are equally applicable to the icon of the Virgin attributed to St. Luke. Some other types of icon—such as that of the "Virgin of the Sign" which represents the Holy Virgin in an attitude of prayer with a medallion of the Christ Emmanuel on her breast, or such as the figure compositions which once adorned the walls of the Church of the Nativity in Bethlehem—are convincing, in the absence of any tradition establishing their origin, by reason of their spiritual quality and their evident symbolism, which testify to their "celestial" origin.[30] Certain variations of these prototypes have been "canonized" in the Eastern Orthodox Church, on account of miracles worked through their intervention, or because of their doctrinal or spiritual perfection;[31] these variations have in their turn become prototypes for icons.

It is very significant for Christian art, and for the Christian point of view in general, that these sacred images have a miraculous origin, and thus one that is mysterious and at the same time historical. This fact moreover makes the relation between the icon and its prototype very complex: on the one hand the miraculous image of the Christ or of the Virgin is to the work of art what the original is to the copy; on the other hand the miraculous portrait is itself no more than a reflection or a symbol of an eternal archetype, in this case the real nature of the Christ or of His mother. The situation of art is here strictly parallel to that of faith; for Christian faith is connected in practice to a clearly defined historical event, the descent of the Divine Word

to earth in the form of Jesus, though it has also essentially a non-historical dimension. Is not the decisive quality of faith its acceptance of the eternal Realities of which the event in question is one of the expressions? To the extent that spiritual consciousness grows less and the emphasis of faith is directed to the historical character of the miraculous occurrence rather than to its spiritual quality, the religious mentality turns away from the eternal "archetypes" and attachs itself to historical contingencies, which thereafter are conceived in a "naturalistic" manner, that is to say, in the manner that is most accessible to a collective sentimentality.

An art that is dominated by spiritual consciousness tends to simplify the features of the sacred image and to reduce them to their essential characteristics, but this in no way implies, as is sometimes suggested, a rigidity of artistic expression. The interior vision, oriented towards the celestial archetype, can always communicate to the work its subtle quality, composed of serenity and plenitude. On the other hand in periods of spiritual decadence the naturalistic element inevitably shows through. This element was in any case latent in the Greek inheritance of Western painting, and its incursions, threatening the unity of the Christian style, made themselves felt well before the "Renaissance". The danger of "naturalism" or an arbitrary exaggeration of style, replacing the spiritual imponderables of the prototype by purely subjective features, became all the more real because collective passions, held in check by the unalterable character of the scriptural traditions, found an outlet in art. This is as much as to say that Christian art is an extremely fragile thing, and that it can only retain its integrity at the cost of ceaseless watchfulness. When it becomes corrupted, the idols which it then creates react in their turn, on the whole in a predominantly harmful way, on the collective mentality. When this has happened neither the opponents nor the partisans of the religious image need ever be short of valid arguments, because the image is good in one aspect and bad in another. However that may be, a sacred art can never be safeguarded without formal rules and without a doctrinal consciousness in those who control and inspire it; consequently the responsibility falls on the priesthood, whether the artist be a simple artisan or a man of genius.

The Byzantine world only became conscious of all that is

implied in sacred art as a consequence of the disputes between iconoclasts and iconodules, and to a large extent thanks to the threatening approach of Islam. The uncompromising attitude of Islam towards images necessitated something like a metaphysical justification of the sacred image on the part of the Christian community in danger, all the more so because the Islamic attitude appeared to many Christians to be justified by the Decalogue. This became the occasion for recalling that the veneration of the image of the Christ is not only permissible, but that it is also the manifest testimony of the most essentially Christian dogma : that of the incarnation of the Word. God in His transcendent Essence cannot be represented, but the human nature of Jesus which He received through His mother is not inaccessible to representation; moreover the human form of the Christ is mysteriously united with His Divine Essence, despite the distinction of the two "natures", and this justifies the veneration of His image.

At first sight this apologia for the icon appears to be concerned only with its existence and not with its form; nevertheless the argument just quoted implies the development of a doctrine of the symbol, which must determine the whole orientation of art : the Word is not merely the pronouncement, at once eternal and temporal, of God, it is equally His image, as St. Paul said;[32] that is to say, It reflects God on every level of manifestation. The sacred image of the Christ is thus only the final projection of the descent of the Divine Word to earth.[33]

The VIIth council of Nicea (A.D. 787) established the justification of the icon in the form of a prayer addressed to the Virgin who, as the substance or the support of the incarnation of the Word, is also the true cause of its figuration : "The indefinable (*aperigraptos*) Word of the Father made Himself definable (*periegraphe*), having taken flesh of Thee, O Mother of God, and having refashioned the image (of God) soiled (by original sin) to its former estate, has suffused It with Divine beauty. But confessing salvation we show it forth in deed and word."

The principle of symbolism had already been demonstrated by Dionysius the Areopagite :[34] "The sacerdotal tradition, as well as the divine oracles, hides that which is intelligible beneath that which is material, and that which surpasses all beings beneath the veil of these same beings; it gives form and likeness to that

which has neither form nor likeness, and through the variety
and materiality of these emblems it makes multiple and compo-
site that which is excellently single and incorporeal" (*Of Divine
Names*, I. 4). The symbol, he explains, is two-faced; on one side
it is deficient with respect to its transcendent archetype, to the
point of being separated from it by all the abyss that separates
the terrestrial world from the divine world; on the other side, it
participates in the nature of its model, for the inferior proceeds
from the superior; in God alone subsist the eternal types of all
beings, and all are penetrated by the Divine Being and the
Divine Light. "We see then that one can attribute likenesses to
celestial beings without impropriety, though they be produced
from the most lowly parts of matter, since this matter itself, hav-
ing received its subsistence from absolute Beauty, preserves
through all its material structure some vestiges of intellectual
beauty, and since it is possible through the medium of this matter
to raise oneself to the immaterial archetypes, provided that one
is careful, as has been said, to look at the metaphors more parti-
cularly in the light of their unlikeness, that is to say, instead of
considering them always in the same light, to take account of
the distance that separates the intelligible from the sensible, and
to define them in the way that most appropriately suits each of
their modes" (*Of the Celestial Hierarchy*, I. 4).[35] But the dual
aspect of the symbol is assuredly nothing else but the dual nature
of form, understood, in the sense of *forma*, as the qualitative im-
print of a being or a thing; for form is always a limit and at
the same time the expression of an essence, and that essence is
a ray of the Eternal Word, supreme archetype of all form and
so of every symbol, as is shown by these words of St. Hierotheos,
the great teacher quoted by Dionysius in his book on Divine
Names : "As form giving form to all that is formless, in so far as
It is the principle of form, the Divine Nature of the Christ is
none the less formless in all that has form, since It transcends all
form. . . ." Here is the ontology of the Word in its universal
aspect; the particularized and as it were personal aspect of the
same Divine Law is the Incarnation, by which "The indefinable
Word of the Father made Itself definable." This is expressed by
St. Hierotheos in the following words : "Having condescended
through love of man to assume man's nature, having really in-
carnated Itself . . . (the Word) nevertheless kept in this state Its

marvellous and superessential nature. In the very midst of our
nature It remained marvellous, and in our essence superessential,
containing in Itself eminently all that belongs to us and comes
from us, above and beyond ourselves."[36]

According to this spiritual view, the participation of the
human form of the Christ in His Divine Essence is as it were
the "type" of all symbolism: the Incarnation presupposes the
ontological link which unites every form with its eternal arche-
type; at the same time it safeguards that link. Nothing remained
but to relate this doctrine to the nature of the sacred image, and
this was done by the great apologists of the icon, notably St.
John Damascene,[37] who inspired the VIIth Council of Nicea,
and Theodore of Studion, who finally clinched the victory over
the iconoclasts.

In the *Libri Carolini* Charlemagne reacted against the icono-
dule formulae of the VIIth Council of Nicea, doubtless because
he saw the danger of a new idolatry among Western peoples,
who are less contemplative than Eastern Christians: he wanted
the function of art to be didactic rather than sacramental. From
this time onwards the mystical aspect of the icon became more
or less esoteric in the West, while it remained canonical in the
East, where it was also supported by monasticism. The trans-
mission of sacred models continued in the West until the Renais-
sance, and even today the most celebrated miraculous images
venerated in the Catholic Church are icons in the Byzantine
style. The Roman Church could put forward no doctrine of the
image in opposition to the dissolving influence of the Renaissance,
whereas in the Eastern Orthodox Church the tradition of the
icon has been carried on, though less intensively, right up to
modern times.[38]

VII

The doctrinal foundation of the icon determines not only its
general orientation, its subject and its iconography, but also
its formal language, its style. This style is the direct result
of the function of the symbol: the picture must not seek to re-
place the object depicted, which surpasses it eminently; accord-
ing to the words of Dionysius the Areopagite it must "respect
the distance that separates the intelligible from the sensible".

For the same reason it must be truthful on its own plane, that is to say it must not create optical illusions, such as arise from a perspective in depth or a modelling that suggests a body projecting a shadow. In an icon the only perspective is the logical; sometimes the optical perspective is deliberately reversed; modelling by superimposed "lights", inherited from Hellenism, is reduced until it no longer disturbs the flat surface of the picture; often it is translucid, as if the persons represented were penetrated by a mysterious light.[39] There is no determinate illumination in the composition of an icon; instead the gold background is called "light", for it corresponds to the celestial Light of a world transfigured.[40] The folds of clothing, the arrangement of which is also derived from Greek antiquity, become the expression, not of physical movement, but of a spiritual rhythm : it is not the wind that swells the fabrics, it is the spirit that animates them. The lines no longer serve only to mark the contours of bodies, they acquire a direct significance, a graphic quality both limpid and supra-rational.

Much of the spiritual language of the icon is transmitted with the technique of icon-painting which is organized in such a way that inspiration accompanies it almost spontaneously, provided that the rules are observed and that the artist himself is spiritually prepared for his task. This must be taken to mean, in a general sense, that the painter must be sufficiently integrated with the life of the Church; in particular, he must prepare himself for his work by prayer and fasting; he must meditate on the subject to be portrayed with the help of the canonical texts. When the subject chosen is simple and central, such as the image of the Christ alone or of the Virgin and Child, his meditation will be founded on one of the formulae or prayers that are of the essence of the tradition; in such a case the traditional model of the icon, with its synthetic symbolism, will respond to the intellectual essence of the prayer and will reveal its virtualities. Indeed the schematic arrangement of the icon always affirms the metaphysical and universal background of the religious subject, and this incidentally proves the non-human origin of the models. Thus, for example, in most icons of the Virgin and Child the outlines of the Mother as it were envelop those of the Child; the mantel of the Virgin is often dark blue, like the measureless depth of the sky or like deep water, while the clothing

of the Divine Child is royal red. All these details have a profound significance.

Along with the *acheiropoietos* image of the Christ, that of the Virgin and Child is the icon *par excellence*. The representation of the Child, whose nature is mysteriously divine, is in a sense justified by that of His Mother, who clothed Him with Her flesh. A polarity then becomes apparent between the two figures, full of natural attractiveness, but of inexhaustible significance: the nature of the Child is considered in relation to the nature of His Mother and as it were through Her nature; conversely, the presence of the Divine Child, with His attributes of royalty and wisdom—or of His future Passion—confers an impersonal and profound aspect on maternity: the Virgin is the model of the soul in its state of primordial purity, and the Child is like the germ of the Divine Light in the heart (pl. V).

This mystical relationship between the Mother and the Child finds its most direct expression in the "Virgin of the Sign", the oldest examples of which date from the fourth or fifth century; the Virgin is depicted in the attitude of prayer with Her hands uplifted and with the medallion of the young Christ Emmanuel on Her breast. It is the "Virgin who shall be with child" according to the Prophet Isaiah, and it also the prayerful Church or soul in which God will manifest Himself.

The icons of saints find their doctrinal foundation in the fact that they are indirectly icons of the Christ: the Christ is present in man sanctified and "lives" in him, as the Apostle expresses it.

The principal scenes of the Gospels have been handed down in the form of type compositions; some of their features are related to the apocryphal Gospel of the Infancy. That the Infant Jesus should be born in a cave, that the cave should be in a mountain, and that the star which announced His birth should send forth its ray like a vertical axis on to the cradle in the cave, all this implies nothing that does not correspond to a spiritual truth; and the same applies to the angels, the royal Magi, the shepherds and their flocks. A representation of this kind is in accordance with the sacred Scriptures, but it is not derived directly from them, and it could not be accounted for in the absence of a tradition to safeguard the symbolism.

It is significant that according to the Christian perspective eternal realities appear in the form of historical events, and this

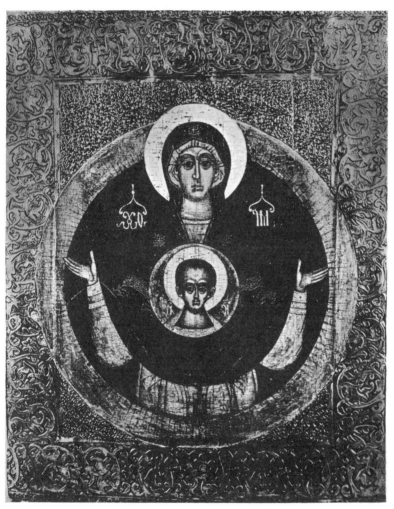

Plate V. The Holy Virgin of the Sign

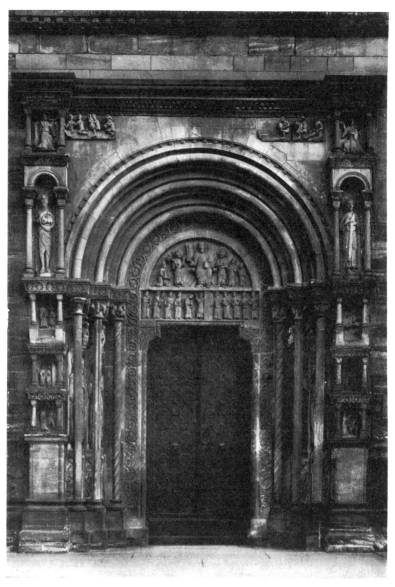

Plate VI. Romanesque portal of the Cathedral of Basle

alone makes them accessible to representation. Thus, for example, the descent of the Christ into hell, conceived as an event occurring simultaneously with the death on the Cross, is really situated outside time: if the early patriarchs and prophets of the Old Testament cannot escape from the darkness except through the intervention of the Christ, it is because the Christ in question is really the Eternal Christ, the Word; the prophets had encountered it before its incarnation in Jesus. Nevertheless, since the death on the Cross is like the intersection of time and eternity in the life of Jesus, it is legitimate from a symbolical point of view to represent the risen Saviour as descending, in His human form, into the antechamber of hell, where He smashes the gates and holds out His hand to the ancestors of humanity, the patriarchs and prophets assembled to welcome Him. Thus the metaphysical meaning of a sacred image is not contradicted by its childish or "ingenuous" appearance.

NOTES

1. The same can be said of the germs of philosophical rationalism latent in Christian thought; this is a striking corroboration of what has just been said about art.

2. "Gnosis, by virtue of the very fact that it is a 'knowing' and not a 'being', is centred on 'that which is' and not on 'that which ought to be'. It gives rise to a view of the world and of life that differs widely from the view, more 'meritorious' perhaps but less 'true', adopted by the volitive outlook with respect to the vicissitudes of existence." (Frithjof Schuon: *Sentiers de Gnose*, Paris, La Colombe, 1959, chap. *La gnose, langage du soi.*)

3. It is noteworthy that the general shape of the Christian temple does not perpetuate that of the Graeco-Roman temple, but the shapes of the basilica with apse and of domed buildings. The latter do not appear in Rome until a relatively late period.

The interior of the Pantheon, with its immense dome taking in the light from above through a "solar eye", is not without grandeur, but this is neutralized by the anthropomorphic and commonplace character of the details. It has a sort of philosophical grandeur perhaps, but it is a grandeur that has nothing to do with contemplation.

4. In the Orthodox feast of the Elevation of the Cross, the liturgy exalts the universal power of the Cross, which "makes to flower anew the incorruptible life, and confers deification on creatures, and brings the devil finally to the ground". In these words the analogy of the tree of the world, changeless axis of the cosmos, can be discerned.

5. It will be remembered that Dante made Caesar the artisan of the world destined to receive the light of the Christ.

6. The nomadic life, the absence of a fixed sanctuary and the prohibition of images are related to the purification of the people of Israel.

7. According to St. Augustine, Solomon built the temple as "type" of the Church and of the body of the Christ (*Enarr. in Ps.* 126). According to Theodoret, the temple of Solomon is the prototype of all the churches built in the world.

8. St. Augustine compares the temple of Solomon with the Church, the stones of which it is built being the believers, and its foundations the prophets and the apostles; all these elements are joined together by Charity (*Enarr. in Ps.* 39). This symbolism was developed by Origen. St. Maxim the Confessor sees in the church built on earth the body of the Christ, as well as man and the universe.

9. Maxim the Confessor adopts this point of view.

10. This is St. Augustine's point of view. See also Simeon of Thessalonica, *De divino Templo*, Patrologia Migne.

11. See Paul Naudon, *Les Origines religieuses et corporatives de la Franc-Maconnerie*, Paris, Dervy, 1953.

12. See E. Moessel, *Die Proportion in Antike und Mittelalter, München*, C. H. Beck'sche Verlagsbuchhandlung, 1926.

13. First among divine instruments—and weapons—is lightning, which symbolizes the Word or the Primordial Intellect, and is in its turn symbolized by ritual sceptres, such as the *Vajra* in Hindu and Buddhist iconography. The legendary power of certain famous swords is also significant in this connection.

14. The art of ploughing is often considered as having a divine origin. Physically the act of ploughing the ground has the effect of opening it to the air, thus promoting the fermentation that is indispensable for the assimilation of the soil by vegetation. Symbolically the soil is opened up to the influences of Heaven, and the plough is the active agent or generative organ. It may be noted in passing that the replacement of the plough by machines has reduced many fertile soils to sterility and thus changed them into deserts; it is a case of the curse inherent in machines spoken of by René Guénon in his book *Le Régne de la quantite et les signes des temps*, Paris, Gallimard, 1950. English translation, *The Reign of Quantity and the Signs of the Times*, by Lord Northbourne, Luzac, 1954.

15. The symbolism of the reed pen (*calamus*) and the book, or the pen and the tablet, plays a very important part in the Islamic tradition. According to the doctrine of the Sufis the "supreme *calamus*" is the "Universal Intellect", and the "guarded tablet" on which the *calamus* writes the destiny of the world corresponds to the *Materia prima*, the un-created—or non-manifested—"Substance", which under the influence of the "Intellect" or the "Essence" produces everything comprised in the "creation". See the author's book *Introduction aux doctrines ésotériques de l'Islam*, Lyon, Derain, 1955.

16. It could equally well be said that these instruments correspond to

the different "dimensions" of knowledge. See Frithjof Schuon, *De l'Unité transcendante des Religions,* chap. *Des dimensions conceptuelles,* Paris, Gallimard, 1948.

17. *Non aspettar mio dir più, nè mio cenno;*
 Libero, dritto, e sano è tuo arbitrio,
 E fallo fora non fare a suo senno,
 Per ch'io te sopra te corono e mitrio.
 (*Purgatorio* XXVII. 139–140)

18. See René Guénon, *L'Esotérisme de Dante,* Paris, Les Editions Traditionnelles, 1939.

19. According to the words of the Apostle: "Ye also, as lively stones, are built up a spiritual house. . . ." (1 Peter ii. 5.)

20. Albert the Great wrote: "Know that one does not become an accomplished philosopher save by knowing the two philosophies of Aristotle and of Plato." (Cf. E. Gilson, *La Philosophie au moyen âge,* Payot, Paris, 1944, p. 512.) Similarly, St. Bonaventura said: "Among the philosophers, Plato received the word of Wisdom, Aristotle that of Science. The former considered principally superior reasons, the latter inferior reasons." (Cf. St. Bonaventura, works presented by Father Valentin—M. Breton, Aubier, Paris, 1943, p. 66.) The Sufis were of the same opinion.

21. Cf. Anicius Manlius T. S. Boethius, *De Unitate et Uno,* Patrologie Migne.

22. Together with Isidore of Seville and Martianus Cappella.

23. See also René Guénon, *Le Symbolisme de la Croix,* Véga Paris, 1957, chapter on the symbolism of weaving.

24. Certain churches built within ancient Greek or Roman sanctuaries may be regarded as exceptions; but they are "exceptions" in a very relative sense, since sanctuaries alone are in question.

25. It has been asserted that the traditional form of the iconostasis, with its little columns framing the icons, was derived from the stage of the ancient theatre, which had a back wall similarly adorned with pictures and pierced by doors through which the actors entered and left. If there is any truth in this analogy, it is because the form of the ancient theatre was related to a cosmic model, so that the doors at the back of the stage are like the "gates of Heaven", by which the gods descend to earth and souls ascend to Heaven.

26. These various forms of the cross all saw the light during the earliest centuries of Christianity. Sometimes the radiating aspect of the cross predominates, and sometimes the static or square aspect, these two elements being combined in different ways with the circle or the disc. The cross of Jerusalem for instance, with branches ending in lesser crosses, suggests the omnipresence of Grace by the multiple reflection of the divine centre, while at the same time it mysteriously links the cross with the square. In Celtic Christian art the cross and the solar wheel are united in a synthesis full of spiritual evocations.

The hieratic shapes of the tiara and the mitre also recall solar symbols. As for the staff of the bishop, it ends either in two opposed serpents'

heads like the caduceus, or in a spiral, the latter is sometimes stylized in the form of a dragon with its jaws open towards the paschal lamb; it is then an image of the cosmic cycle "devouring" the sacrificial victim, the sun or the Man-God.

27. For example, the cross inscribed in a circle, which can be regarded as the key figure in sacred architecture, represents also the diagram of the four elements grouped round the "quintessence", and linked together by the circular movement of the four natural qualities: heat, humidity, cold and dryness, which correspond to the subtle principles governing the transmutation of the soul in the alchemical sense. Thus the physical, psychic and spiritual orders are brought into correspondence in a single symbol.

28. A copy of the *Mandilion* is preserved in the cathedral of Laon.

29. If this imprint were the work of a painter, it would be impossible to attribute it either to an ancient or medieval artist, or to an artist of modern times. Against any such attribution are, in the first case, the absence of stylization, and in the second, the depth of the spiritual quality, not to mention historical reasons. It is anyhow out of the question that an image of such spiritual veracity should be the outcome of a fraud.

30. The most ancient example of the "Virgin of the Sign" dates from the fourth century; it was found in the Roman catacomb of the Cimitero Maggiore. The same composition became very famous in the form of the *Blacherniotissa*, a miraculous Virgin of Constantinople.

31. This last case is that of the celebrated picture by St. Andrew Rublev representing the three Angels visiting Abraham. The motive as such goes back to palaeo-Christian art; it constitutes the only traditional iconograph of the Holy Trinity. (Cf. Ouspensky and Lossky, *Der Sinn der Ikonen*, Urs Graf-Verlag, Bern, 1952.)

32. Cf. *Col.* I. 15: *"Qui est imago Dei invisibilis, primogenitus omnis creaturae...."*

33. Cf. L. Ouspensky and V. Lossky, *op. cit.*

34. No purpose is served by depreciating, however indirectly this great spiritual writer by inflicting on him the new surname of "Pseudo-Denys", whatever may be the value of recent historical theories.

35. From the French translation by Maurice de Gandillac: Oeuvres *complètes du Pseudo-Denys l'Areopagite,* Paris, Aubier, 1949.

36. *Ibid.*

37. It is significant that St. John Damascene (700–750) lived in a small Christian community entirely surrounded by the Islamic civilization.

38. The tradition nearly died out in the eighteenth century, but it seems to be coming to life again in a few widely separated places in our own days.

39. This is related to the doctrine of the transfiguration of bodies by the light of Tabor, according to Hesychast mysticism. Cf. Ouspensky and Lossky, *op. cit.*

40. Cf. *ibid.*

Chapter III

"I AM THE DOOR"

Considerations on the iconography
of the Romanesque church portal

I

A SANCTUARY is like a door opening on the beyond, on the Kingdom of God. That being so, the door of the sanctuary must itself recapitulate the nature of the sanctuary as a whole, and its symbolical relationships must be the same.[1] This idea is expressed in the traditional iconography of the church portal, more particularly in that of the Romanesque portal, also in that of the Gothic portal when its period is not too remote from the Romanesque.

The architectural form of a church portal of that period constitutes by itself a sort of summary of the sacred building, for it combines two elements: the door and the niche; the niche is morphologically analogous to the choir of the church, and reflects its characteristic ornamentation.

From a constructional point of view the purpose of the combination of door and niche is to reduce the weight carried by the lintel of the door: most of the thickness of the wall is thus unloaded on to the coving of the niche, and through it on to the uprights of the splay. The combination of these two architectural forms, each of which has something of a sacred character, has brought about a coincidence of the iconographic arrangements particularly associated with these two forms, and in their clothing of Christian symbols and by virtue of their conformity to Christian symbolism, they are the vehicles of a primordial cosmological wisdom.

In all sacred architecture the niche is a form of the "Holy of Holies", the place of the epiphany of God, whether that epiphany be represented by an image in the niche or by an abstract symbol, or not suggested by any sign other than the

purely architectural form. This is the significance of the niche in Hindu, Buddhist and Persian art; it keeps the same function in the Christian basilica and also in Islamic art, where it is found in the form of the niche of prayer (*Mihrāb*). The niche is the reduced image of the "cave of the world" : its arch corresponds to the vault of the sky, as does a dome, while its piers correspond to the earth, like the cubical or rectangular part of a temple.[2]

As for the door, which is essentially a passage from one world to another, its cosmic model belongs to the temporal and cyclical order rather than to the spatial order; similarly "The Gates of Heaven", that is to say the solstitial doors, are primarily doors in time or cyclical breaks, their fixation in space being secondary.[3] The portal in the shape of a niche therefore combines, through the very nature of its elements, a cyclical or temporal symbolism with a static or spatial symbolism.

These are the given constants on which are founded the great iconographic syntheses of medieval portals. Each of these masterpieces of Christian art, by a sovereign choice of iconographic compossibles, reveals certain aspects of this rich complex of ideas, while always safeguarding their internal unity, according to the law which prescribes that "the superimposed symbolism must conform to the symbolism inherent in the object".[4] All the carved or painted ornamentation of the portal is related to the spiritual significance of the door, which in its turn is identified with the function of the sanctuary and thereby with the nature of the Man-God, who said of Himself : "I am the door : by me if any man enter in, he shall be saved . . ." (John X. 9).

A few types of portal from Romanesque churches will now be described. They are very different one from another both in their iconography and in their artistic modalities.

The portal of the North transept of the cathedral of Basle (pl. VI) commonly called the "portal of St. Gall" (*Galluspforte*, corresponding to the patronymic of the adjacent chapel), is a work in the purest Romanesque style. It has all the static equilibrium of that style and all its serene structural unity, although it is situated, historically speaking, on the threshold of the Gothic era. At first sight its iconography is so complex that some people have supposed it to be no more than an amalgam of fragments

derived from an earlier building destroyed in the earthquake of 1185; we shall see however that the arrangement of the images becomes perfectly coherent as soon as it is related to the symbolism of the door as such.

To begin with, the principal elements of the carved ornamentation must be enumerated. The tympanum is dominated by the figure of the Christ seated between St. Peter and St. Paul, who intercede with Him on behalf of their *protégés*, the donor and the builder of the portal.[5] The Christ carries the standard of the Resurrection in His right hand and the open book in His left hand. To this figure of the Christ as victor and judge are related, as to an ideal centre, the group of the four Evangelists, whose effigies, surmounted by the four beasts of the Apocalypse— the winged man, the eagle, the lion and the ox—are carved between the pillars of the door in such a way as to be incorporated in the outer angles of the stepped splay. In the inner angles of the splay are placed small columns which, when seen from in front, half cover the effigies and symbols mentioned. This arrangement, which recalls the painted decoration of certain apses, is made more complex by the addition of a second figure of the Christ to the lintel of the doorway, where He is represented as the divine bridegroom who opens the door to the wise virgins while turning his back on the foolish ones.

The portal properly so called is framed in a sort of external porch, consisting of small pavilions placed one above the other. This has been compared to the architectural facing of a Roman triumphal arch. In two of the pavilions that are bigger than the others are statues of St. John the Baptist and St. John the Evangelist; the traditional association of these two saints is related to the presence of the Christ in the tympanum in the same way as the alpha and omega of the ideograms are related to the Christic symbol. Above these two statues, in two other pavilions of the external porch, are two angels sounding the trumpet of the Resurrection; at the side of each, men and women leave their graves and put on their clothing;[6] beneath the two St. Johns, and up to the height of the uprights of the portal, six other pavilions or tabernacles contain reliefs representing works of charity. To these, the principal elements of the figured ornamentation, are added other ornaments in the shape of animals and plants, which will be referred to later.

The iconography appears to be to some extent equivocal in that St. John the Evangelist is represented twice, once in the group of the four evangelists on the uprights of the portal, and once in symmetrical opposition to St. John the Baptist at the side of the archivolt. This apparent illogism is however easily explained by the fact that the two representations belong to two distinct iconographic groupings, respectively related to the static (or spatial) aspect and the cyclical (or temporal) aspect of the symbolism of the door. In fact the quaternary of the evangelists corresponds symbolically to the four pillars—or corners—on which the sacred building is founded, for the evangelists represent the "terrestrial" supports of the manifestation of the Word, and thereby become identified not only with the "cornerstones" of the Church,[7] but also, by analogy, with the foundations of the cosmos as a whole, that is to say, with the four elements and their principles both subtle and universal. This analogy finds its most ancient and most direct figurative expression in the painted or mosaic ornamentation of certain domes, where the image of the Christ Pantocrator dominates the middles of the cupola, which is supported by the portraits or the symbols of the four evangelists, placed on the pendentives which join the cupola to the corners of the building:[8] though earth is dependent on Heaven, or the cosmos on its Divine Principle, yet still the latter must look to the terrestrial or cosmic order if it is to manifest itself therein in particularized mode, in the "descent" through which it brings salvation. This is the ontological relation which, by the very nature of things, the static order of the temple expresses, and we find the same thing on a reduced scale in the elements of the portal, where the tympanum corresponds to the dome and the four pillars of the uprights to the four corners of the building.

The "static" or symbolically spatial aspect of the cosmos— or of the divine revelation—is in a certain sense opposed to the cyclical and temporal aspect. The latter is symbolized in the iconography now in view by the two St. Johns, the precursor of the Christ and the apostle of the Apocalypse; their respective functions mark the beginning and the end of the cycle of the revelation of the Divine Word on earth, just as their feasts which are situated approximately at the winter solstice and the summer solstice, correspond to the two "turning points" of the sun.

the sun itself is the cosmic image of the Light "which lighteth every man that cometh into the world" (John I. 9).[9] The analogy of the two St. Johns with the two solstices is suggested in the portal of Saint Gall by their situation at the two extremities of the archivolt, which is identified with the solar cycle in many other portals that are ornamented with the signs of the zodiac.

The two solstices are called "doors" (januae) because through them the sun "enters" the ascending or descending phase of its annual journey, or because two opposed cosmic tendencies "enter" through them into the terrestrial world, a cyclic and temporal reality being thus translated into the relatively spatial symbolism of the door. The symbolism of Janus[10] is relevant here; Janus was the protecting deity of the collegia fabrorum, whose heritage seems almost certainly to have passed to the craft corporations of the Middle Ages. The two faces of Janus became identified in Christianity with the two St. Johns, while the third face, the invisible and eternal countenance of the god, showed itself in the person of the Christ. As for the two keys of gold and of silver, the appurtenances of the ancient god of initiations, they appear again in the hand of St. Peter, as in the relief on the tympanum of our portal.

We have seen that the cyclical revelation of the Word implies an order that is inverted with respect to the order of its "static" and symbolically spatial revelation, for the first mentioned brings about a resorption of the terrestrial world into the celestial world, following the discrimination between possibilities that are susceptible of transformation and those that are to be rejected. This is the judgement which is referred to in several elements of the iconography, such as the angels sounding the trumpet, and which the parable of the wise and foolish virgins, represented on the lintel of the door, relates directly to the functional significance of the door as such : for the bridegroom Christ stands on the threshold of the door of the Heavenly Kingdom, inviting some to pass through and refusing entry to others. Moreover, at the feet of this figure of the Christ is situated the geometrical centre of the whole structure of the portal, the design of which can be laid out within a circle divided into six and twelve parts (fig. 16).[11]

The door is not other than the Christ Himself. This is the lesson conveyed by the representations of the six works of charity,

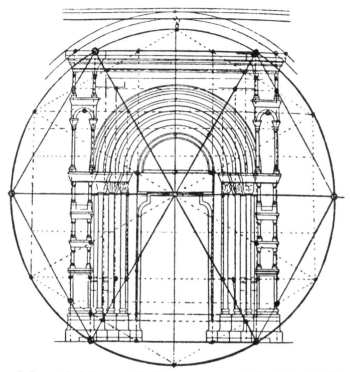

Fig. 16. Geometrical diagram of the Romanesque portal of the Cathedral of Basle,
after P. Maurice Moullet

for they too are an integral part of the theme of the Last Judge-
ment, since the Lord will mention them when he speaks to the
elect and afterwards to the damned: "Come, ye blessed of my
Father, inherit the kingdom prepared for you from the founda-
tion of the world: for I was an hungred, and ye gave me meat:
I was thirsty, and ye gave me drink: I was a stranger, and ye
took me in: naked, and ye clothed me: I was sick, and ye
visited me: I was in prison, and ye came unto me . . . Verily I
say unto you, Inasmuch as ye have done it unto one of the least
of these my brethren, ye have done it unto me. . . ." And to
the damned the Christ will say "Depart from me, ye cursed, into
everlasting fire . . . for I was an hungered, and ye gave me no
meat: I was thirsty, and ye gave me no drink: I was a stranger,
and ye took me not in: naked, and ye clothed me not: sick
and in prison, and ye visited me not" (Matt. xxv. 34–43).

Charity, then, is the recognition of the uncreated Word in creatures; for creatures do not show their real nature except in so far as they are poor and needy, that is to say, cleansed of pretensions and of all powers attributed to themselves. He who recognizes the presence of God in his neighbour, realizes it in himself; thus it is that spiritual virtue leads towards union with the Christ, Who is the Way and the Divine Door. None will cross the threshold of that Door but one who has himself become that Door; this is expressed in the myth of the posthumous journey of the soul in the *Kaushītaki-Upanishad* in the following way: when the soul arrives at the sun, the sun interrogates it on its identity, and only when it answers "I am Thou" does it enter into the divine world. The same truth appears again in the story of the Persian Sufi Abū Yazīd al-Bistāmi, who after his death appeared to a friend in a dream and told him how he had been received by God. The Lord asked him: "What do you bring me?" Abū Yazīd enumerated his good works, but when none of them was accepted he said at last: "I bring Thee Thyself", and not till then did God accept him.[12]

On the tympanum of our portal may be seen the image of a master mason kneeling before the Christ and offering Him a model of the portal; he is therefore offering to the Christ, who is Himself the Door, the symbol of the Christ. This is an expression not only of the essence of every spiritual way, but also of the nature of all sacred art; for in going back to a sacred prototype, which he adapts to a particular set of material conditions, the artist identifies himself with that prototype; in giving it an outward form, while working to the rules that have been transmitted to him, he realizes its essence.

II

The zoomorphic and plant-like ornaments of the portal will now be given special consideration, so that they can be looked at from a more general point of view, because they represent something like a reminiscence of a more ancient iconography that may well be prehistoric; its formulae have been preserved as much through their decorative perfection as through the organic union of ornament with architecture. This moreover implies that ornamentation of this kind must almost always be

considered in its relation to other symbols, particularly geometrical ones, as in the example that follows.

First place must be given to two motives that are chiefly characteristic of Asiatic art, although their Christian significance in Western art is evident, namely the wheel and the tree of life. These two emblems adorned the tympana of portals at the height of the Middle Ages, at a time when there was reluctance to expose images of sacred personages on the outside of churches. The wheel, with its evident analogy to the cosmic wheel, is represented by the monogram of the Christ surrounded by a circle.[13] As for the tree, it is usually represented as a stylized vine, in conformity with the words "I am the vine".[14] Both these motives, which have in any case a close relationship to the principles of sacred architecture, are found in the much earlier Hindu and Buddhist iconography of the ritual niche;[15] a historical conjunction took place eventually in the Near East.

The tree of life is perpetuated in the Romanesque portal of the Cathedral of Basle in the form of a stylized vine with its

Fig. 17. Diagram of the double lion on the Romanesque portal of the Cathedral of Basle

scroll-like growth surrounding the door. As for the cosmic wheel, it has been moved to a position above the portal, in the form of a great rose window, with sculptures that recall the "wheel of fortune" as described by Boethius in his "Consolation of Philosophy"; the sculptor has portrayed himself at the lowest point on this wheel.

The zoomorphic ornaments most often met with on medieval portals are the lion and the eagle and a combination of the two, namely, the griffon, as well as the dragon. The lion and the eagle are essentially solar animals, and so is the griffon; its dual

nature symbolizes the two natures of the Christ.[16] On the portal of the Cathedral of Basle (fig. 17) groups of eagles and pairs of lions with a single head form the capitals of the small columns placed in the angles of the uprights.

The dragon is generally found in symmetrically opposed pairs on each side of the door or of the archivolt,[17] and it seems to belong to the symbolism of the solstice, if account be taken of analogies in Oriental and in Nordic art; on the portal just des-cribed two dragons face to face adorn the consoles that support the lintel. The position of these dragons under the feet of the Christ makes them appear sometimes like natural or infernal forces tamed by the Man-God, and this in no way contradicts their solstitial significance, for it is precisely the antithesis of cosmic tendencies, manifested in the ascending and descending phases of the annual cycle, that is transcended by the Man-God Asiatic art uses the same motive (fig. 18a and 18b).[18]

Hindu art provides in the *torana* something like a model for all the zoomorphic iconography of the portal. The *torana* is the triumphal arch surrounding the door of a temple or the niche holding the image of the divinity; its features are prescribed in the codes of sacred architecture, such as the *Mānasāra-shilpa-shāstra*. The two bases or piers of the *torana* are adorned with lionesses (*shardūla*) or leogryphs (*vyali*), which are solar animals and manifestations of *Vāk*, the creative word. The abutments of the arches end in the figure of the *makara*, the marine monster that corresponds to Capricorn, the sign of the winter solstice. Here too the solar symbolism is presented in its two opposed and complementary aspects : the lioness corresponds to the posi-tive, and therefore in a sense spatial, expansion of the Light or of the Divine Word, while the *makara* expresses the "devouring" and transforming aspect of Divine Reality manifested as a cycle or as time. The top of the *torana* is usually surmounted by the *Kirtti-mukha* or *Kāla-mukha*, a terrible mask of protean shapes, synthesizing the lioness and the marine dragon and representing the unplumbable—and consequently terrifying and obscure— abyss of the divine power of manifestation.[19]

In Romanesque art there are numerous analogies with the lions and dragons of the *torana*,[20] but the dragons are nearer to those of the Far East—which came to the West through Buddhist and Seljuk art[21]—or to Nordic dragons, than to the Hindu

Fig. 18a. Door of the Talisman of Baghdad

Fig. 18b. Symbolic arch from the Irish Book of Kells (fol. 25 R) with a saint
between two monsters

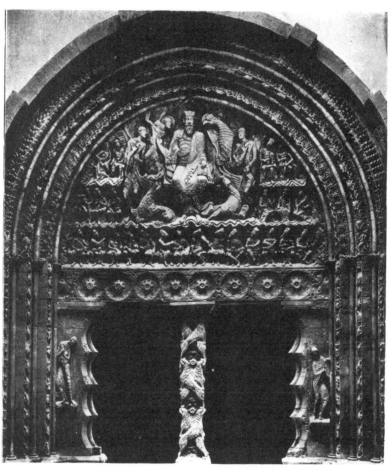

Plate VII. Portal of the Abbey Church of Moissac

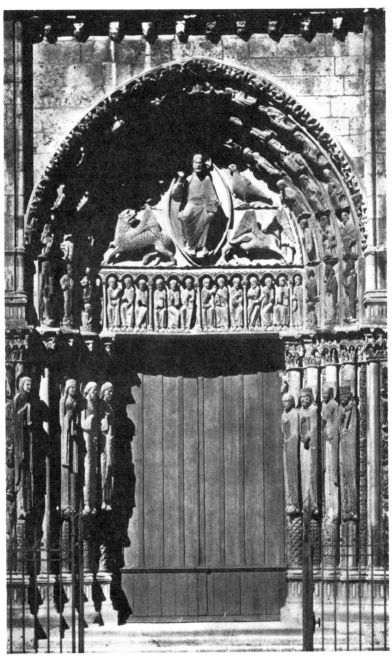

Plate VIII. The Royal Portal of the Cathedral of Chartres, central bay

makara, which is derived from the dolphin. As for the *Kāla-mukha*, the mask of God, it could not be expected to occupy as important a place in Christian art as it does in Hindu or Far Eastern art (it is the Chinese T'ao-T'ieh), for its symbolism is intimately connected with the Hindu notion of cosmic illusion. Nevertheless, what appear to be replicas of it are found in Romanesque art, particularly on capitals, but it is not possible to determine their significance.[22]

The *Kāla-mukha* has a dual aspect. On the one hand it represents death, and this is its meaning when it crowns the door of the temple, for he who passes through that door must die to the world; on the other hand it symbolizes the fount of life, suggested by the drifts of vegetative and zoomorphic ornaments that spring from its mouth. This last feature finds its analogy in medieval Christian art, in the form of the lion's mask "spewing" vegetable shapes; the motive is probably of very ancient origin and is identifiable with that of the lion spewing a jet of water; it is an image of the sun, the source of life, and so without doubt a symbol analogous to the *Kāla-mukha*.[23] In Christian art it takes on the significance of the lion of Judah from which emanates the tree of Jesse or the vine of the Christ.[24]

It would be easy to multiply examples of Asiatic themes that have passed into the Christian art of the Middle Ages. Those mentioned above will suffice to give a glimpse of the vast current of folk-lore in which Western medieval art is bathed. The sources of this current are prehistoric, and it has been from time to time reinforced by direct importations from the East. In many cases it would be difficult or impossible to say what these motives meant to the Christian artisan; but however that may be, the logic inherent in the forms as such favoured the awakening, in the light of a contemplative wisdom, of the symbols packed away in the collective memory we know as folk-lore.

In the zoomorphic iconography of the Romanesque portal there is a terrible and often grotesque element, which reveals a spiritual realism inwardly not without relationship to the gorgon-like symbolism of the *Kāla-mukha*. As the solstice approaches, the imminent cyclical change of direction unleashes extremes of contrast in the cosmic environment: when the Gates of Heaven (*janua coeli*) open, the gates of hell (*janua inferni*) are also unlocked. Some of the terrifying images on the walls of the

portal have the function of breaking up evil influences; some-
times their gotesque appearance is of help in "objectivizing"
the powers of darkness, by unveiling their real nature. Certain
country customs in which, on the approach of the winter
solstice, evil spirits are chased away by means of grotesque
masquerades[25] have a similar function.

III

As we have seen, the niche of the portal corresponds to the
choir of the church. Like the choir it is the place of the divine
epiphany, and as such it conforms to the symbolism of the celes-
tial door, which is not only the entry through which souls pass
into the Kingdom of Heaven, but also the way out by which the
divine messengers "descend" into the "cave" of the world. This
symbolism is of pre-Christian origin, and becomes as it were
integrated with Christianity through the celebration of Christmas
—the night of the birth of the Divine Sun into the world—
approximately at the winter solstice, the "Gate of Heaven".

The portal with niche is thus an iconostasis which simul-
taneously both hides and reveals the mystery of the Holy of
Holies, and in this connection it is also a triumphal arch and a
throne of glory. This last aspect predominates in the great portal
of the Abbey Church of Moissac, with its enormous tympanum,
supported by a central pillar, displaying the apocalyptic vision
of the Christ surrounded by the animals of the tetramorph and
the twenty-four elders of the Revelation; the central pillar made
up of lionesses holds up this glorious vision like a throne built
of tamed cosmic powers (pl. VII).

Within the confines of Western art the portal of Moissac
appears like a sudden miracle, as much because of its spiritual
unity as because of its perfection as sculpture, which cannot be
completely accounted for by reference to any known precedent,
such as related Romanesque sculptures, Moorish influence
or Byzantine ivories.

The artistic language of the portal of Moissac is very different
from that of the Romanesque portal of the Cathedral at Basle.
The forms of the portal of Basle are articulated like a sequence
in Latin syntax; their harmony at once severe and gentle is like
a Gregorian chant. The sculptures of Moissac on the other hand

have a flamboyant quality, which however causes no rupture of
the static unity of the whole. The ogival shape of the arch confers
on the entire portal a calm ascending tendency, like that of a
candle flame burning motionless with a purely inward vibration.
The surface of the relief as a whole is kept even, but it is per-
forated in places, like a sort of "fretwork", affording opportunities
for vigorous lines and accents; within the stylized outlines the
surfaces are treated with great delicacy, the arrangement of the
forms has everywhere a plastic richness that is both supple and
restrained. In the tympanum the play of shadows gravitates
round the motionless centre of the Christ in Glory; it is from
Him, from this figure so broadly displayed, that all brightness
seems to flow. At the same time the attitudes of the four and
twenty elders surrounding the Lord lead the eye from all sides
towards the motionless centre, thereby suggesting a sort of
rhythmic movement, which however never oversteps the limits
set by the geometry of the work; there is no instantaneous
impressionism, no psychic dynamism, no emphasis that contra-
dicts the permanent nature of sculpture.

The relief on the tympanum represents the following vision
of St. John: "And immediately I was in the spirit: and, behold,
a throne was set in heaven, and one sat on the throne. And he
that sat was to look upon like a jasper and a sardine stone: and
there was a rainbow round about the throne, in sight like unto
an emerald. And round about the throne were four and twenty
seats: and upon the seats I saw four and twenty elders sitting,
clothed in white raiment; and they had on their heads crowns
of gold. And out of the throne proceeded lightnings and thunder-
ings and voices: and there were seven lamps of fire burning
before the throne, which are the seven Spirits of God. And before
the throne there was a sea of glass like unto crystal: and in the
midst of the throne, and round about the throne, were four
beasts full of eyes before and behind. And the first beast was
like a lion, and the second beast like a calf, and the third beast
had a face as a man, and the fourth beast was like a flying eagle"
(Rev. iv. 2-7). The sculptor has represented only those features
of the vision that lend themselves to plastic symbolism. Around
the Christ of the tympanum the four beasts[26] which symbolize
permanent aspects of the Divine Word and the celestial proto-
types of the four evangelists, display a corona of flamboyant

wings: two archangels stand close to them. The four and twenty
elders, absorbed in the contemplation of the Eternal, hold in their
hands cups, symbols of a passive participation in beatific union,
or lutes, symbols of an active participation.[27] On the two pillars
carrying the lintel are carved the image of St. Peter, standing on
a lion with the keys in his hand, and that of the prophet Isaiah,
who foretold the birth of the Christ from a virgin.

The archivolts and the lintel of the portal are covered with a
rich flowering of ornaments. At the two ends of the lintel two
monsters are seen; their open mouths spout scrolls which twine
round the large rose ornaments ranged along the lintel. This
motive recalls strikingly the Hindu iconography of the *makara*
in the *torana*.[28] Was a Hindu model handed down through
Islamic art, from which are derived in any case the general pro-
portions of the door, its ogival shape and the lobed outline of
the door-jambs? The sculptures on the central column also have
their Oriental prototypes; the motive of crossed lions goes right
back, through Islamic art, to Sumerian art; it recalls the design
of the royal throne, the shape of which is reflected in the lion-
like features of the folding seats of the Middle Ages. Hindu
iconography is also familiar with the "lion seat" (*simhāsana*),
the traditional form of the Divine Throne.[29] The genius of the
sculptor of Moissac emerges in the idea of placing one above
the other three pairs of lionesses, mutually interdependent for
support, in such a way as to produce a play of static compensa-
tions which well reflects the involuntary equilibrium of the for-
midable powers of nature (fig. 19). The star-like patterns of
three rose-ornaments, with the six tails ending in lotus buds
curled over them, co-ordinate the interlaced pattern of the six
beasts; all the speculative intelligence, the realism and the gaiety
of the Middle Ages are expressed in this sculpture. The three
"storeys" of the lioness throne are doubtless not without their
significance; they suggest the hierarchy of created worlds. The
contrast between the monsters on the central column and the
glorious vision of the Christ on the tympanum is profoundly
revealing: the throne of the divine glory, which is revealed at
the end of time, when the "ages" have completed their revolution
and time is merged into the simultaneity of everlasting day—
this throne or support is none other than the cosmos in its final
equilibrium, established through the total integration of all

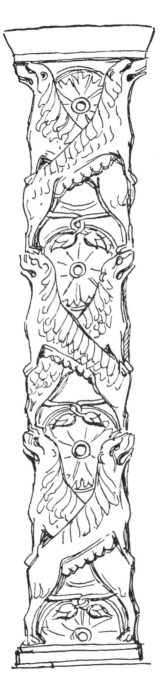

Fig. 19. Central pier
from the Abbey of
Moissac

natural antitheses. The same is true of the microcosmic order:
the support of divine illumination is the equilibrium of all the
passionate forces of the soul, *natura domptata* in the alchemical
sense of the words.

Hindu iconography—the portal of Moissac takes us back to
it again and again—comprises two forms of the divine throne:
the "lion seat" symbolizes the subjugated cosmic forces, while
the "lotus seat" (*padmāsana*) expresses the perfect and receptive
harmony of the cosmos.[30]

It is not particular features only of the *torana* which, as
reflected in the portal of Moissac, call forth these comparisons;
the sculptures as a whole, while evoking the majesty and the
sacerdotal beauty of the Christ, are no less reminiscent of the
plastic art of India. Like it, they have something of the plenitude
of the lotus, they fascinate by the abstract audacity of their
hieratic gestures, and it is as if they were animated by the
rhythm of the sacred dance. This undeniable affinity cannot
possibly be explained by any formal contact between the two
arts, although certain features of the ornamentation may suggest
such a meeting; the relationship in question is spiritual and
therefore inward, and on that plane every coincidence is possible.
There can be no doubt that the portal of Moissac manifests a
real and spontaneous contemplative wisdom; the Asiatic elements
in the ornamentation, perhaps transmitted through the Islamic
art of Spain, do not represent the essentials that underlie the
relationship now in view, they only serve to confirm it, and so
to speak to crystallize it.

IV

It has been shown that the plan of the temple, which summar-
izes the entire cosmos, is arrived at by a fixation in space of the
celestial rhythms that regulate the whole visible world. This
transposition of the cyclical order into the spatial order also
defines the functions of the various doors of the sanctuary, which
are placed according to the cardinal directions.[31]

The Royal Portal of the Cathedral of Chartres (pl. VIII),
with its three bays opening towards the West, reveals three
different aspects of the Christ, and these are also aspects of the
temple itself, identified as it is with the body of the Christ.

The left-hand bay, situated to the North of the central bay is dedicated to the Christ ascending to Heaven; the right-hand bay, situated to the South of the central bay, is dedicated to the Virgin and to the nativity of the Christ; the central bay, the real "Royal gate", presents the Christ in Glory, according to the apocalyptic vision of St. John. Thus the two niches on the left and on the right, corresponding respectively to the northern and southern sides of the church, represent, in conformity with the symbolism of the solstitial "gates"—the gate of winter and the gate of summer—the celestial nature and the terrestrial nature of the Christ. As for the central bay, it symbolizes for all time the one and only door, which transcends cyclical antitheses and reveals the Christ in His Divine Glory, appearing as judge of all things at the final reintegration of this "age" in the timeless.

The figure of the Christ in Glory surrounded by the tetramorph fills the central tympanum. The composition is limpid and radiant, and its balance, held between the almond-shaped aureole of the Christ and the slightly ogival arch of the tympanum, seems alive, as if it were breathing calmly, swelling from the centre and returning to it. The four and twenty elders of the Apocalypse occupy the covings, sitting on thrones and wearing crowns and separated from the tympanum by a rank of angels; on the lintel the twelve apostles are portrayed.[32]

The effigies carved on the pillars of the bays are those of prophets and royal personages of the Old Testament, some of them no doubt are also the ancestors of the Christ; the whole of this zone, analogous to the rectangular and "terrestrial" part of a temple, thus corresponds to the ancient Law which, from a Christian point of view, prepared the coming of the "Word made flesh".

The representation of the ascension of the Christ in the tympanum of the left-hand bay is in conformity with traditional iconography. The Christ is carried aloft in a cloud held by two angels; other angels descend from clouds like thunderbolts and announce the event to the apostles assembled. In the covings the signs of the zodiac are carved, alternating with figures showing the labours of the months, and this underlines the celestial character of this lateral bay, its situation on the North side of the principal door being connected with the "Gate of Heaven" (*janua coeli*), the winter solstice.

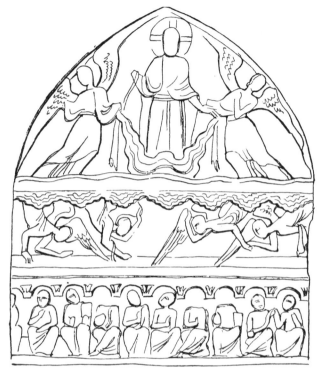

Fig. 20. Tympanum of the left-hand bay

The tympanum of the right-hand bay is dominated by the statue of the Virgin and Child, sitting on a throne and directly facing the spectator, between two archangels swinging censers, in accordance with a Byzantine tradition. Their movement, like that of doves on the point of flight, accentuates by contrast the majestic immobility of the Virgin between them. The composition of this lunette is the reverse of that of the ascension of the Christ, in which the angels are leaning outwards, like petals dropping from a flower. Below this group—at once severe and joyful—of the Virgin and archangels are the following scenes, in two horizontal bands: the Annunciation, the Visitation, the Nativity and the Presentation in the Temple. The lowest point of the tympanum, which is not separated from the lintel, is occupied by the Virgin lying on her bed; the bed has a flat roof

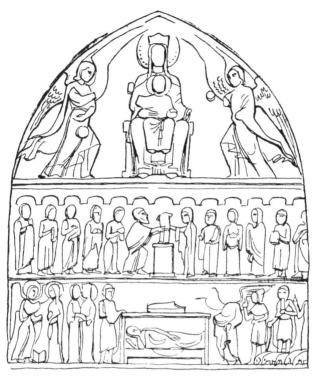

Fig. 21. Tympanum of the right-hand bay

over it, and on this roof is the cradle with the Child. This unusual peculiarity can be explained by the parallelism of the three superposed groups. At the lowest point the Virgin lying horizontally, beneath the new-born infant, symbolizes perfect humility, and therefore also the pure passivity of Universal Substance, the *materia prima* which is entirely receptive with respect to the Divine Word. In the band immediately above, and on the same vertical axis, the Infant Jesus standing upright on the altar of the temple accentuates the analogy between the Virgin and the altar of sacrifice; higher up, in the arch of the tympanum, the Virgin seated on the throne and holding the Infant in her lap corresponds to the Universal Mother, who is the humble foundation of all creatures and at the same time their most sublime substance, as is indicated by Dante in his

well known prayer addressed to the Virgin: *Vergine madre, figlia del tuo figlio, umile ed alta più che creatura . . . (Paradiso,* XXXIII 1 sqq.).

The threefold nature of the theme of the Virgin and the Child is brought into prominence by the geometrical symbolism of the scenes: in the lowest, the two horizontal lines of the Mother and of the cradle; above this, the vertical line of the Child on the altar; and finally, right at the top, the majestic silhouette of the Virgin encompassing the Child on all sides: the Mother and the Child can in fact be enclosed within two concentric circles.

The Virgin represents Universal Substance, which is passive with respect to the Divine Word, and for that very reason She is the symbol and the personification of the soul illumined by Grace. Consequently the three groups of the Mother and Child necessarily express three phases in the spiritual development of the soul; these phases can be defined as spiritual poverty, the gift of self and union with God, or again in alchemical language as "mortification", "sublimation" and "transmutation". The majestic Virgin of the tympanum, whose symmetrical outline envelops the Child, suggests the state of the illumined soul, which contains the heart united with God.

The analogy between the Virgin and the illumined soul is strengthened by the allegories of the seven liberal arts in the covings of the same bay. The liberal arts are the reflections of the seven celestial spheres in the soul, of which they express the amplitude and perfection. St. Albert the Great said that the Virgin possessed naturally a knowledge of these arts, that is to say, of that which constitutes their essences. This brings out even more clearly the complementarism which dominates the iconography of the two lateral bays: on one side is the ascension of the Christ to Heaven, surrounded by the signs of the zodiac, on the other the iconography of the Virgin, surrounded by the liberal arts. Here we see the two domains of Heaven and of of Earth, of Essence and of Substance, of the Spirit and of the Soul, of the Greater Mysteries and of the Lesser Mysteries, attached respectively to the solstitial doors of winter and of summer.

It should be noted however that the symbolical attribution of the two lateral doors to the winter and summer solstices implies

an inversion, for the sign of Capricorn, which corresponds to the winter solstice, belongs to the southern hemisphere. This inversion also finds expression in the iconography of the Royal Portal, for it is the right-hand bay, situated on the South side and dedicated to the Virgin, which carries the representation of the Nativity, and the feast of the Nativity coincides very nearly with the winter solstice. An analogous compensation takes place in the spiritual order: the virginal and receptive beauty of the soul, which ascends "from beneath", meets the revelation of the Divine Word, which comes "from on high".

The iconographic themes of the three bays of the Royal Portal are outwardly linked together by the little scenes carved on the capitals of the columns. These scenes form a more or less continuous band; they represent episodes in the life of the Christ, and thereby, in conformity with the eminently historical perspective of Christianity, they associate all spiritual reality with the life of Christ.

In conclusion, the three "dimensions" comprised in the iconography of the Romanesque church portal may be enumerated. They are: the cosmological dimension, related most directly to the art of building; the theological dimension, which comes to light through the religious theme of the images; and lastly the metaphysical dimension, which includes the mystical meaning in the most profound sense of the words. It is from the emphasis given to the Christic symbols that the cosmological plan derives all its spiritual breadth; on the other hand, the conformity of the religious iconography to cosmic prototype releases the content of the images from a historical and literal interpretation and transposes it into metaphysical and universal Truth.

NOTES

1. Sometimes the architectural form of a sanctuary is reduced to that of the doorway alone; this is the case with the Japanese *torii*, which marks a sacred place.

2. René Guénon, *Le Symbolisme du dôme*, in *Etudes Traditionnelles*, October 1938: see also, by the same author, *La sortie de la caverne, ibid.,* April 1938, and *Le dôme et la roue, ibid.,* November 1938. The outline of the niche reproduces the plan of the rectangular

basilica with a semicircular apse. The analogy between the plan of the temple and the shape of the porch is also mentioned in a Hermetic work which appeared in 1616, *Les Noces Chymiques de Christian Rosenkreutz*, by Jean Valentin Andreae, Paris, Chacornac frères, 1928, first French translation.

3. It is well known that the solstitial points change their position with respect to the fixed stars, returning to their starting point in 25,920 years; nevertheless they determine the cardinal directions and consequently also all constant measures of space.

4. Cf. Frithjof Schuon: *De l'Unité transcendante des Religions*, Ch. IV: *La question des formes d'art*, Gallimard, Paris, 1945, p. 84. English translation, *The Transcendent Unity of Religions*, Faber, 1953.

5. The donor is presented by an angel to St. Paul. The artist kneels beside St. Peter.

6. Signifying the "putting on" of their new bodies.

7. Generally speaking the apostles are identified with the "pillars" of the Church, in accordance with the description of the Heavenly Jerusalem, with its walls strengthened by twelve pillars bearing the names of the apostles (Rev. xxi. 14). The heavenly Jerusalem is the prototype of the Christian temple. The iconographic theme in which statues of the evangelists form the pillars of the portal is found in many other Romanesque portals in France and in Lombardy.

8. For example in the Church of San Vittorio in Ciel d'Oro, with its mosaic cupola dating from the fifth century. This church is now incorporated into the complex of the Basilica of San Ambrogio in Milan.

9. "... Thus it is also with the image wherein is manifested the Divine Goodness, that great sun which is wholly light and whose brilliance never fails, because it is a feeble echo of the Good, it is this that illumines all that can be illumined, it is this that possesses an overflowing light and pours out over the totality of the visible world, at every level from the height to the depth, the brightness of its own radiance...." St. Dionysius the Areopagite, *Les Noms Divins*, III. 3, from the French translation by M. de Gandillac.

10. Cf. René Guénon, *Les Portes solsticiales, Etudes Traditionnelles*, May 1938; *Le Symbolisme du Zodiac chez les Pythagoricien, ibid.*, June 1938: *Le Symbolisme solstitial de Janus, ibid.*, July 1938; *La Porte étroite, ibid*; December 1938; *Janua Coeli, ibid.*, January–February 1946.

11. Cf. P.-Maurice Moullet, *Die Galluspforte des Basler Münsters*, Holbein Verlag (Basle), 1938. It should be remembered that the proportions of a sacred building arise normally from the regular subdivision of a directing circle, image of the celestial cycle. Through this procedure proportion, which affirms Unity in space, is consciously related to rhythm, which expresses Unity in time. It is this that explains, in the case of Romanesque portals, their harmony at once evident and irrational: their measurements escape from the quantitative principle of number.

12. In Sufism Abū Yazīd al-Bistāmi is one of the revealers of the "supreme identity".

13. For example, a cross with eight rays adorns the tympanum of a Romanesque church at Jaca in Catalonia.

14. A frequent motive in Romanesque art is the vine twined about among all sorts of figures: men and animals eating the grapes, monsters gnawing the shoots, and hunting scenes.

15. According to the *Mānasāra-shilpa-shāstra*, a sacred niche must contain the tree of the world or an image of the divinity.

16. Cf. Dante, *La Divina Comedia, Purgatorio*, Canto XXXII.

17. For example on the portals of the Basilica of St. Michael of Pavia, of the Cathedral of San Donnino d'Emilia, of the Duomo of Verona and of San Fedele of Como.

18. It must suffice to call attention to the remarkable similarity between a relief crowning the Door of the Talisman at Baghdad and a miniature in the Irish Book of the Gospels from Kells, which reproduces the architecture of a porch (Eusebian Canon fol. 2v). In each of these compositions a man with a halo—in the Irish miniature he recalls the Christ—seizes the tongues of two dragons facing one another with open jaws. The relief from Baghdad is of the Seljuk period, later than the Irish miniature; the shape of the dragons reflects that of Far-Eastern models. The composition in question occurs very frequently, with certain variations, in Nordic jewellery, in the lesser arts of islamic countries and in Romanesque ornamentation.

19. Cf. Stella Kramrisch, *op. cit.*, p. 318 sq. See also René Guénon, *Kāla-mukha*, in *Etudes Traditionnelles*, March–April 1946.

20. More particularly in the Romanesque architecture of Lombardy there is found an arrangement of the portal with a porch, in which the pillars rest on lions and the abutments are adorned with griffons or dragons (the portals of the Duomo at Verona, of the Cathedral at Assisi, of the ancient church of Ste Marguerite at Como, of the Duomo at Modena and at Ferrara, etc.)

21. This is the Islamic art of the Near East, influenced by the Turkish expansion of the twelfth and thirteenth centuries. The Turkish people brought certain features of Mongolian civilization into Islamic countries.

22. For example at Saumur, Tournus, Venosa, Königslauterbach, etc. It is also found in a more stylized form in pre-Christian Scandinavian jewellery.

23. Graeco-Roman art was able to absorb oriental motives as purely decorative elements; medieval art brought out anew the symbolical character of these motives.

24. On the tympanum of the south door of St. Godehard at Hildesheim in Saxony are two lions whose mouths emit stylized plants.

25. This custom has been maintained more particularly in the Alpine valleys.

26. The apocalyptic text speaks of "beasts", although one of them had the face of a man; the reason is that the quality of humanity here implies only a specific distinction and not a hierarchical pre-eminence. St. Thomas said that the distinction between the various angels is analogous, not to the distinction between different individuals of the

same species, but to that between different species. This explains the animal symbolism of the tetramorph, as well as the symbolism of gods having the shapes of animals in certain ancient civilizations, the rank of such gods being only that of angels.

27. According to a tradition well known among the Arabs, the lute (*al-'ud*) recapitulates in its proportions and in its tuning the cosmic harmony. It replaces the harp in the iconography of our portal (cf. Rev. xv. 2).

28. From the mouths of the *makaras* on the abutments of the arches of the *torana* often come vine branches, garlands of vegetation or strings of pearls.

29. The "lion seat" is usually combined with the *torana*, adorned with *makaras* and surmounted by the *kāla-mukha*, like a triumphal frame round the image of a god.

30. The lotus expands on the surface of the water, and water signifies the totality of all possibilities in their state of passive indistinction. Similarly, the Koran says that the Throne of God "was on the water".

31. The symbolism of the cardinal directions in their relation to the liturgy and to sacred architecture is explained in such medieval works as the "Mirror of the World" of Honorious d'Autun and the "Mirror of the Church" of Durandus.

32. Two other witnesses, perhaps the prophets Isaiah and Ezekiel, stand beside the twelve apostles, one on the right and one on the left.

Chapter IV

THE FOUNDATIONS OF ISLAMIC ART

"God is beautiful and He loves beauty"
(saying of the Prophet)

I

UNITY, in itself eminently "concrete", nevertheless presents itself
to the human mind as an abstract idea. This fact, together with
certain considerations connected with the Semitic mentality,
explains the abstract character of Islamic art. Islam is centred
on Unity, and Unity is not expressible in terms of any image.

The prohibition of images in Islam is not however absolute.
A plane image is tolerated as an element in profane art, on
condition that it represents neither God nor the face of the
Prophet;[1] on the other hand an image "that casts a shadow" is
only tolerated exceptionally, when it represents a stylized animal,
as may happen in the architecture of palaces or in jewellery.[2]
In a general way the representation of plants and fantastic
animals is expressly allowed, but in sacred art stylized plant forms
are alone admitted.

The absence of images in mosques has two purposes. One is
negative, namely, that of eliminating a "presence" which might
set itself up against the Presence—albeit invisible—of God, and
which might in addition become a source of error because of the
imperfection of all symbols; the other and positive purpose is that
of affirming the transcendence of God, since the Divine Essence
cannot be compared with anything whatsoever.

Unity, it is true, has a participative aspect, in so far as it is
the synthesis of the multiple and the principle of analogy; it is
in that aspect that a sacred image presupposes Unity and
expresses it in its own way; but Unity is also the principle of
distinction, for it is by its intrinsic unity that every being is
essentially distinguished from all others, in such a way that it is
unique and can neither be confused nor replaced. This last

aspect of Unity reflects most directly the transcendence of the Supreme Unity, its "Non-Alterity" and its absolute Solitude. According to the fundamental formula of Islam: "there is no divinity other than God" (*lā ilāha ill, Allāh*), it is through the distinction of the different planes of reality that everything is gathered together beneath the infinite vault of the Supreme Unity: once one has recognized the finite for what it is one can no longer consider it "alongside of" the Infinite, and for that very reason the finite reintegrates itself with the Infinite.

From this point of view the fundamental error is that of projecting the nature of the absolute into the relative, by attributing to the relative an autonomy that does not belong to it: the primary source of this error is imagination, or more precisely illusion (*al-wahm*). Therefore a Muslim sees in figurative art a flagrant and contagious manifestation of the said error; in his view the image projects one order of reality into another. Against this the only effective safeguard is wisdom (*hikmah*), which puts everything in its proper place. As applied to art, this means that every artistic creation must be treated according to the laws of its domain of existence and must make those laws intelligible; architecture, for example, must manifest the static equilibrium and state of perfection of motionless bodies, typified in the regular shape of a crystal.

This last statement about architecture needs amplification. Some people reproach Islamic architecture with failing to accentuate the functional aspect of the elements of a building, as does the architecture of the Renaissance, which reinforces heavily loaded elements and lines of tension, thus conferring on constructional elements a sort of organic consciousness. But according to the perspective of Islam, to do so implies nothing less than a confusion between two orders of reality and a lack of intellectual sincerity: if slender columns can in fact carry the load of a vault, what is the good of artificially attributing to them a state of tension, which anyhow is not in the nature of a mineral? In another aspect, Islamic architecture does not seek to do away with the heaviness of stone by giving it an ascending movement, as does Gothic art; static equilibrium demands immobility, but the crude material is as it were lightened and rendered diaphanous by the chiselling of the arabesques and by carvings in

the form of stalactites and hollows, which present thousands of facets to the light and confer on stone and stucco the quality of precious jewels. The arcades of a court of the Alhambra, for example, or of certain North-west African mosques, repose in perfect calm; at the same time they seem to be woven of luminous vibrations. They are like light made crystalline; their innermost substance one might say, is not stone but the Divine Light, the creative Intelligence that resides mysteriously in all things (pl. IX).

This makes it clear that the "objectivity" of Islamic art—the absence of a subjective urge, or one that could be called "mystical"—has nothing to do with rationalism, and anyhow, what is rationalism but the limitation of intelligence to the measure of man alone? Nevertheless that is exactly what the art of the Renaissance does through its "organic" and subjectively anthropomorphic interpretation of architecture. There is but one step between rationalism and individualistic passion, and from these to a mechanistic conception of the world. There is nothing of that sort in Islamic art; its logical essence remains always impersonal and qualitative; indeed, according to the Islamic perspective, reason (al-'aql) is above all the channel of man's acceptance of revealed truths and these truths are neither irrational nor solely rational. In this resides the nobility of reason, and consequently that of art: therefore to say that art is a product of reason or of science, as do the masters of Islamic art, does not in any sense signify that art is rationalistic and must be kept clear of spiritual intuition, quite the contrary; for in this case reason does not paralyse inspiration, it paves the way towards a non-individual beauty.

The difference that divides the abstract art of Islam from modern "abstract art" may be mentioned here. The moderns find in their "abstractions" a response that is ever more imme-diate, more fluid and more individual to the irrational impulses that come from the subconscious; to a Muslim artist on the other hand abstract art is the expression of a law, it manifests as dir-ectly as possible Unity in multiplicity. The writer of these lines, strong in his experience of European sculpture, once sought to be taken on as a hand by a North-west African master decorator. "What would you do," said the master "if you had to decorate a plain wall like this one?" "I would make a design of vines, and

fill up their sinuosities with drawings of gazelles and hares."
"Gazelles and hares and other animals exist everywhere in
nature," replied the Arab, "why reproduce them? But to draw
three geometrical rose patterns, one with eleven segments and
two with eight, and to link them up in such a way that they fill
this space perfectly, that is art."

It could also be said—and this is confirmed by Muslim masters
—that art consists in fashioning objects in a manner conformable
to their nature, for that nature has a virtual content of beauty,
since it comes from God; all one has to do is to release that
beauty in order to make it apparent. According to the most
general Islamic conception, art is no more than a method of
ennobling matter.

II

The principle which demands that art should conform to the
laws inherent in the objects it deals with is no less respected in
the minor arts, for example that of rug-making, so characteristic
to the world of Islam. The restriction to geometrical forms alone,
which are faithful to the flat surface of the composition, and
the absence of images properly so called, have proved no obstacle
to artistic fertility, on the contrary, for each piece—apart from
those mass produced for the European market—expresses a
creative joy.

The technique of the knotted rug is probably of nomadic
origin. The rug is the real furniture of the nomad, and it is in
rugs of nomadic origin that one finds the most perfect and the
most original work. Rugs of urban origin often show a certain
artificial refinement, which deprives the shapes and colours of
their immediate vigour and rhythm. The art of the nomadic rug-
maker favours the repetition of strongly marked geometrical
forms, as well as abrupt alternations of contrast and a diagonal
symmetry. Similar preferences are apparent throughout almost
the whole of Islamic art, and this is very significant with respect
to the spirit which those preferences manifest; the Islamic men-
tality shows a relationship on the spiritual plane to what the
nomadic mentality is on the psychological plane : an acute sense
of the fragility of the world, a conciseness of thought and action
and a genius for rhythm are nomadic qualities.

When one of the first Muslim armies conquered Persia, they found in the great royal hall of Ctesiphon an immense "carpet of spring" with decorations of gold and silver. It was taken with other booty to Medina, where it was simply cut into as many pieces as there were ancient companions of the Prophet. This apparent act of vandalism was however not only in conformity with the rules of war as laid down by the Koran, but it also gave expression to the profound suspicion felt by Muslims for every work of man that seeks to be absolutely perfect or eternal. The carpet of Ctesiphon incidentally portrayed the earthly paradise, and its division among the companions of the Prophet is not without spiritual significance.

This too must be said : although the world of Islam, which is more or less coextensive with the ancient empire of Alexander,[3] includes many peoples with a long sedentary history, yet the ethnic waves which have periodically renewed the life of these peoples, and imposed on them their domination and their preferences, have always been of nomadic origin : Arabs, Seljuks, Turks, Berbers and Mongols. In a general way Islam combines badly with an urban and bourgeois "solidification".[4]

Traces of the nomadic mentality can be found even in Islamic architecture, although architecture belongs primarily to sedentary cultures. Thus, constructional elements such as columns, arches and portals have a certain autonomy, despite the unity of the whole; there is no organic continuity between the various elements of a building; when it is a case of avoiding monotony —and monotony is not always considered an evil—it is achieved less by the gradual differentiation of a series of analogous elements than by incisive changes. The "stalactites" in stucco hung from the inner surfaces of the arches and the patterns of the arabesques "carpeting" the walls certainly keep alive some reminiscences of nomadic "furnishings", consisting as they do of rugs and tents.

The primitive mosque, in the form of a vast hall of prayer with its roof stretched horizontally and supported by a palm-grove of pillars, comes near to the nomadic environment; even an architecture as refined as that of the mosque at Cordova, with its superposed arcades, is reminiscent of a palm-grove.

The mausoleum with a cupola and a square base accords with the nomadic spirit in the conciseness of its form.

The Islamic hall of prayer, unlike a church or a temple, has
no centre towards which worship is directed. The grouping of
the faithful round a centre, so characteristic of Christian com-
munities, can only be witnessed in Islam at the time of the
pilgrimage to Mecca, in the collective prayer round the Kaaba.
In every other place believers turn in their prayers towards
that distant centre, external to the walls of the mosque. But the
Kaaba itself does not represent a sacramental centre comparable
to the Christian altar, nor does it contain any symbol which
could be an immediate support to worship,[5] for it is empty. Its
emptiness reveals an essential feature of the spiritual attitude of
Islam : whereas Christian piety is eager to concentrate on a
concrete centre—since the "Incarnate Word" is a centre, both
in space and in time, and since the Eucharistic sacrament is no
less a centre—a Muslim's awareness of the Divine Presence is
based on a feeling of limitlessness; he rejects all objectivation of
the Divine, except that which presents itself to him in the form
of limitless space.

None the less, a concentric plan is not alien to Islamic archi-
tecture, for such is the plan of a mausoleum roofed with a cupola.
The prototype of this plan is found in Byzantine as well as in
Asiatic art, where it symbolizes the union of heaven and earth,
the rectangular body of the building corresponding to the earth
and the spherical cupola to heaven. Islamic art has assimilated
this type while reducing it to its purest and clearest formulation;
between the cubical body and the more or less ogival cupola, an
octagonal "drum" is usually inserted. The eminently perfect and
intelligible form of such a building can dominate the indeter-
minate spaciousness of an entire desert landscape. As the mauso-
leum of a saint it is effectively a spiritual centre of the world.

The geometrical genius, which asserts itself so strongly in
Islamic art, flows directly from the kind of speculation favoured
by Islam, which is "abstract" and not "mythological". There is
moreover no better symbol in the visual order of the internal
complexity of Unity—of the passage from the Indivisible Unity
to "Unity in multiplicity" or "multiplicity in Unity"—than the
series of the regular geometrical figures contained within a circle,
or that of the regular polyhedra contained within a sphere.

The architectural theme of a cupola with ribs resting on a
rectangular body, to which it is connected in many different ways,

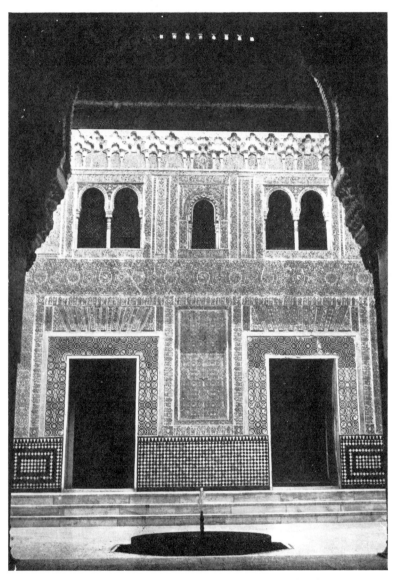

Plate IX. The Court of the Meshwar of the Alhambra

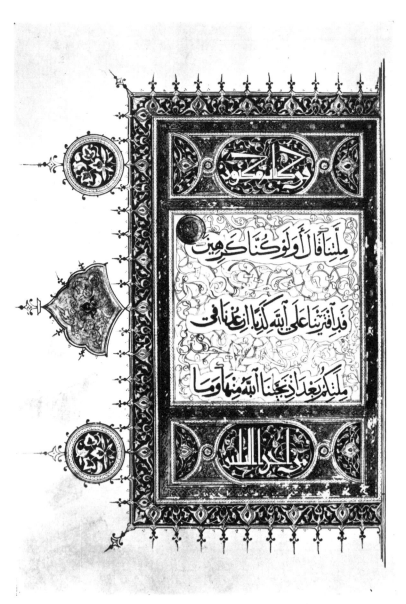

Plate X. Page of an Egyptian Koran of the XIVth century

has been abundantly developed in the Islamic countries of Asia Minor. This style is founded on the art of building in brick, and from it Gothic architecture, with all its speculative spirit, probably received its first impulses.

The sense of rhythm, innate in nomadic peoples, and the genius for geometry : these are the two poles which, transposed into the spiritual order, determine all Islamic art. Nomadic rhythmicality found its most direct expression in Arab prosody, which extended its influence as far as the Christian troubadours, while speculative geometry belongs to the Pythagorean inheritance very directly taken over by the Muslim world.

III

Art to the Muslim is a "proof of the divine existence" only to the extent that it is beautiful without showing the marks of a subjective individualistic inspiration; its beauty must be impersonal, like that of the starry sky. Islamic art does indeed attain to a kind of perfection that seems to be independent of its author; his triumphs and his failures disappear before the universal character of the forms.

Wherever Islam has assimilated a pre-existing type of architecture, in Byzantine countries as well as in Persia and in India, subsequent development has been in the direction of a geometrical precision having a qualitative character—not quantitative nor mechanical—which is attested by the elegance of its solutions of architectural problems. It is in India that the contrast between the indigenous architecture and the artistic ideals of the Muslim conquerors is without doubt most marked. Hindu architecture is at once lapidary and complex, elementary and rich, like a sacred mountain with mysterious caverns; Islamic architecture leans towards clarity and sobriety. Wherever Islamic art appropriates incidental elements from Hindu architecture, it subordinates their native power to the unity and the lightness of the whole.[6] There are some Islamic buildings in India that are numbered among the most perfect in existence; no architecture has ever surpassed them.

But Islamic architecture is most faithful to its peculiar genius in the *Maghreb*, the West of the Muslim world. Here, in Algeria, in Morocco and in Andalusia, it realizes the state of crystalline

perfection that turns the interior of a mosque—or of a palace—
into an oasis of freshness, a world filled with a limpid and almost
unworldly beatitude.[7]

The assimilation of Byzantine models by Islamic art is exem-
plified with special clarity in the Turkish variations on the theme
of the Hagia Sophia. As is well known, the Hagia Sophia consists
of an immense central dome flanked by two half-cupolas, which
in their turn are amplified by several vaulted apses. The whole
covers a space more extensive in the direction of one axis than
of the other; the proportions of the resulting environment are
highly elusive and seem to be indefinite owing to the absence of
conspicuous articulations. Muslim architects like Sinan, who took
up the theme of a central cupola amplified by adjacent cupolas,
found new solutions more strictly geometrical in conception. The
Selimiye mosque at Edirna is a notably characteristic example;
its huge dome rests on an octagon with walls alternately flat and
curved into apses, resulting in a system of plane and curved
facets with clearly defined angles between them. This transforma-
tion of the plan of the Hagia Sophia is comparable to the cutting
of a precious stone, made more regular and more brilliant by
polishing.

Seen from inside, the cupola of a mosque of this type does not
hover in indefinity, but neither does it weigh upon its pillars.
Nothing expresses effort in Islamic architecture, there is no
tension, nor any antithesis between heaven and earth. "There is
none of that sensation of a heaven descending from above, as
in the Hagia Sophia, nor the ascending tendency of a Gothic
cathedral. The culminating point in the Islamic prayer is the
moment when the forehead of the believer prostrated on the rug
touches the floor, that mirror-like surface which abolishes the
contrast of height and depth and makes space a homogeneous
unity with no particular tendency. It is by its immobility that
the atmosphere of a mosque is distinguished from all things
ephemeral. Here infinity is not attained by a transformation
from one side of a dialectical antithesis to the other; in this
architecture the beyond is not merely a goal, it is lived here and
now, in a freedom exempt from all tendencies; there is a repose
free from all aspiration; its omnipresence is incorporated in the
edifice so like a diamond" (after Ulya Vogt-Göknil).[8]

The exterior of Turkish mosques is characterized by the con-

trast between the hemisphere of the dome, more in evidence than in the Hagia Sophia, and the needles of the minarets: a synthesis of repose and vigilance, of submission and active witness.

IV

In the arabesque, the typical creation of Islam, the geometrical genius meets the nomadic genius. The arabesque is a sort of dialectic of ornament, in which logic is allied to a living continuity of rhythm. It has two basic elements, the interlacement and the plant motif. The former is essentially a derivative of geometrical speculation, while the latter represents a sort of graphic formulation of rhythm, expressed in spiraloid designs, which may possibly be derived not so much from plant forms as from a purely linear symbolism. Ornaments with spiraloid designs—heraldic animals and vines—are also found in the art of Asiatic nomads; the art of the Scythians is a striking example (fig. 22)

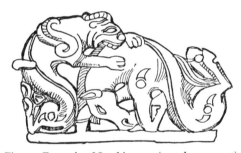

Fig. 22. Example of Scythian art (metal ornament)

The elements of Islamic decorative art are drawn from the rich archaic heritage that was common to all the peoples of Asia as well as to those of the Near East and of northern Europe. It came to the surface again as soon as Hellenism, with its essentially anthropomorphic art, had gone into retreat. Christian medieval art picked up this same heritage, brought to it by the folk-lore of immigrant peoples from Asia, and by insular art, both Celtic and Saxon, itself one of the most astonishing syntheses of prehistoric motives. But this heritage was soon obscured and diluted in the Christian world by the influence of Graeco-Roman

models, assimilated by Christianity. The Islamic spirit has a much more direct affinity with this vast current of archaic forms (figs. 23 and 24) for they are in implicit correspondence with its

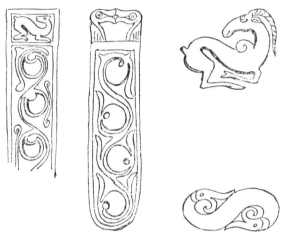

Fig. 23. *Left:* two tongues from nomad belts found in Hungary; *right:* two pins of the period of migrations, found in central Europe

Fig. 24. Ornament of a nomad cooking-pot from Daghestan

conscious return towards a primordial order, towards the "primordial religion" (*din al-fitrah*). Islam assimilates these archaic elements and reduces them to their most abstract and most generalized formulations; it levels them out in a certain sense, and thereby eliminates any magical qualities they may have possessed; in return, it endows them with a fresh intellectual lucidity, one might almost say—with a spiritual elegance.

The arabesque, which is the outcome of this synthesis, has also

analogies in Arab rhetoric and poetry; a rhythmical outpouring
of thought is given precision by parallels and inversions strictly
interlinked. The Koran itself uses the same means of expression;
in its periods they become elements in a spiritual algebra and
rhythms of incantation. Thus the Divine witness of the Burning
Bush, which the Hebrew Bible conveys in the words "I am that
I am" is rendered in the Koran by the paraphrase : "I am God,
beside whom there is no divinity but I."

At the risk of pressing the point too hard, let it be said that for
a Muslim the arabesque is not merely a possibility of producing
art without making images; it is a direct means for dissolving
images or what corresponds to them in the mental order, in the
same way as the rhythmical repetition of certain Koranic
formulae dissolves the fixation of the mind on an object of desire.
In the arabesque all suggestion of an individual form is eliminated
by the indefinity of a continuous weave. The repetition of
identical motives, the flamboyant movement of lines and the
decorative equivalence of forms in relief or incised, and so
inversely analogous, all contribute to this effect. Thus at the sight
of glittering waves or of leafage trembling in the breeze, the soul
detaches itself from its internal objects, from the "idols" of
passion, and plunges, vibrant within itself, into a pure state of
being.

The walls of certain mosques, covered with glazed earthen-
ware mosaic or a tissue of delicate arabesques in stucco, recall
the symbolism of the curtain (*hijāb*). According to a saying of
the Prophet, God hides himself behind seventy thousand curtains
of light and of darkness; "if they were taken away, all that His
sight reaches would be consumed by the lightnings of His
Countenance". The curtains are made of light in that they hide
the Divine "obscurity", and of darkness in that they veil the
Divine Light.

V

Islam regards itself as the renewal of the primordial religion
of humanity. The Divine Truth has been revealed through the
mediation of the prophets or the "messengers", at very different
times to the most diverse peoples. The Koran is but the final
confirmation, the "seal", of all these numerous revelations, the

sequence of which goes back to Adam; Judaism and Christianity
have the same title to inclusion in the sequence as the revelations
that preceded them.

This is the point of view that predisposes the Islamic civiliza-
tion to take to itself the heritage of more ancient traditions, at
the same time stripping the legacy of its mythological clothing,
and reclothing it with more "abstract" expressions, more nearly
in conformity with its pure doctrine of Unity. Thus it is that
the craft traditions, such as persisted in Islamic countries to the
very threshold of our times, are generally said to have come
down from certain pre-Islamic prophets, particularly from Seth,
the third son of Adam, who re-established the cosmic equilibrium
after the murder of Abel by Cain. Abel represents nomadism,
the rearing of animals, and Cain sedentarism, the cultivation of
the earth; Seth is therefore synonymous with the synthesis of the
two currents.[9]

Pre-Islamic prototypes preserved in the craft traditions also
came to be connected with certain parables in the Koran and
with certain sayings of the Prophet, in the same way as pre-
Christian traditions assimilated by Christianity were connected
with Gospel parables analogous to them.

In speaking of his ascent to heaven (mirāj) the Prophet
describes an immense dome made of white mother-of-pearl and
resting on four corner pillars, on which are written the four
parts of the Koranic formula: "In the name—of God—the
Compassionate—the Merciful", and from which flow four rivers
of beatitude, one of water, one of milk, one of honey and one
of wine. This parable represents the spiritual model of every
building with a dome. Mother-of-pearl or white pearl is the
symbol of the Spirit (ar-rūh) the "dome" of which encloses the
whole creation. The universal Spirit, which was created before
all other creatures, is also the divine Throne which comprehends
all things (al-'arsh al-muhīt). The symbol of this Throne is
invisible space extending beyond the starry sky; from the terres-
trial point of view, which is natural to man and affords the most
direct symbolism, the stars move in concentric spheres more or
less remote from the earth as centre, and surrounded by limitless
space which in its turn is "enclosed" by the universal Spirit con-
sidered as the metaphysical "situation" of all perception or know-
ledge.

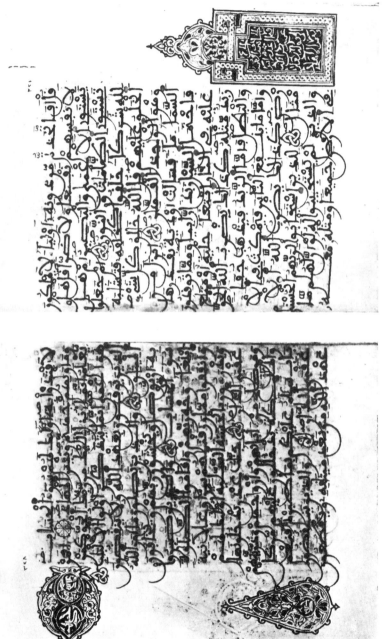

Plate XI. Pair of pages of a Koran from the Maghreb, sixteenth century

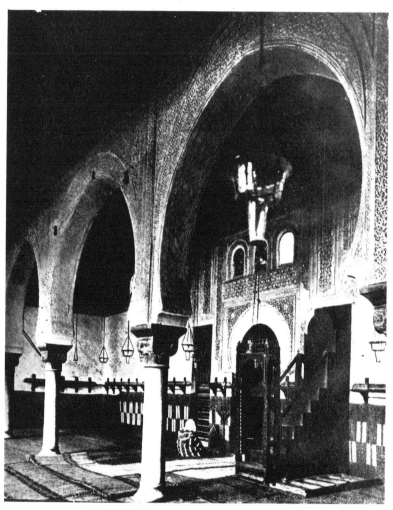
Plate XII. Hall of Prayer of the Medersa Bu'Manya at Fez

While the dome of a sacred building represents the universal Spirit, the octagonal "drum" that supports it symbolizes the eight angels, "bearers of the Throne", who in their turn correspond to the eight directions of the "rose of the winds". The cubical part of the building then represents the cosmos, with the four corner pillars (arkān) as its elements, conceived as principles both subtle and corporeal.

The building as a whole expresses equilibrium, the reflection of the Divine Unity in the cosmic order. Nevertheless since Unity is always Itself, whatever the degree at which it is envisaged, the regular shape of the building can also be transposed *in divinis;* the polygonal part of the building will then correspond to the "facets" of the Divine Qualities (as-sifāt) while the dome recalls undifferentiated Unity.[10]

A mosque generally comprises a court with a fountain, where the faithful can make their ablutions before accomplishing their prayers. The fountain is often protected by a small cupola shaped like a baldaquin. The court with a fountain in the middle, as well as the enclosed garden watered by four runnels rising in its centre, are made in the likeness of Paradise, for the Koran speaks of the gardens of Beatitude, where springs of water flow, one or two in each garden, and where celestial virgins dwell. It is in the nature of Paradise (*jannah*) to be hidden and secret; it corresponds to the interior world, the innermost soul. This is the world which the Islamic house must imitate, with its inner court surrounded with walls on all four sides or with an enclosed garden furnished with a well or fountain. The house is the *sacratum* (*haram*) of the family, where woman reigns and man is but a guest. Its square shape is in conformity with the Islamic law of marriage, which allows a man to marry up to four wives, on condition that he offers the same advantages to each. The Islamic house is completely closed towards the outer world—family life is withdrawn from the general social life—it is only open above, to the sky, which is reflected beneath in the fountain of the court.

VI

The spiritual style of Islam is also exemplified in the art of clothing, and particularly in the masculine costume of purely

Islamic countries. The part played by costume has a special importance, because no artistic ideal established in painting or sculpture can replace or relativize the living presence of man in his primordial dignity. In one sense the art of clothing is collective and even popular; it is nevertheless indirectly a sacred art, for the masculine costume of Islam is as it were a priestly costume generalized, just as Islam "generalized" the priesthood by abolishing the hierarchy and making every believer a priest. Every Muslim can perform the essential rites of his tradition by himself; anyone, provided that his mental faculties are intact and his life conforms to his religion, may in principle preside as *imām* over any gathering great or small.

The example of the Mosaic law makes it clear that priestly costume as such is a branch of the sacred art in the strictest sense of the words. Its formal language is determined by the dual nature of the human form, which is the most immediate symbol of God and at the same time, because of its egocentricity and subjectivity, the thickest of the veils that hide the Divine Presence. The hieratic garments of Semitic peoples hide the individual and subjectively "passionate" aspect of the human body, and emphasize on the contrary its "god-like" qualities. These qualities are brought out by combining their microcosmic evidences, more or less veiled by the polyvalence of the human form, with their macrocosmic evidences; thus, in the symbolism of the clothing, the "personal" manifestation of God is united with His "impersonal" manifestation, and through the complex and corruptible form of man, the simple and incorruptible beauty of the stars is projected. The golden disc which the High Priest in the Old Testament wore on his breast corresponds to the sun; the precious stones which adorn various parts of his body, and are placed so as to correspond to the subtle centres of the *shekhina,* are like stars; his head-dress is like the "horns" of the crescent moon: and the fringes of his vestments recall the dew or the rain of Grace.[11] Christian liturgical vestments perpetuate the same formal language, while relating it to the sacerdotal function of the Christ, who is both officiant and victim of the sacrifice.[12] Alongside the priestly vestment with its solar characteristics, there is the monastic garment, which serves only to efface the individual and sensual aspects of the body,[13] whereas the costume of the laity, with the exception

of the insignia of consecrated kings and the heraldic emblems of nobles,[14] originates merely in plain necessity or in worldliness. In this way Christianity makes a distinction between the priest, who participates by virtue of his impersonal function in the glory of the Christ, and the profane person, whose whole attire can be but vanity, and who is integrated with the formal style of the tradition only when he assumes the garb of the penitent. It may be noted in this connection that modern masculine attire shows a curious inversion of these qualities: its negation of the body, with its natural suppleness and beauty, becomes the expression of a new individualism, hostile to nature and coupled with an instinctive hatred of all hierarchy.[15]

The masculine costume of Islam is a synthesis of the sacerdotal and the monastic attire, and at the same time it affirms masculine dignity. It is the turban which, according to the saying of the Prophet,[16] is the mark of spiritual, and therefore sacerdotal dignity, together with the white colour of the clothing, the cloak with broad folds and the *haik* enveloping the head and shoulders. Certain articles of clothing appropriate to dwellers in the desert have been generalized and "stylized" for a spiritual purpose. On the other hand the monastic character of the Islamic costume is affirmed by its simplicity and by the more or less strict prohibition[17] of golden ornaments and of silk. Women alone may wear gold and silk, and then it is not in public but only in the interior of the house—which corresponds to the inner world of the soul —that they may display such finery.

Wherever an Islamic civilization is beginning to decay, the turban is the first thing that is banished, and next the wearing of loose and pliable garments, such as facilitate the movements of the ritual prayer. As for the campaign that is waged in certain Arab countries in favour of the hat, it is aimed directly at the abolition of the rites, for the rim of a hat prevents the forehead from touching the ground in the prostration; the cap with the peak, so peculiarly suggestive of the profane, is no less inimical to the tradition. If the use of machines necessitates the wearing of such clothes, it simply proves that, from the point of view of Islam, reliance on machines draws man away from his existential centre, where he "stands upright before God".

This description of Islamic costume would not be complete without some mention of the "sacred vestment" (*ihrām*) of the

pilgrim, worn on the occasion of the great pilgrimage (al-hajj) to the interior of the sacred territory that includes Mecca. The pilgrim wears only two pieces of cloth without seam, tied round the shoulders and the hips, and sandals on his feet. Thus attired he is exposed to the intense heat of the sun, conscious of his poverty before God.

VII

The noblest of the visual arts in the world of Islam is calligraphy, and it is the writing of the Koran that is sacred art *par excellence;* it plays a part more or less analogous to that of the icon in Christian art, for it represents the visible body of the Divine Word (pls. X and XI).[18]

In sacred inscriptions the Arabic letters combine fluently with arabesques, especially with plant motives, which are thus brought into closer relationship with the Asiatic symbolism of the tree of the world; the leaves of this tree correspord to the words of the Sacred Book. Arabic calligraphy contains within itself alone decorative possibilities of inexhaustible richness; its modalities vary between the monumental Kufic script with its rectlinear forms and vertical breaks, and the *naskhi* with its line as fluid and as serpentine as it could be. The richness of the Arabic script comes from the fact that it has fully developed its two "dimensions" : the vertical, which confers on the letters their hieratic dignity, and the horizontal, which links them together in a continuous flow. As in the symbolism of weaving, the vertical lines, analogous to the "warp" of the fabric, correspond to the permanent essences of things—it is by the vertical that the unalterable character of each letter is affirmed—whereas the horizontal, analogous to the "weft", expresses becoming or the matter that links one thing to another. A significance of the kind is particularly evident in Arab calligraphy, where the vertical strokes transcend and regulate the undulating flow of the connecting strokes.

Arabic is written from right to left; this is as much as to say that the writing runs back from the field of action towards the heart. Among all the phonetic scripts of Semitic origin, Arabic writing has the least visual resemblance to Hebrew writing; Hebrew is static like the stone of the Tables of the Law, while

at the same time it is full of the latent fire of the Divine Presence, whereas Arabic manifests Unity by the breadth of its rhythm: the broader the rhythm the more its unity becomes evident.

The friezes of inscriptions crowning the inner walls of a hall of prayer (pl. XII), or surrounding the *mihrāb,* recall to the believer, as much by their rhythm and their hieratic form as by their meaning, the majestic and forceful current of the Koranic language.

This plastic reflection of a Divine incantation traverses the whole of Islamic life; its expressive richness, its upsurge endlessly renewed and its inimitable rhythms, compensate the elusive simplicity of its content, which is Unity; it is immutability of idea and inexhaustible flow of utterance, architectural geometry and indefinite rhythm of ornament.

The *mihrāb* is the niche oriented towards Mecca and is the place where the *imām* who recites the ritual prayer stands in front of the rows of believers who repeat his gestures. The primary function of this niche is acoustic, to re-echo the words directed towards it; but at the same time its form is reminiscent of that of a choir or an apse, the "holy of holies", the general shape of which it reproduces on a smaller scale. This analogy is confirmed in the field of symbolism by the presence of the lamp hung in front of the niche of prayer.[19] The lamp recalls the "niche of light" of which it is said in the Koran: "God is the light of the heavens and of the earth. His light is like a niche in which there is a lamp; the lamp is in a glass, which is like a shining star..." (*Sūrah of Light,* v. 35). Here is something like a meeting-point between the symbolism of the mosque and of the Christian temple, as well as of the Jewish temple and perhaps of the Parsee temple. To return however to the acoustic function of the prayer-niche: it is by virtue of its reverberation of the Divine Word during the prayer that the *mihrāb* is a symbol of the Presence of God, and for that reason the symbolism of the lamp becomes purely accessory, or one might say "liturgical";[20] the miracle of Islam is the Divine Word directly revealed in the Koran and "actualized" by ritual recitation. This makes it possible to situate Islamic iconoclasm very precisely: the Divine Word must remain a verbal expression, and as such instantaneous and immaterial, in the likeness of the act of creation; thus alone will it keep its evocative power pure, without

being subject to that attrition which the use of tangible materials instils, so to speak, into the very nature of the plastic arts, and into the forms handed on through them from generation to generation. Being manifested in time but not in space, speech is outside the ambit of the changes brought about by time in spatial things; nomads know this well, living, as they do, not by images but by speech. This is the point of view and the manner of its expression natural to peoples in migration and particularly to Semitic nomads; Islam transposes it into the spiritual order,[21] conferring in return on the human environment, particularly on architecture, an aspect of sobriety and intellectual transparency, as a reminder that everything is an expression of the Divine Truth.

NOTES

1. When Mecca was conquered by the Muslims, the Prophet first ordered the destruction of all the idols which the pagan Arabs had set up on the court of the Kaaba; then he entered the sanctuary. Its walls had been ornamented by a Byzantine painter, among other figures were one of Abraham throwing divinatory arrows and another of the Virgin and Child. The Prophet covered the last named with his two hands and ordered the removal of all the others.

2. An artist newly converted to Islam complained to Abbas, uncle of the Prophet, that he no longer knew what to paint (or carve). The patriarch advised him to attempt nothing but plants and fantastic animals, such as do not exist in nature.

3. It can be said that Alexander was the artisan of the world that was destined for Islam, in the same way that Caesar was the artisan of the world that was to welcome Christianity.

4. One of the reasons for the decadence of Muslim countries in modern times is the progressive suppression of the nomadic element.

5. The famous black stone is set in a corner of the Kaaba. It does not mark the centre towards which believers turn in their prayers, and besides, it has no "sacramental" function.

6. From its inception Islamic architecture integrated into itself certain elements of Hindu and Buddhist architecture; but these elements had come to it through the art of Persia and of Byzantium; it was only later on that Islamic civilization directly encountered that of India.

7. The analogy between the nature of crystal and spiritual perfection is implicitly expressed in the following formula which emanates from the Caliph Ali: "Muhammad is a man, not like other men, but like a precious stone among stones." This formula also indicates the point of junction between architecture and alchemy.

8. *Turkische Moscheen*, Origo-Verlag, Zurich, 1953.

9. René Guénon, *Cain et Abel* in *Le Règne de la Quantité et les Signes des Temps*, Paris, NRF, 1945. English translation, Luzac, London, 1953.

10. See the author's book, *Introduction aux doctrines ésotériques de l'Islam*, Derain, Lyon, 1955.

11. Analogous symbols are found in the ritual costume of the North American Indians: the head-dress with bison horns, and the fringes of the garment as an image of rain and of grace. The head-dress of eagle's feathers recalls the "Thunder Bird" which rules the world from on high, also the radiant sun, both being symbols of the Universal Spirit.

12. See Simeon of Thessalonica, *De divino Templo*.

13. Nudity can also have a sacred character, because it recalls the primordial state of man and because it abolishes the separation between man and the universe. The Hindu ascetic is "clothed in space".

14. Heraldry has probably a dual origin. In part it is derived from the emblems of nomadic tribes—from "totems", and in part from Hermetism. The two currents mingled in the Near East under the Empire of the Seljuks.

15. Modern masculine attire, which has its origins partly in the French Revolution and partly in English puritanism, represents an almost perfect synthesis of anti-spiritual and anti-aristocratic tendencies. It affirms the forms of the body, while "correcting" them to fit in with a conception that is inept as well as being hostile to nature and to the intrinsically divine beauty of man.

16. The turban is called "the crown (or the diadem) of Islam".

17. It is not a question of a canonical interdiction but of a reprobation, applied more strictly to gold than to silk.

18. The disputes among Islamic theological schools about the created or uncreated nature of the Koran are analogous to the disputes among Christian theologians about the two natures of the Christ.

19. This is the motive reproduced in a more or less stylized form on many prayer-rugs. It may be mentioned that the prayer-niche is not always furnished with a lamp, no such symbol being obligatory.

20. The conch which adorns a few of the most ancient prayer-niches is in fact derived as an architectural feature from Hellenic art. However, it seems to be connected with the very ancient symbolism in which the conch is compared to the ear and the pearl to the Divine Word.

21. Islamic iconoclasm has another side to it: man being created in the image of God, to imitate his form is regarded as blasphemy. But this point of view is a consequence of the prohibition of images, rather than a main reason for it.

THE IMAGE OF BUDDHA

I

BUDDHIST art springs from Hindu art by way of a sort of alchemical transmutation, which could be said to have "liquefied" the cosmic mythology of India and turned it into images of states of the soul, while at the same time "crystallizing" the subtlest element in Hindu art, namely, the quasi-spiritual quality of the human body ennobled by the sacred dance, purified by the methods of Yoga and as it were saturated with a consciousness not limited by the mind. It is this quality that is condensed into an incomparable formula in the sacred image of the Buddha, which absorbs all the spiritual beatitude inherent in the ancient art of India, and becomes the central theme round which all other images revolve.

The body of the Buddha and the lotus; these two forms, taken from Hindu art, express the same thing: the immense calm of the Spirit awakened to Itself. They recapitulate the whole spiritual attitude of Buddhism—and one might add also the psycho-physical attitude which serves as its support for spiritual realization.

The image of the Divine Man enthroned on the lotus is a Hindu theme. We have seen that within the Vedic altar is immured a conventional image of a golden man (*hirânya-purusha*); the image rests on a disc of gold which in its turn rests on a lotus leaf. It is a symbol of *Purusha,* the Divine Essence in its aspect as eternal essence of man, and it is also an image of *Agni,* the son of the gods, through whom *Prajāpati,* the universe, is realized in his original totality. *Purusha* has all these aspects; He manifests Himself on every plane of existence in a manner that conforms to the laws inherent to that plane, without Himself undergoing any change. *Agni* is the spiritual germ from which springs the universal nature of man; that is why he is hidden in the altar, just as he is hidden in the heart of man; he is born of the primordial waters, which are the totality of the virtual

potentialities of the soul or of the world; hence the lotus that supports him.

Buddhist art has perpetuated the symbol of the golden man, though it appears nevertheless to deny that which Hinduism affirms through this same symbol. The Hindu doctrine affirms above all an infinite Essence, of which all things are but a reflection—it is of *Purusha* that all things are made, says the Veda —whereas the Buddhist doctrine has nothing to say about the Being or the Essence of things; it appears to deny all divinity. Instead of starting its exposition from a supreme principle, which could be likened to the apex of a pyramid made up of all states of existence—and this is what the universe looks like from a theocentric point of view—it proceeds only by way of negation, as if it were taking man and his nothingness as starting point, and building thereon a pyramid with its apex downwards and expanding indefinitely upwards, towards the void. But despite the inversion of perspective, the quintessence of the two traditions is the same. The difference between their respective points of view is this: Hinduism envisages divine Realities in an "objective" manner, by virtue of their reflection in the mind, such a reflection being possible, outside and independently of their immediate spiritual realization, because of the universal nature of the Intellect. Buddhism on the other hand lays hold on the Essence of man—or the Essence of things—only by way of a "subjective" path, that is to say, by the spiritual realization of that Essence and by that alone; it rejects as false or illusory every purely speculative affirmation of supra-formal Reality. This attitude is justified[1] by the fact that the mental objectivation of Divine Reality may often constitute an obstacle to its realization because every reflection involves an inversion with respect to that which it reflects—this is demonstrated by the above example of the pyramid narrowing towards its apex, symbol of the principle —and because thought limits consciousness and in a sense congeals it; at the same time thought directed to God appears to be situated outside its object, whereas God is infinite and nothing can really be situated outside Him; all thought about the Absolute is therefore vitiated by a false perspective. For these reasons the Buddha says that he teaches nothing about the origin of the world or of the soul, and is only concerned with suffering and the way of deliverance from suffering.

Seeing that this negative attitude is adopted in its doctrine, Buddhist art could never in principle depict more than the human appearance of Gautama,[2] characterized by all the signs of his renunciation of the world. Stripped of his royal attributes and seated in the attitude of meditation, he holds in his left hand the wooden bowl of a beggar, symbol of his surrender to the Non-Ego, while his right hand touches the earth in witness of his lordship over it; such is the fundamental image of the Buddha (pl. XIII). Nevertheless this ascetic figure, so notably reminiscent of some of its ancient Hindu predecessors, finally absorbs, despite its lack of adornment, all the solar powers of ancient Hindu art. It is as if an ancient god of light were incarnated in the image of Shakyamuni renouncing the world; the Buddha of history did in fact integrate in himself, through his victory over becoming, all the undivided plenitude of existence.

In some representations of the Buddhist paradise the lotus throne of the *tathāgata* rises out of a pool just as *Agni* is born from the primordial waters. Together with the human image of the Blessed One, the lotus becomes the principal theme in Buddhist art which, in a certain sense, is thereafter wholly contained within these two poles. The form of the lotus expresses in a direct, "impersonal" and synthetic manner what the human form of the Buddha manifests in a more "personal" and more complex manner. Moreover this human form, through its symmetry and static plenitude, makes an approach to the form of the lotus; it will be remembered that the Buddha is called "the jewel in the lotus" (*mani padme*).

In Hinduism the lotus primarily symbolizes the universe in its passive aspect, as throne or receptacle of the divine Manifestation, whereas Buddhism compares it in the first place to the soul which is born out of a dark and formless state—the mire and the water—and expands in the light of *Bodhi*,[3] the universe and the soul are however in correspondence one with the other. The fully expanded lotus is also like a wheel, and the wheel is also a symbol of the cosmos or of the soul; the spokes united by the hub signify the directions of space or the faculties of the soul united by the Spirit.

When the Buddha Shakyamuni rose from his seat under the tree of *Bodhi*, after the long meditation which delivered him from the dominion of life and death, miraculous lotuses

blossomed under his feet. He took a step in each of the four directions of space and turned towards the zenith and the nadir,[4] smiling; immediately the numberless heavenly beings came near to offer him their homage. This story prefigures implicitly the triumph of Buddhism over the Hindu cosmos, a triumph that is reflected in the domain of art: the ancient Hindu divinities leave their thrones on eternal mountain and thereafter gravitate, like so many satellites, around the sacred icon of the *tathāgata*; thus situated they represent no more than psychic realities, or "magical" and more or less ephemeral emanations from the Buddha himself.

By way of compensation a generalized type of buddha makes its appearance, and it acquires a non-historical and universal significance, until it sets its mark, like a divine seal, on all aspects of the cosmos. For instance, the celestial buddhas of the *Mahāyāna*,[5] sometimes called *dhyāni*-buddhas, rule over the ten directions of space: the eight directions of the "rose of the winds" and the two opposed directions of the vertical. Physical space is here the image of "spiritual" space; the ten directions symbolize the principal aspects or qualities of *Bodhi;* the centre, from which these directions all radiate, and with which they are all in principle identified, is the Inexpressible. For this reason the celestial buddhas are spiritual projections of the single Buddha Shakyamuni—and in this relation they are sometimes represented as springing from his head—and at the same time prototypes of all incarnate buddhas. These various relationships are by no means mutually exclusive, for each buddha necessarily "contains" all Buddhahood, while manifesting more particularly one or other of his permanent aspects: "one single person of the buddhas becomes several, and several become one".[6] On the one hand the various *dhyāni*-buddhas correspond to different spiritual attitudes of Shakyamuni; on the other hand Shakyamuni is himself integral with the spiritual cosmos which they constitute: according to one point of view, he is an incarnation of the Buddha *Vairocana*, who is situated at the centre of the cosmic rose, and whose name means "he who spreads the light in every direction"; according to another point of view, he is an incarnation of the buddha *Amitābha*, the All-Compassionate, who rules over the Westerly direction and has as his satellite or

analogue the *bodhisattva Avalokiteshvāra*, whom the Far East knows by his Taoist name of *Kwan-yin* or *Kwannon*.

In their representation of the spiritual cosmos the Buddhist *mandalas* follow the age-old design of the open lotus-flower, thus recalling the multiple manifestation of the Vedic *Agni*. The images of the buddhas or bodhisattvas who rule over the different sectors of the "rose of the winds" all bear an iconographic resemblance to the classical type of Shakyamuni, from which they are usually distinguished only by their respective colours and attributes; they can also be identified by their gestures (*mudrās*), but these same gestures are also characteristic of the various attitudes of Shakyamuni, or of the different phases of his teaching. Although the ten directions of space correspond to particular *bodhisattvas*[7] there is no limit to the number of the latter : they are as numberless as the grains of the sands of the Ganges, say the *Sūtras*, and each of them presides over thousands of worlds : and besides, each buddha is reflected in a constellation of *bodhisattvas*[8] and is possessed as well of innumerable "magical bodies" : thus it is that the fundamental image of the Buddha seated on a lotus and surrounded by an aureole is susceptible of infinite variation. According to a symbolical conception developed in certain speculative schools of the *Mahāyāna*, the limitless compassion of the Buddha is present in the smallest particles of the universe in the form of so many *bodhisattvas* enthroned on lotuses; and the same idea of a manifestation endlessly renewed is expressed in some classical representations of the Buddhist paradise, in which numerous buddhas and *bodhisattvas*, analogous one to the other, rest on a lotus arising from a celestial pool or flowering on the branches of a great tree.[9]

This galaxy of buddhas is as it were a compensation for the absence of a "theory" in the real sense of the word, that is to say, of a theocentric view of the world. It is not a question of an ontological principle differentiating itself through a descending hierarchy of reflections, but of the ascetic as a type, or more exactly of the *muni*, of one freed from the flux of existence, who makes an opening on to the void and diversifies himself in accordance with the possible modes of his deliverance. The multitude of the buddhas and *bodhisattvas* indicates the relativity of the human receptacle : in his manifested personality the Buddha is distinct from principial Unity; there is nothing

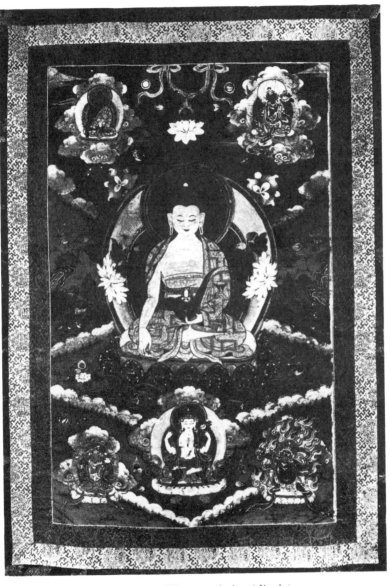

Plate XIII. Tibetan painting (*t'hanka*)

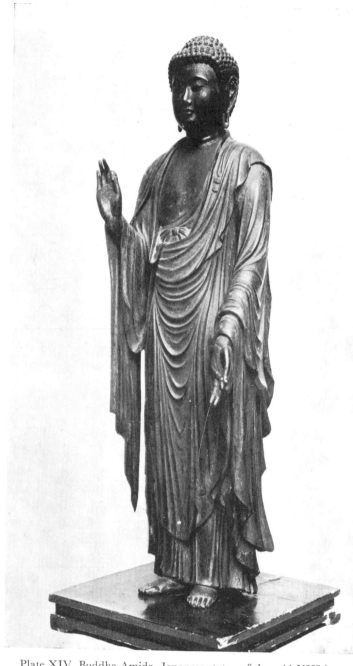

Plate XIV. Buddha Amida. Japanese statue of the mid-XIIIth century

absolutely unique in manifestation, so that the indefinite differ-
entiation of the type or model of all Buddhahood is like an in-
verted reflection of the non-differentiation of the Absolute.

From another point of view, to the extent that each *bodhi-
sattva* is released from becoming, he takes to himself its under-
lying qualities; his "body of fruition" (*samboghakaya*) becomes
a synthesis of the cosmic qualities, while his "body of essence"
(*dharmakaya*) is beyond all qualification. "The *bodhisattvas* as
a whole emanate from the earth and together they express the
cosmic body of the Buddha" says Chia-Siang Da-Shi[10]; the re-
ceptivity of the Buddha expands until it embraces in a qualita-
tive sense the whole manifested universe; and at the same time it
is through him, and by virtue of his receptivity alone, that the
Infinite assumes a "personal" aspect. This is where the Buddhist
perspective meets the Hindu, and the meeting cannot but take
place, for the two perspectives interpenetrate one another like
the two inversely analogous triangles of the "seal of Solomon".

The meeting of the two perspectives is responsible for the wide
use in Mahāyānist iconography of symbols which in Hinduism
are associated with different divine aspects, including for ex-
ample, divine instruments like the *vajra*, and even the multiplica-
tions of heads and arms in a single *bodhisattva*, not forgetting
the Tantric aspect of lamaist art. On the other hand it is also
possible that Hindu iconography was influenced by Buddhism,
for its anthropomorphism was developed after the Buddhist in-
vasion of India.

In the art of the *Hinayāna*, in Ceylon, Burma and Siam, there
is nothing but an indefinite repetition of the image of the earthly
Buddha, Shakyamuni. In the absence of a metaphysical symbol-
ism—which the *Mahāyāna* borrowed from the Hindu tradition
—the icon of the *Hinayāna* tends to become reduced to a
formula of extreme simplicity and soberness, as if it were con-
fined to a narrow region half-way between image and non-
image, between iconolatry and iconoclasm. Its repetitiveness
seems to recall the serene and majestic monotony of the Sutras.

II

The image of Shakyamuni (pl. XIV), in becoming a model
for other images, assumed a character of universality; neverthe-

less it retains to a greater or less degree a resemblance to the
Shakyamuni of history, if only because he necessarily manifested
in all aspects of his sojourn on earth the idea of Buddhahood in
every aspect of his being. According to tradition the *tathāgata*
himself bequeathed his image to posterity: according to the
Divyāvadāna, King Rudrāyana or Udāyana sent painters to the
Blessed One to take his portrait, but while they were trying in
vain to capture the likeness of the Buddha, he told them that
their (spiritual) laziness was preventing them from succeeding,
and he caused a canvas to be brought on to which he "pro-
jected" his own likeness.[11] This story is very directly reminiscent
of the Christian tradition of the *acheiropoietos* image.[12] Another
story is that a disciple of the *tathāgata* tried in vain to draw his
portrait; he could not manage to seize the right proportions, every
measurement turning out to be too small; in the end the Buddha
commanded him to trace the outline of his shadow projected on
to the ground. The important point in these two stories is that
the sacred image appears as a "projection" of the *tathāgata* him-
self, and we shall return to this aspect of the tradition; as for the
"measure" that eludes human art, it corresponds, like the mea-
sure of the Vedic altar, to essential "form". In this connection
too there is a parallel between the Buddhist conception and a
certain Christian conception: in the Middle Ages the "true mea-
sure" of the body of Jesus was handed down, inscribed on bands
or on columns. Finally from another source we learn that King
Prasenajit of Shrāvastī—or King Udāyana of Kaushāmbī—
caused a statue to be carved in sandalwood from the living
Buddha himself.

Here a few words may be said about the apparently "non-
iconic" character of primitive Buddhist art. On the bas-reliefs
of Sānchī and Amarāvatī, which are among the earliest sculp-
tured monuments of Buddhism, the *tathāgata* is not represented
in his human likeness; his presence in the midst of his disciples
and worshippers is indicated only by emblems such as the sacred
tree adorned with jewels or the wheel of the Law placed on a
throne.[13] However, the absence of portraits carved in stone does
not necessarily involve the absence of portraits carved in wood
nor *a fortiori* of painted icons. It is as if these were different
degrees of artistic exteriorization, a traditional image is to a
certain extent tied to a regularly transmitted technique. The

transposition of a plane image into a carved image involves an increased "objectivation" of the symbol which is not always desirable;[14] this remark applies equally to Christian art.[15]

It is true that an attitude of relative iconoclasm might be expected to follow from the preaching of the Buddha himself, at least from his first sermon, which was public and insists only on the rejection of passions and of their mental concomitants: it outlines Buddhahood, that is to say the transcendent and superhuman nature of a buddha, only indirectly and by the clash of negations. The *Kālingabodhi Jātaka* moreover relates that the Blessed One forbade the erection of a monument (*chetya*) to which worship and the gifts of the faithful might be offered during his absences.[16] But the image given by the Buddha himself, through his miraculous "projection" of himself, is in quite a different category, and the sacred narrative that speaks of the inability of painters to capture by their own efforts the likeness of the *tathāgata*, or to lay hold on his measurements, answers in advance the iconoclastic argument. The sacred icon is a manifestation of the grace of the Buddha, it emanates from his superhuman power, in that it is an expression of his vow not to enter into *nirvāna* without having first delivered all beings from the *samsāra*.[17]

The statement just made appears to be contradictory to the doctrine of *Karma*, according to which salvation is to be found only in the inward denudation that arrests the wheel of births and deaths; it is not possible to lay hold of *Bodhi* from without, by speculation or by the mental assimilation of symbols; but when the waves of passion die, *Bodhi* will shine forth of itself. This however is only one "dimension" of Buddhism, for Buddhism would be neither conceivable nor efficacious without the fascinating example of the Buddha himself, and without the spiritual perfume that emanates from his words and his actions, in short, without the grace which the *tathāgata* spreads abroad in sacrificing his own merits for the good of all beings. This grace, without which it would be impossible for man to surpass himself, is an effect of the original vow of the Blessed One; through this vow his own will broke all its ties with the individual will.[18]

Yet if one considers the matter fully one can see that the two aspects of Buddhism, the doctrine of *Karma* and its quality of

grace, are inseparable, for to demonstrate the real nature of the world is also to transcend it; it is to manifest by implication the changeless states, and it is a breach made in the closed system of becoming. This breach is the Buddha himself; thenceforth all that comes from him carries the influx of *Bodhi*.

In the "golden age" of Buddhism a plastic representation of the *tathāgata* may have been superfluous; it may even have been inopportune in an environment still strongly impregnated with Hinduism. But later on, when the spiritual understanding and the wills of men were weakening, and when a certain cleavage took place between their thoughts and their wills, every means of grace, including the sacred image, became opportune and even indispensable. Such is notably the case with certain formulae of invocation, which are as it were enshrined in the canonical texts; they were, generally speaking, only brought into use at a particular time and under the stimulus of an appropriate inspiration. Similarly, we learn from certain Buddhist sources that such and such an artist, having gained great spiritual merit, was transported into the paradise of Shakyamuni or of Amitābha so that he might record and transmit his image.[19]

The impossibility of proving the historical authenticity of a sacred portrait such as that of the Buddha must be admitted, but this in no way invalidates the truth that the image in its traditional form expresses the very essence of Buddhism; one could even say that it constitutes one of the most powerful proofs of Buddhism.

III

The traditional portrait of the Buddha Shakyamuni is founded partly on a canon of porportions and partly on a description of the distinguishing marks of the body of a buddha derived from the Scriptures (fig. 25).

A diagram of the proportions in use in Tibet[20] shows the outlines of the seated body, not including the head, enclosed within a square that is reflected in the square framing the head; similarly the outline of the surface of the chest, measured from the level of the shoulders to the navel, is reflected, on a scale reduced by a simple proportion, within the square enclosing the face. Measurements on a descending scale regulate the height of the

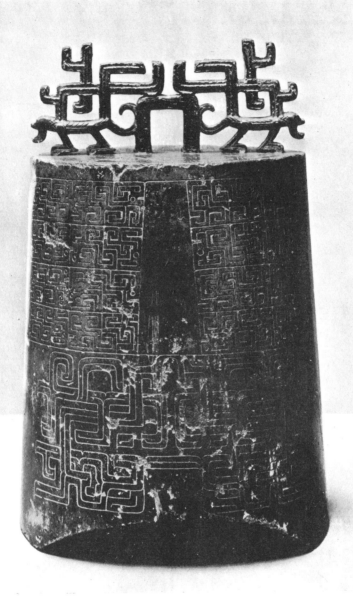

Plate XV. Sacred bell adorned with meanders. Early Han period

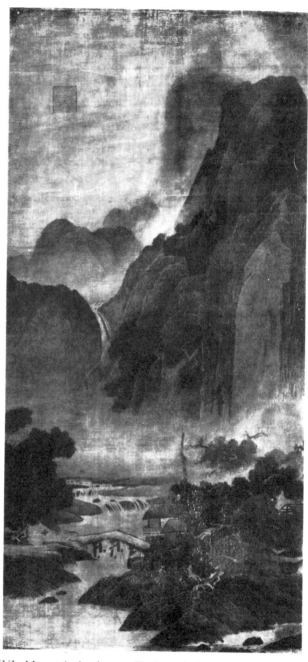

Plate XVI. Mountain landscape. Taoist painting attributed to Fan K'uan
Period of the Sung Dynasty

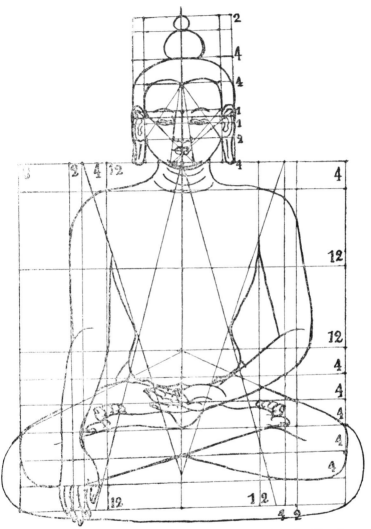

Fig. 25. Diagram of the proportions of the "true image" of the Buddha, from a drawing by a Tibetan artist

torso, the face and the sacred protuberance on the crown of the head. The proportions prescribed in this diagram, of which variants may exist, ensure the static perfection of the figure as a whole, and an impression of unshakable and serene equilibrium.

There is a hidden analogy between the human image of the Buddha and the shape of the *stupa*, the shrine holding a relic. The *stupa* may be considered as representing the universal body of the *tathāgata* : its various levels or storeys, square below and more or less spherical above, symbolize the multiple planes or levels of existence. The same hierarchy is reflected on a smaller scale in the human image of the Buddha, whose torso is like the cubical part of the *stupa*, while his head, crowned with the protuberance of "buddhahood", corresponds to the cupola surmounted by a pinnacle.

The gestures of the hands are derived from the science of *mudrās*, inherited by Buddhism from Hinduism. Generally speaking the symbolism of gestures is based on the fact that the right hand corresponds quite naturally to the active pole of the universe or of the soul, while the left hand represents the passive or receptive pole. The polarity is that of essence and substance, of *Purusha* and *Prakriti*, of Heaven and Earth, of Spirit and psyche, of will and sensibility, etc. The relation of the positions of the two hands can therefore express at the same time a fundamental aspect of the doctrine, a state of the soul and a phase or an aspect of the cosmos.

The image of the Buddha retains some of his personal characteristics, scrupulously preserved by tradition; these are superimposed on a hieratic type, the general form of which is more or less defined or fixed, and is more in the nature of a symbol than a portrait. In the eyes of Far Eastern peoples, who received the traditional image of the Buddha from India, that image always retains certain specifically Indian racial characteristics, even though Chinese and Japanese replicas of the very same icon betray their Mongol origin. Moreover an assimilation to the Mongoloid type detracts in no way from the original expression of the image, quite the contrary : its look of imperturbable calm, of static plenitude and of serenity is reinforced by this reconciliation of races. It could also be said that the spiritual norm of which the sacred image of the Buddha is the vehicle, is communicated to the spectator as a psycho-physical attitude highly char-

acteristic of the congenital demeanour of Mongol peoples of the Buddhist faith. In all this there is something like a magical relationship between the worshipper and the icon : the icon penetrates the bodily consciousness of the man, and the man as it were projects himself into the image; having found in himself that of which the image is an expression, he transmits back to it a subtle power which then shines forth on others.

Before closing this chapter a further word must be said about the Hellenic influence on the sculpture of the school of Gandhara. The importance of that influence has been often exaggerated, and such effect as it had can only have been towards naturalism; naturalism did indeed threaten at first to overwhelm the hieratic models, but its onset was soon stemmed. Thereafter naturalism survived only within a strictly traditional framework, in the shape of a delicate richness of line or surface, enlivening the work as a whole without disturbing its essential quality in any way. If the Hellenic influence was anything more than a passing accident, it is only in so far as it slightly displaced the artistic plane of expression without altering its essence; it may have been responsible for the change from the painted to the carved sacred portrait.

The door through which Hellenism effected an entry was the apparently philosophical character of Buddhism in its analysis of the world. The teaching of Shakyamuni on the inexorable concatenation of causes and effects, desires and griefs, appeals *a priori* to reason alone; but the theory of *karma,* which is not unrelated to stoicism, is but the shell of the Buddha's message; its kernel is accessible only to contemplation and is out of the reach of all rational thought. The rationalizing shell is more pronounced in the *Hīnayāna*; in the *Mahāyāna* it is as if the presence of the supra-formal kernel had burst the shell. Moreover the sacred images of the *Mahāyāna* have more spiritual breadth than those of the *Hīnayāna* which tend towards formality and grace of ornament.

The painting of the *Mahāyāna* profited to some extent from the subtle techniques of Taoist art : the drawing at once concise and fluid, the restrained delicacy of colouring and the characteristic treatment of clouds and the backgrounds of the landscapes that surround the apparition of a buddha, confer an almost vision-like quality on these pictures; some of them show evidence

of a direct intuition, an intuition that is "personal" or "lived" : they had moreover an effect as of inspired preaching.[21] The Japanese genius, which so easily reconciles spontaneity and severity, has contributed to the creation of some of the most marvellous of works, such as certain images of *Amida* (*Amitābha*) appearing above a lotus like the disc of the sun in an unsullied dawn, or of *Kwannon* gliding over the waters like the full moon at twilight.

The "sacramental" function of the image of the Buddha derives from the fact that the image perpetuates the bodily presence of the Buddha himself, and that it constitutes in a certain sense the indispensable complement of a doctrine made up of pure negations; for if Shakyamuni avoided all mental objectivation of the transcendent Essence, it was because he was thereby enabled to express it all the more fully in the spiritual beauty of his mere existence. Like his revelation of the Way, the economy of his means is also a grace.

Boddhidharma, the patriarch of *Dhyāna*, said : "The essence of things is not describable; to express it words are used. The royal way that leads to perfection is not marked out; in order that initiates may be able to recognise it, forms are used."

NOTES

1. Each of the great spiritual traditions of humanity has a characteristic "economy" of its spiritual means, for it is out of the question that man should make use of all possible supports at the same time, or that he should follow two paths at once, despite the fact that the goal of all paths is fundamentally the same.

A tradition guarantees that the means which it offers are sufficient to guide men towards God or out of the world.

2. The Buddha or the *tathāgata* is he who has attained to total deliverance; the Buddha Shakyamuni is the personage of history, whose individual name was Gautama. The appellation chosen depends on the aspect of Buddhahood under consideration at the time.

3. *Bodhi* is the totally awakened state of being, usually referred to as "Enlightenment". The Tree of *Bodhi* is the world tree under which a Buddha attains to the Supreme Knowledge.

4. Cf. Paul Mus, *Barabudur*, Hanoi, 1935. The "seven steps" of the Buddha, directed towards the different regions of space, recall the movements which the Sioux Indians execute in the *Hanblesheyapi*, the rite of invocation accomplished in solitude on the peak of a mountain (cf. Hehaka Sapa, *op. cit.*).

5. *Mahāyāna* means Great Way and *Hinayāna* (p. 125) Lesser Way, These are the two main divisions of the Buddhist world, the former including China, Japan and Tibet and the latter the more southerly countries. Both accept all the fundamental doctrines of Buddhism, but they differ in their respective "ideals". The Mahāyānic ideal is represented by the *Bodhisattva* (see note 8) whose perspective combines the ideas of ascent towards Enlightenment and sacrificial redescent for the sake of redeeming all suffering beings. In the *Hinayānic* perspective only the first phase is explicit. The difference of emphasis has conditioned the spiritual method, devotional life and art of each school.

6. Inscription of Long-men, quoted by Paul Mus, *op. cit.*, p. 546.

7. According to a *Shingon* iconography, reproduced by Ananda K. Coomaraswamy in *Elements of Buddhist Iconography* (Harvard, 1935), four *tathāgatas* occupy the cardinal regions and four *bodhisattvas* the intermediate regions. The names of the regents of space may vary according to the spiritual plane envisaged.

8. A *bhodisattava* is a being qualified to attain to *nirvāna* in this life.

9. Cf. Henri de Lubac, *Amida,* Ed. du Seuil, Paris, 1955, chap. *"Amitābha et la Sukhavati".*

10. Commentary on the *Lotus Sutra,* quoted by Henri de Lubac, *op. cit.,* p. 284.

11. Cf. Ananda K. Coomaraswamy, *op. cit.,* p. 6.

12. Cf. p. 94.

13. Here again there is a parallel with the oldest emblems of the Christ. On the tympana of church doors the ancient symbolical iconography persisted up to the Romanesque period; there was a reluctance to represent the Christ in human form in such places, but on the other hand the monogram in the shape of a wheel and the tree of life were freely used. The symbol of the "throne made ready" is also found in some Byzantine icons.

14. The notion that the painted image of the Buddha conforms more nearly to the sacred Law than does the carved image recurs in Japan, in the *Jodo-shin-shu* school.

15. Sculptured representations of the Christ appear much later than painted ones.

16. Cf. Ananda K. Coomaraswamy, *op. cit.,* p. 4.

17. Anyone who is surprised at the idea that the Buddha's vow can save "all beings" may well be equally surprised at the dogma according to which the Christ died "for all men". The universal grace actualized by a supreme sacrifice cannot however become operative in either case except where it is welcomed.

18. In theological language one would say that by his vow his will became identified with the Divine Will.

19. Cf. Henri de Lubac, op. cit.

20. Reproduced in *Peaks and Lamas* by Marco Pallis, Cassell, London, 1939.

21. Particularly the images of *Amitabha* painted by Genshin in the tenth century of our era. Cf. Henri de Lubac, *op. cit.,* p. 143.

LANDSCAPE IN FAR EASTERN ART

I

THE subject of Far Eastern landscape painting inevitably brings to mind the masterpieces of the "Southern School", which are distinguished by an exquisite economy in the use of resources and a "spontaneity" in execution, as well as by the use of Indian ink and a technique of washes. The term "Southern" applied to this school carries no geographical implication, it is merely a label for a particular tendency in Chinese Buddhism, and its products really represent Taoist painting in the form in which it was perpetuated within the framework of Chinese and Japanese *dhyana* Buddhism.[1] The "Northern School" will not be considered here. It makes use of precise and detailed outlines, bright opaque colours and gold; in this way it approaches the Indo-Persian miniatures in style.

Far back in Chinese antiquity the whole of Taoist art was summarized in the emblem of a disc perforated in the centre. The disc represents the heavens or the cosmos, the void in its centre the unique and transcendent Essence. Sometimes these discs are decorated with the symbol of the two cosmic dragons, analogous to the complementary principles *Yang* and *Yin*, the "active" and the "passive"; the dragons circle round the hole in the centre as if they were trying to lay hold on the unseizable void. The point of view is the same in landscape paintings of Buddhist (*ch'an*) inspiration, where all the elements, mountains, trees and clouds, are there only in order to emphasize by contrast the void, out of which they seem to have arisen at that very instant, and from which they are detached like ephemeral islets.

In the earliest Chinese representations of landscapes, engraved on metal mirrors, on bowls or on funereal slabs, beings and objects seem to be subordinated to the play of the elements, wind, fire, water and earth. To express the movement of clouds, water and fire, various kinds of curvilinear meander are used;

rocks are conceived as an ascending movement of the earth; trees are defined less by their static outlines than by their structure, which reveals the rhythm of their growth. The cosmic alternation of *Yang* and *Yin*, the active and the passive, is apparent in every form or composition (pl. XV). All this accords with the six maxims formulated in the fifth century of our era by the famous painter Hsieh Ho: 1. The creative spirit must identify itself with the rhythm of the cosmic life; 2. the brush must express the intimate structure of things; 3. the likeness will be established by the outlines; 4. the particular appearances of things will be conveyed by colour; 5. the groupings must be co-ordinated according to a plan; 6. tradition must be perpetuated through the models it provides. From this it can be seen that it is rhythm and its primary expression as linear structure that are the foundations of the work, rather than the static plan and plastic contours of things, as is the case in the traditional painting of the West.

The technique of painting in Indian ink was developed from Chinese writing, itself derived from a real pictography. A Chinese calligraphist uses his brush with his hand unsupported, modulating the line by a movement that starts from the shoulder. It is this method that gives to the painting its quality of fluidity combined with conciseness.

In this style of painting there is no strict perspective, centred on a single point, but space is suggested by a sort of "progressive vision". When looking at a "vertical" picture, hung on the wall at the height of a seated observer, the eye as it were climbs up the steps of the distance, from bottom to top; a "horizontal" picture is unrolled from one end to the other as it is examined, and the eye follows the movement. This "progressive vision" does not separate space completely from time, and for that reason it is nearer to the truth of experience than is a perspective artificially arrested on a single "viewpoint". Moreover all traditional arts, whatever their methods, work towards a synthesis of space and time.

Although Tao-Buddhist painting does not indicate the source of light by the play of light and shade, its landscapes are none the less filled with a light that permeates every form like a celestial ocean with a pearly lustre: it is the beatitude of the Void (*shūnya*) that is bright through the absence of all darkness.

The composition is made up of allusions and evocations, in

accordance with this saying from the Tao Te King: "The great-
est perfection must appear imperfect, and then it will be infinite
in its effect; the greatest abundance must appear empty, and
then it will be inexhaustible in its effect." Never does a Chinese
or Japanese painter represent the world in the likeness of a
finished cosmos, and in this respect his vision is as different as
possible from that of a Westerner, even of a traditional West-
erner, whose conception of the world is always more or less
"architectural". A Far Eastern painter is a contemplative, and
for him the world is as if it were made of snowflakes, quickly
crystallized and soon dissolved. Since he is never unconscious of
the non-manifested, the least solidified physical conditions are for
him the nearer to the Reality underlying all phenomena; hence
the subtle observation of atmosphere that we admire in Chinese
paintings in ink and wash.

Attempts have been made to relate this style to European im-
pressionism, as if the starting points of each were not radically
different, despite certain accidental analogies. When impression-
ism relativizes the characteristic and stable contours of things
in favour of an instantaneous effect of atmosphere, it is because
it is seeking, not the presence of a cosmic reality superior to in-
dividual objects, but on the contrary a subjective impression as
fleeting as it could be; in this case it is the ego, with its wholly
passive and affective sensibility, that colours the scene. Taoist
painting on the contrary avoids from the start, in its method and
in its intellectual orientation, the hold of mind and feeling, avid
as they are of individualistic affirmations; in its eyes the instan-
taneity of nature, with all its inimitable and almost unseizable
qualities, is not in the first place an emotional experience; that
is to say the emotion found in nature is not in any way in-
dividualistic nor even homocentric; its vibration dissolves in the
serene calm of contemplation. The miracle of the instant, im-
mobilized by a sensation of eternity, unveils the primordial
harmony of things, a harmony that is ordinarily hidden under
the subjective continuity of the mind. When this veil is suddenly
torn, hitherto unobserved relationships, linking together beings
and things, reveal their essential unity. A particular painting may
represent, for instance, two herons on the bank of a stream in
springtime; one of them gazes into the depths of the waters, the
other holds up his head listening, and in their two momentary

yet static attitudes they are mysteriously at one with the water, with the reeds bent by the wind, with the mountain tops appearing over the mist. By way of a single aspect of virgin nature, the timeless has touched the soul of the painter like a lightning stroke.

II

Though full of suggestiveness, this art exists in the first place for the painter himself; it is a method for actualizing contemplative intuition, and it is as such that it has been assimilated and developed by the *dhyana* Buddhism of the Far East, which can itself be regarded as a synthesis of Taoism and Buddhism. *Dhyana* Buddhism can however be acquitted of eclecticism, because the confluence of the two traditions is based on a fully orthodox identification of the Buddhist notion of universal Void (*shūnya*) with the Taoist notion of Non-Being; this Void or Non-Being leaves its mark at different levels of reality as non-determination, non-form and non-corporeity.

The technique of painting in Indian ink, with its calligraphy made up of flowing signs that are perfectly crystallized only through the workings of a superlative insight, is in harmony with the intellectual "style" of *dhyana* Buddhism, which seeks with all its resources to provoke, after an internal crisis, a sudden release of illumination, the Japanese *Satori*. The artist following the *dhyana* method must therefore practise calligraphic painting until he has mastered it, and then he must forget it. Similarly he must concentrate on his subject, and then detach himself from it; then alone will intuition take charge of his brush.[2]

It should be noted that this artistic procedure is very different from that adopted in the other and hieratic branch of Far Eastern Buddhist art, which derives its models from India and concentrates on the sacred image of the Buddha. Far from postulating a sudden flash of intuition, the creation of an "icon" or a statue of the Buddha is essentially founded on the faithful transmission of a prototype; it is well known that the sacred image incorporates proportions and special signs attributed by tradition to the Buddha of history. The spiritual efficacy of this art is safeguarded by the singleness of its aim and the almost changeless character of its forms. The intuition of the artist may bring out certain qualities implicit in his model, but adherence

to tradition and faith suffice to perpetuate the sacramental quality of his art.

To return to the painting of landscapes, the unalterable rules of the art are less concerned with the object to be represented than with the artistic procedure as such. Before concentrating on his work, or more exactly on his own essence empty of images, the disciple of *Zen* must prepare his instruments in a particular way and arrange them as for a rite; the formality of his gestures precludes in advance the intrusion of any individualistic "urge". Creative spontaneity is thus actualized within a consecrated framework.

The two figurative arts just mentioned have this in common, namely that they both express primarily a state of being at rest in itself. This state is suggested in the hieratic art by the attitude of the Buddha or *bodhisattva* and by forms that are saturated with an interior beatitude, whereas the landscape paintings express it through an "objective" content of consciousness, a contemplative vision of the world. This "existential" quality in Buddhist art could be said to counter-balance the negative form of the doctrine.

Meditation on the visible earth and sky is no doubt an inheritance from Taoism; under the changing face of the elements lies hidden the great Dragon who rises from the waters, leaps towards the sky and is manifested in the storm; nevertheless visual meditation as such has a starting-point in Buddhism which indeed is the same as the starting-point of *dhyana* itself. According to the particular tradition associated with that way, the *dhyana* method arose out of the "sermon of the flower": appearing one day before his disciples as if intending to expound the doctrine to them, the Buddha held up a flower without saying a word. The monk Mahākāshyapa alone, the first patriarch of *dhyana*, understood his purpose and smiled up at the Master, who said to him "I hold the most precious treasure, spiritual and transcendental, which at this moment I transmit to you, venerable Mahākāshyapa".[3]

III

The method of *dhyana*, which finds its direct reflection in art, comprises an aspect that has given rise to many false assimila-

tions: namely, the part played in it by the unconscious, or more precisely "non-conscious" modalities of the soul. It is important not to confuse the "non-consciousness" (*Wu-nien*) or the "non-mental" (*Wu-hsin*) of *dhyana* Buddhism[4] with the "sub-conscious" of modern psychologists, for the state of intuitive spontaneity actualized by the *dhyana* method is evidently not *beneath* normal individual consciousness, but is on the contrary *above* it The true nature of being is "non-conscious" because it is neither "conscious" in the sense of possessing a distinctive intelligence nor "unconscious" and obscure like the inferior prolongations of the soul which constitute the subconscious. Nevertheless, from the point of view of method, the domain of "non-consciousness" includes by virtue of a certain symbolical relationship, the "unconscious" in its aspect of potentiality; this aspect is situated on the same level as instinct. The individual polarization of the intelligence creates a contrast between the fragmented and changing daylight of distinctive consciousness and the undifferentiated night of "non-consciousness", and thereafter "non-consciousness" covers the degrees of unitive knowledge (*Prajnā*) as well as the subtle affinities that exist, on a lower plane, between the soul and its cosmic environment. It is not the passive and obscure sub-conscious—the domain of chaotic residues[5]—that concerns us here, for the psychological "non-conscious" is in this case identified with the plastic power of the soul; this plastic power is in a sense related to nature conceived as the great material storehouse of forms. Engrossment by the mind, or more exactly by interested and anxious thought, prevents the "instinctive" faculties of the soul from unfolding in all their original generosity;[6] it will be seen that this touches closely on artistic creation. When sudden illumination, *Satori*, pierces the individual consciousness, the plastic power of the soul responds spontaneously to the supra-rational action of *Prajnā,* just as in nature at large all movements are apparently unconscious, while in reality they are obedient to universal Intelligence.

Nature is like a blind man who acts in the same way as a man gifted with sight; its "unconsciousness" is but a contingent aspect of universal "non-consciousness". In the eyes of a *dhyana* Buddhist the non-mental character of virgin nature, of minerals, plants and animals, is as it were their humility before the unique Essence, which surpasses all thought. That is how a natural land-

scape with its cyclical transformations unveils for him the alchemy of the soul; the motionless plenitude of a summer day and the crystalline clearness of winter are like the two extreme states of the soul in contemplation; the tempest of autumn is the crisis, and the glittering freshness of spring corresponds to the spiritually regenerated soul. It is in this sense that one must understand the paintings of the seasons by a Wu Tao-Tsu or a Huei-Tsung.

IV

The sister art to landscape painting in the Far East is the art of siting houses, temples and cities in the most propitious manner in any particular natural setting. This art, which has been codi- fied in the Chinese doctrine of "wind and water", the *Feng-shui*, is a form of sacred geography. Based on a science of orientation, it is a complete art in itself, directed to the conscious modifica- tion of certain elements in the landscape, with a view to actualiz- ing its positive qualities and neutralizing evil influences arising out of the chaotic aspects of nature.

This branch of the ancient tradition of China was also assimi- lated by *dhyana* Buddhism, which becomes *Zen* in Japan, where it has been developed to a state of perfection, and where inter- iors of an extreme sobriety are set against the natural variety of gardens and hills, which can be excluded or admitted by moving light side-walls. When the side-walls of a pavilion or a room are shut, there remains nothing to distract the mind; a diffused light filters through the paper windows; the surroundings of the monk sitting on his mat are harmonious and simple, and lead him towards the "void" of his own Essence; by contrast, when he moves the walls aside, his attention is turned towards his natural surroundings, and he contemplates the world as if he were seeing it for the first time. He will then see the original formation of the landscape and its vegetation combined with the art of the gardener, who knows how to efface himself before the genius of nature while at the same time shaping it accord- ing to an overriding inspiration. Inside the room, where order and cleanliness prevail, every form bears witness to that intel- lectual objectivity which sets things in order while respecting the nature of each; to each of the primary materials, cedar

wood, bamboo, reeds and paper, is accorded its proper value with a judicious discrimination; the geometrical rigidity of the general effect is mitigated here and there by a pillar roughly shaped with an axe or a curved beam like an untamed mountain tree; by these means poverty is allied to nobility, originality to clarity, primordial nature to wisdom.

In such an environment the arbitrariness of individuality, with its passion and its boredom, have no place; here the changeless law of the Spirit prevails, and with it the innocence and beauty of nature.

V

Landscape in the eyes of a Chinese is "mountain and water". The mountain or the rock represents the active or masculine principle, *Yang*, and the water corresponds to the feminine and passive principle, *Yin*. The complementary nature of the two is expressed most plainly and richly in a waterfall, the first choice of *dhyana* painters as a subject. Sometimes it is a cascade of several stages, hugging the side of a mountain in springtime, sometimes a single jet dropping from the cliff's edge, or a strong spate, like the famous cascade of Wang-Wei which appears from the clouds and disappears into a veil of foam in one great leap, so that the spectator soon feels that he is himself being swept onwards in the swirl of the elements.

Like every symbol, that of the waterfall veils Reality while at the same time revealing it. The inertness of a rock is the inverse of the immutability appertaining to the celestial or divine act, and similarly the dynamism of the water veils the principial passivity of which it is the expression. Nevertheless, through an attentive contemplation of rock and waterfall, the spirit eventually brings about a sudden integration. In the endless repeated rhythm of the water, hugging the motionless rock, it recognizes the activity of the immutable and the passivity of the dynamic; from that point it lifts its gaze, and in a sudden illumination it catches a glimpse of the Essence which is at once pure activity and infinite repose, which is neither motionless like rock nor changeable like water, but inexpressible in Its reality empty of all forms (pl. XVI).

NOTES

1. The Sanskrit word *dhyana* means "contemplation". Its Chinese equivalent is *ch'an-na* or *ch'an*, and Japanese *zenna* or *zen*. Cf. Daisetz Teitaro Suzuki, *Essays in Zen Buddhism,* Third Series, Rider [1949-53]; and E. Steinilber-Oberlin.

2. A similar method is applied in the art of archery. See the excellent book by E. Herrigel (Bungaku Hakushi), *Zen in the Art of Archery.* Routledge and Kegan Paul, London, 1953.

3. Cf. Daisetz Teitaro Suzuki, *Essais sur le Bouddhisme Zen,* collection *Spiritualités Vivantes,* Paris, Albin Michel, 1953, Vol. 1, p. 215 sqq.

4. Cf. Daisetz Teitaro Suzuki, *The Zen Doctrine of No Mind,* London, Rider [1949].

5. There is a modern psychological school which defines the "collective subconscious" as an entity not directly accessible to scientific investigation—since the unconscious cannot as such become conscious—but such that its latent propensities, improperly called "archetypes", can be inferred from certain irrational "outbursts" of the soul; the "abrupt" illumination of *Zen* seems to corroborate this last definition. Using this hypothesis, the "collective subconscious" has been made into a sort of elastic container, wherein everything that does .ot simply belong to the physical or rational orders can find a place, even intuition and faculties such as telepathy and premonition. At least that is the idea; but in reality psychological research still continues to be restricted, in this case as in other, by the point of view adopted by psychologists. Anyone who scrutinizes, dissects and classifies cannot but place himself, with or without good reason, "above" the object of his study; for this reason his object is necessarily less than himself, that is to say, less than his mind, which in its turn is limited by the categories of science. If the "subconscious" were really the ontological source of individual consciousness, that consciousness could never put itself into the position of a detached and "objective" observer with respect to its own source; the "unconscious" that can become in an indirect way an object of scientific investigation will therefore always be a "subconscious", that is to say, a sub-human reality, normal or unhealthy as the case may be. If this "subconscious" contains any ancestral psychic tendencies, they can only be purely passive in character; they must not be confused with the supra-mental sources of traditional symbolism, of which they are at most shadows or residues. A psychologist who seeks to study the "religious phenomena of the soul" by reference to the subconscious will therefore only get hold of their inferior psychic concomitants.

6. Thus it is that in the art of archery inspired by *Zen* the target is hit though the archer has not directed his aim at it. The interference of discursive thought clogs natural genius; an illustration of this is the Chinese fable of the spider who asks the millipede how he manages to walk without tangling up his feet; the millipede begins to think, and suddenly he cannot walk any more. . . .

THE DECADENCE AND THE RENEWAL OF CHRISTIAN ART

I

A WORK of art, if it is to be of spiritual import, need not be a "work of genius"; the authenticity of sacred art is guaranteed by its prototypes. A certain monotony is in any case inseparable from traditional methods: amid all the gaiety and pageantry that are the privilege of art, this monotony safeguards spiritual poverty—the non-attachment of the "poor in spirit" (Matt. v. 3) —and prevents individual genius from foundering in some sort of hybrid monomania; genius is as it were absorbed by the collective style, with its norm derived from the universal. The genius of the artist interprets sacred models in a manner that may be either more or less qualitative; genius is manifested in any particular art in that way and no other; instead of squandering itself in "breadth", it is refined and developed in "depth". One need only think of an art such as that of ancient Egypt to see clearly how severity of style can itself lead to an extreme of perfection.

If this background is kept in view, it becomes possible to understand the fact that at the time of the Renaissance artists of genius were "revealed" almost everywhere, suddenly and with an overflowing vitality. The phenomenon is analogous to what happens in the soul of one who abandons a spiritual discipline. Psychic tendencies that have been kept in the background suddenly come to the fore, accompanied by a glittering riot of new sensations having all the attractiveness of possibilities not yet fully explored; but they lose their fascination as soon as the initial pressure on the soul is relaxed. Nevertheless, the emancipation of the "ego" being thenceforth the dominant motive, individualistic expansivity will continue to assert itself; it will conquer new planes, relatively lower than the first, the difference in psychic "levels" acting as the source of potential energy.

That is the whole secret of the Promethean urge of the Renaissance.

It must however be made clear that the psychic phenomenon described is not in every respect parallel to a collective phenomenon such as the Renaissance, since the individual implicated in a collective collapse of that kind is not directly responsible for it, hence his relative innocence. Genius in particular often partakes of the quasi "natural" or "cosmic" innocence of the psychic forces that are unlocked by the great crises of history; indeed that innocence is what makes the charm of genius. It does not however make its influence any less pernicious on one plane or another.

For the same reason, in every work of real genius—in the current and individualistic sense of the word—there are real values previously unperceived or neglected. Such is necessarily the case, since every traditional art is obedient to a particular spiritual economy that sets limits to its themes and to the means used for their expression, so that an abandonment of that economy almost immediately releases new and apparently boundless artistic possibilities. None the less, such new possibilities can never thereafter be co-ordinated with respect to a single centre; they will never again reflect the amplitude of the soul at rest within itself, in its "state of grace"; their tendency being centrifugal, their various modalities of vision and expression will be mutually exclusive and will succeed one another with ever-growing rapidity. Such in fact are the "stylistic periods", the dizzy succession of which is so characteristic of the European art of the last five centuries. Traditional art has not this dynamism, but it is not for that reason "frozen": the traditional artist, protected by the "magic circle" of sacred form, creates both like a child and like a sage: the models he reproduces are symbolically timeless.

In art as in everything else man finds himself faced by the following alternative: he must seek the Infinite in a relatively simple form, keeping within the limits of that form and working through its qualitative aspects, while sacrificing some possible developments, or he must seek the Infinite in the apparent richness of diversity and change, though it must lead in the end to dispersion and exhaustion.

The economy of a traditional art can however be either more

or less broadly based, it can be flexible or rigid; everything depends on the power of spiritual assimilation inherent in a particular civilization or environment or collective vocation. In the same way racial homogeneity and historical continuity have a part to play : millennial civilizations like those of India and China have been able, spiritually speaking, to integrate very diverse artistic possibilities that are sometimes very close to naturalism, without losing their unity. Christian art was less broadly based; the residues of a pagan art jostled it, so that it had to defend itself against their dissolving influence; but before that influence could prevail, its comprehension of traditional symbolism had first to become blurred. Nothing but an intellectual decadence, and more particularly a weakening of contemplative vision, can explain why medieval art later came to be regarded as "barbarous", clumsy and poor.

Among the possibilities excluded by the spiritual economy of traditional Christian art is the representation of the nude. There are many representations of the Christ crucified, as well as of Adam and Eve and of souls in hell or purgatory, but their nudity is as it were abstract and does not engage the attention of the artist. However that may be, the "rediscovery" of the naked body, considered as such and in its natural beauty, provided without doubt one of the most powerful springs of action of the Renaissance. So long as Christian art conserved its hieratic forms, surrounded by a folk-lore of decoration far removed from any concern with naturalism, the absence of the nude in art passed unnoticed, so to speak; icons were made, not to reveal this or that natural beauty, but to recall theological truths and to be the vehicles of a spiritual presence. As for the beauty of nature, of mountains, forests or human bodies, it could be admired everywhere, outside the domain of art, all the more so because prudery, which grew up only with the urban culture of the fourteenth century, did not obsess the soul of the Middle Ages. Thus it was only when art began to try to imitate nature that the absence of "nudism" in medieval art came to be felt as a gap; but thereafter the absence of any representation of the naked body could only be taken for prudery, and by the same stroke the example of Graeco-Roman statuary, never entirely outside the purview of the Middle Ages, became an irresistible temptation. In this connection the Renaissance appears as a cosmic retribution. It seemed

dangerous to banish human beauty, made as it is in the image of
God, from the plastic arts—if indeed they already existed
but on the other hand one must not lose sight of the maleficent
symbolism of "the flesh" in the Christian perspective and of the
associations of ideas that might arise from it. However that may
be, one can certainly not look to the Renaissance to confer afresh
on physical beauty the sacred significance it held in certain
ancient civilizations and still retains in India. The earliest and
the most beautiful statues of the Renaissance for example the
Fonte Gaia of Jacopo della Quercia or the *David* of Donatello,
have a tenderness that is still quite springlike, but they soon
gave place to a Graeco-Roman rhetoric devoid of content, and to
a passionate expansivity which is "amplitude" only to a spirit
bound to "this world". Nevertheless it sometimes happens that
Renaissance Sculpture is superior in qualities of nobility and
intelligence to that of classical antiquity, and this can no doubt
be explained by the influence of Christian experience, but it is
by no means enough to confer on "renascent" art the smallest
trace of traditional authenticity.

Similar considerations apply to the discovery of landscape in
fourteenth century painting, as well as, much later on, that of
the "open air", the play of atmosphere and light. As subjects of
artistic expression, each of these contains values precious in them-
selves and susceptible of becoming symbols—they function as
symbols in other arts, particularly in the Far East—but Western
art had discarded its sacred models, thus losing its internal hier-
archy, the formal principle of its attachment to the source of
tradition. Indeed the thing that makes the "desecration" of art
final and in a sense irreversible is not so much the choice of
themes or subjects as the choice of formal language or "style".

There could be no better illustration of this law than the intro-
duction into "renascent" painting of mathematical perspective,
which is nothing but a logical expression of the individual point
of view, that of the individual subject who takes himself as the
centre of the world. For if naturalism seems to capture the
visible world as it is in its "objective" reality, it is because it
has first projected the purely mental continuity of the individual
subject on to the outer world. It makes that world poor and
hard and empty of all mystery, whereas traditional painting is
limited to the transcription of symbols, while leaving to reality

its own unfathomable depths. It is mathematical perspective, be it noted, centred on a single point that is here in question, and not a perspective of approximation, modified by occasional trans-locations of the optical centre; such a perspective is not irreconcilable with an art having a spiritual foundation, for its purpose is not illusion but narrative coherence.

In the case of painters like Andrea Mantegna and Paolo Uccello the science of perspective became a real mental passion, a cold passion perhaps, and one not far removed from intellectual research, but destructive of pictorial symbolism : through perspective the picture becomes an imaginary world, and at the same time the world becomes a closed system, opaque to every gleam of the supernatural. In mural painting a mathematical perspective is in reality absurd, for it not only destroys the architectural unity of the wall, but it also obliges the spectator to place himself on the imaginary visual axis, on pain of subjecting all the forms to a false foreshortening. In much the same way architecture is stripped of its most subtle qualities when the purely geometrical proportions of medieval art are replaced by arithmetical, and therefore relatively quantitative, proportions; in this respect the prescriptions of Vitruvius did much harm. These things serve incidentally to show up the pedantic character of the Renaissance : in losing its attachment to Heaven, it loses also its link with the earth, that is to say, with the people and with the true tradition of the crafts.

A rigorous perspective in painting inevitably involves a loss of chromatic symbolism, since colour is called upon to represent an illumination indispensable to the production of an illusion of space, and so loses its direct nature. A medieval painting is luminous, not because it suggests a source of light situated in the world depicted, but because its colours directly manifest qualities inherent in light; they are touches of the primordial light that is present in the heart. The development of chiaroscuro on the contrary turns colour into nothing more than the play of an imaginary light; the magic of lighting carries painting into a sort of intermediate world analogous to a dream, a dream sometimes grandiose, but one that envelops the spirit instead of liberating it. It is Baroque art that took this development to an extreme, until at last spatial forms, suggested by chiaroscuro, lose the almost tangible corporeity conferred on them in Renaissance

painting; at this point colour seems to acquire a quality of autonomy, but it is colour lacking in sincerity, almost feverish, with a sort of phosphorescence that ends by devouring forms like a smouldering fire. Finally the normal relationship between form and colour is reversed, so that it is no longer form, the graphic outline, that gives meaning to colour, but it is colour that produces by its gradation an illusion of volume.

II

So far as post-medieval sculpture is concerned, its illogicality —and its consequent incapacity to give expression to transcendent essences—resides primarily in the fact that it tries to capture instantaneous movement, while its own material is static. Traditional sculpture accepts movement only in some of its more typical phases, themselves reduced to static formulations. A traditional statue, be it Romanesque, Hindu, Egyptian or otherwise, always affirms the motionless axis; it dominates its environment by co-ordinating it ideally to the plan of the three-dimensional cross. With the coming of the Renaissance, and still more of the Baroque, the "sense of space" becomes centrifugal; in the works of Michelangelo for instance it is like a spiral that "devours" space; his works dominate the surrounding void, not because they relate it back to its centre or to its omnipresent axis, but because they project into it their suggestive power, their magic spell.

At this point a possible misunderstanding must be forestalled. Autonomous statuary is a product of the Renaissance, or more exactly its rediscovery is so; statuary detached from the body of a building is scarcely known in Christian medieval art. Sculpture treated like an independent column, thus dominating an architectural environment or a landscape controlled on architectural principles, is fully in the spirit of Graeco-Roman art; in Christian art any such isolation of a sculptured figure would be near to idolatry. The fact is that sculpture expresses more completely than any other plastic art the principle of individuation, for it participates directly in the separative character of space; this quality is accentuated in a statue that is open on all sides. Christian art does not allow any such autonomy except to certain objects connected with its worship, such as statues of the Virgin,

crucifixes or figured reliquaries. Statues which are not liturgical objects, such as those that adorn cathedrals, are almost always incorporated into the building; for the individual human form does not realize its full import save through its attachment to the form, both human and universal, of the Incarnate Word, and that form is represented by the sacred edifice, "mystical body" of the Christ.

There is of course nothing absolute about this way of looking at things, nor is it common to all traditions. In Hindu art for example the independent statue is admitted; if one considers the principles of *Yoga* and the point of view it adopts towards the Divine Presence in man, it becomes clear that this must be so. Nevertheless, a close linkage between sacred sculpture and sacred architecture also exists in Hindu art, and is even one of the aspects of that art that bring it nearest to the art of the cathedral.

The question of statuary leads back to the subject that is fundamental to Christian art: the image of man. In the first place it is the image of God made man, and afterwards that of man integrated in the Word, which is God. In the second case the individual form of man recovers its original beauty by the very fact that it is reintegrated in the beauty of the Incarnate Word; this is expressed in the faces of the saints and prophets on the doors of cathedrals: the Face of the Christ contains them, they rest in Its "form".

In his masterly work *Verlust der Mitte* ("The Loss of the Centre") Hans Sedlmayr has shown how the decadence of Christian art, right up to its most recent phases, is above all a decadence of the image of man: the image of God made man, transmitted by medieval art, is succeeded by the image of autonomous man, of man glorifying himself, in the art of the Renaissance. This illusory autonomy implies from the first the "loss of the centre", for man is no longer truly man when he is no longer centred in God; thereafter the image of man decomposes; first it is replaced, so far as its dignity is concerned, by other aspects of nature, and then it is progressively destroyed; its systematic negation and disfigurement is the goal of modern art.

Here again we can discern a sort of "cosmic retribution". Just as the Incarnation of the Word has its corollary in the

supreme sacrifice, and as the "imitation of Christ" is not con-
ceivable without asceticism, so the representation of the Man-God
demands a "humility" in the means employed, that is to say,
an emphasis on their remoteness from the Divine model. There
is thus no true Christian art without a certain degree of "abstrac-
tion", if indeed it be permissible to use so equivocal a term to
designate that which really constitutes the "concrete" character,
the "spiritual realism", of sacred art. In brief : if Christian art
were entirely abstract it could not bear witness to the Incarnation
of the Word; if it were naturalistic, it would belie the Divine
nature of that Incarnation.

III

Like the bursting of a dam the Renaissance produced a cascade
of creative forces; the successive stages of this cascade are its
psychic levels; towards its base it broadens out and at the same
time loses unity and force.

The imminence of its release can up to a point be discerned
in advance of the Renaissance properly so called, in Gothic art.
The state of equilibrium is represented in the West by Roman-
esque art and in the Christian East by Byzantine art. Gothic art,
more particularly in its latest phase, presents a one-sided develop-
ment, a predominance of the volitive element over the intellec-
tual, an urge rather than a state of contemplation. The
Renaissance can be looked upon as a reaction, both rational and
Latin, against this precarious development of the Gothic style.
Nevertheless, the passage from Romanesque to Gothic art is
continuous and without a break, and the methods of Gothic art
remain traditional—they are founded on symbolism and ôn
intuition—whereas in the case of the Renaissance the break is
almost complete. It is true that all branches of art do not run
parallel; for instance Gothic architecture remains traditional
until it disappears, whereas late Gothic sculpture and painting
succumbed to the naturalistic influence.

And so the Renaissance rejects intuition, brought to light
through the symbol, in favour of discursive reasoning; its dis-
cursiveness evidently does nothing to prevent its being passional;
on the contrary, for rationalism and passion go very well
together. As soon as man's centre, the contemplative intellect or

the heart, is abandoned or darkened, his other faculties are divided among themselves, and psychological oppositions appear. Thus, Renaissance art is rationalistic—this is expressed in its use of perspective and in its architectural theory—and at the same time passional, its passion being comprehensive in character, and amounting to a general affirmation of the ego, a thirst for the big and the unrestricted. While the fundamental unity of vital forms still persists in one way or another, the opposition of faculties continues to look like their free play; it does not yet seem to be irreducible, as it does in later times, when reason and feeling are separated by such a distance that art cannot hold them both at once. At the time of the Renaissance the sciences were still called arts, and art appears as a science.

Nevertheless, the cataract had been released. The Baroque reacted against the rationalism of the Renaissance, the imprisonment of forms within Graeco-Roman formulae, and their consequent dissociation. But instead of overcoming these weaknesses by means of a return to the super-rational sources of tradition, the Baroque sought to melt the congealed forms of the renascent classicism in the dynamism of an uncontrolled imagination. It takes readily to itself the later phases of Hellenistic art, which however display an imagination much more controlled, much calmer and more concrete; the Baroque is animated by a psychic anxiety unknown to antiquity.

Baroque art is sometimes worldly and sometimes "mystical", but in neither case does it penetrate beyond the world of dreams; its sensual orgies and its gruesome *memento mori* are both but phantasmagoria. Shakespeare, who lived on the threshold of that epoch, could say that the world was of "the stuff that dreams are made of"; Calderon de la Barca, in *Life is a Dream* implicitly says the same thing; but both he and Shakespeare stood far above the level on which the plastic art of their time was developed.

The protean power of imagination has a certain part to play in most traditional arts, notably that of India, where however it corresponds symbolically to the productive power of *Māyā*, the cosmic illusion. To a Hindu the Proteism of forms is not a proof of their reality, but on the contrary of their unreality with respect to the Absolute. This is by no means true of Baroque art, which loves illusion; the interiors of Baroque churches, such

as Il Gesù or St. Ignatius in Rome, produce an effect of hallu-
cination; their cupolas with concealed bases and irrational curves
elude every intelligible standard of measurement. The eye seems
to be led into the abyss of a false infinity, instead of being at
rest in a simple and perfect form; the paintings on the ceiling
appear to lie open towards a sky full of sensual and mawkish
angels . . . An imperfect form can be a symbol, but illusion and
falsity are symbols of nothing.

The best plastic creations of the Baroque style are found out-
side the domain of religion, in squares and fountains. Here
Baroque art is both original and unsophisticated, for it has in
itself something of the nature of water, like imagination; it is
fond of conches and marine fauna.

Parallels have been drawn between the mysticism of a St.
Teresa of Avila or a St. John of the Cross and a particular
contemporary style of painting, that of El Greco for example;
but such comparisons are justified at the most by the psycho-
logical conditions of the period and more particularly by its
religious atmosphere. It is true that this style of Baroque painting,
with its magical effects of light, lends itself to the description of
affective states that are extreme and exceptional; but all this
bears no relation to contemplative states. The very language of
Baroque art, its identification with the psychic world, and with
all that mirage of sentiment and imagination, precludes it
grasping the qualitative content of a spiritual state.

Mention should however be made, while considering examples
of the Baroque style, of the strange reality of certain miraculous
Madonnas. In their "modernized" forms they have generally
been transformed by the hieratic costumes conferred on them by
the people, enormous triangles of stiff silk and heavy crowns;
only the face still exemplifies the Renaissance or Baroque style,
but in the face realism, carried to an extreme by the tinting of
features animated by the vacillating light of candles, assumes
the quality of a tragic mask. Here is something much more closely
connected with sacred drama than with sculpture, reconstituted
instinctively by the people, and appearing side by side with the
art of the period and in spite of it.

There are those for whom Baroque art represents the lasts
great manifestation of the Christian vision of the world. This is
no doubt because the Baroque is still aspiring towards a synthesis;

it is even the last attempt at a synthesis of Western life on a foundation of any breadth. None the less, the unity it achieves proceeds rather from a totalitarian volition, melting everything into its own subjective mould, than from an objective co-ordination of things in the light of a transcendent principle, as was the case in medieval civilization.

In the art of the seventeenth century the Baroque phantas-magoria congeals into rationally defined forms that are empty of substance; it is as if the surface of the lava of passion had been coagulated into a thousand hardened shapes. All later stylistic phases oscillate between the same two poles of passional imagina-tion and rational determinism, but the strongest oscillation is still that which took place between the Renaissance and the Baroque, all those that followed being weaker. But from another point of view, it is in the Renaissance and the Baroque con-sidered as whole that the reaction against the traditional inheri-tance was manifested with the greatest violence; for by degrees, as art becomes historically farther removed from this critical phase, it recovers a certain calm, a certain, though very relative, disposition towards "contemplation". At the same time it will be observed that aesthetic experience is fresher, more immediate and more authentic precisely when it is most remote from religious subjects: in a particular "Crucifixion" of the Renais-sance, for example, it may not be the sacred drama but the land-scape that manifests the higher artistic qualities; or in a particular "Entombment" of the Baroque it may be the play of light that is the real theme of the work—that is to say, the thing that uncovers the soul of the artist—while the persons represented are secondary. This is as much to say that the hierarchy of values has collapsed.

Throughout the whole course of this decadence the individual quality of the artist is not necessarily the point at issue; art is above all a collective phenomenon, and men of genius who stand out from the crowd can never reverse the direction of an entire movement; at the most they can only accelerate or maybe slow up certain rhythms. The judgements here passed on the art of the centuries that followed the Middle Ages never take as a term of comparison the art of our times; that goes without saying. The Renaissance and the Baroque had a scale of artistic and human values incomparably richer than anything that can be

met with today. A proof of this, if proof were needed, is the progressive destruction of the beauty of our towns.

In every phase of the decadence inaugurated by the Renaissance partial beauties are revealed, virtues are manifested; but nothing of that sort can make up for a loss of the essential. What good to us is all that human grandeur if the nostalgia of the Infinite innate in us gets no response from it?

IV

The succession of "styles" met with after the end of the Middle Ages can be compared to the succession of the castes that attained predominance in their respective periods. The word "castes" as used here means "human types", such as are in a sense analogous—though not parallel—to the various temperaments, and which may or may not coincide with the social rank normally occupied by each.

Romanesque art corresponds to a synthesis of the castes; it is essentially a sacerdotal art, but it comprises none the less a popular aspect; it satisfies the contemplative spirit while responding to the needs of the simplest soul. Here is serenity of the intellect and at the same time the rough realism of the peasant.

Gothic art puts a growing emphasis on the spirit of chivalrous nobility, on a whole-hearted and vibrant aspiration towards an ideal. With less breadth than Romanesque art, it still has a truly spiritual quality wholly lacking in Renaissance art.

The relative equilibrium of Renaissance art is of an entirely rational and vital order; it is the congenital equilibrium of the third caste, that of the merchants and the artisans. The "temperament" of this caste is like water, which spreads horizontally, whereas nobility corresponds to fire, which surges upwards, consumes and transforms. The first caste, the sacerdotal, is like air, which is everywhere and gives life invisibly, while the fourth caste, that of the serfs, is like the heavy and motionless earth.

It is significant that the phenomenon of the Renaissance is essentially a "bourgeois" phenomenon, and that is why Renaissance art is as much opposed to popular art, as preserved in rural communities, as it is to sacerdotal art. Chivalrous art on the other hand, which is reflected in the Gothic style, never loses its direct

connection with popular art, just as the feudal lord is normally the paternal head of the peasants in his fief.

It may be noted however that these equations, namely: Gothic style = noble and warrior caste, Renaissance style = mercantile and bourgeois caste, are valid only in a broad sense, and are subject to all sorts of gradations. Thus, for example, the bourgeois and city-dwelling spirit, that of the third caste—whose natural preoccupation is the conservation and increase of wealth both in the domain of science and that of practical utility—this spirit is already manifested in certain aspects of Gothic art; the Gothic was moreover the period of the development of urbanism. Similarly, although Gothic art is strongly impregnated with the chivalrous spirit, it is none the less determined as a whole by the sacerdotal spirit; this fact is significant in view of the normal relationship between the first two castes. The break with tradition, the loss of understanding of symbolism, came only with the supremacy of the bourgeois caste. But even here certain reservations must be made: the beginnings of Renaissance art are without doubt characterized by a certain sense of nobility; it could even be said that they show a partial reaction against the bourgeois tendencies manifested in late Gothic art. But this was only a brief interlude; in fact the Renaissance was promoted by nobles who had become merchants and merchants who had become princes.

The Baroque was an aristocratic reaction in bourgeois form, hence its pompous and sometimes suffocating aspect. True nobility loves forms that are clear-cut and light, virile and graceful, like those of a medieval coat of arms. In the same sort of way the classicism of the Napoleonic era is a bourgeois reaction in aristocratic form.

The fourth caste, that of the serf, or more generally that of men tied to the earth, preoccupied with nothing but their physical well-being and devoid of social or intellectual genius, has no style of its own, nor even, strictly speaking, any art, if that word is used in its full sense. Under the rule of that caste art is replaced by industry, itself the final creation of the mercantile and artisanal caste after it has become detached from tradition.

V

Natura non facit saltus: but all the same, the human spirit does "make jumps". Between medieval civilization, centred on the Divine Mysteries, and that of the Renaissance, centred on the ideal man, there is a deep cleavage, despite historical continuity. In the nineteenth century another cleavage appeared perhaps even more radical. Up till then man and the world around him still constituted an organic whole, at least in practice and in the domain of art which is here our concern; scientific discoveries, it is true, continually extended the horizon of this world, but the forms of everyday life remained within the "measure of man", that is to say, within the measure of his immediate psychic and physical needs. This is the fundamental condition under which art flourished, for art is the result of a spontaneous harmony between the spirit and the hand. With the coming of industrial civilization this organic unity was broken; man found himself looking, not at a motherly nature, but at lifeless matter, at a matter which, in the form of ever more automatic machines, was usurping the very laws of thought. Thus man, having turned his back on the changeless reality of the spirit, of "reason" in the ancient and medieval sense of the word, saw his own creation rising up against him like a "reason" external to himself, a "reason" hostile to everything in the soul and in nature that is generous, noble and sacred. And man has given way to this situation: with all his new science of "economics", whereby he hopes to maintain his mastery, all he is doing is to confirm and establish his dependence on the machine. The machine caricatures the creative act, wherein a supra-formal archetype is reflected into multiple forms, analogous one to another but never the same; it merely produces an indefinite number of strictly uniform copies.

The result is that art is uprooted from the soil that fed it; it is no longer the spontaneous complement of the craftsman's labour nor the natural expression of a social life, but it is thrust back into a purely subjective field. As for the artist, he is no longer what he was at the time of the Renaissance, a kind of philosopher or demiurge; he is but a solitary seeker, without principle and without aim, unless indeed he is no more than the medium or the clown of his public.

This crisis broke out in the second half of the nineteenth century; as at all historical turning-points, there was then a sudden and fleeting opening up of fundamental possibilities. With the rejection of naturalism, still connected as it was with the "homocentricity" of the Renaissance, the worth of "archaic" arts was recognized; it came to be understood that a picture is not an imaginary window looking out on nature, that the laws of painting are derived in the first place from geometry and chromatic harmony, that a statue is not a figure frozen in full movement and by chance, and transformed into stone or bronze; the part played by "stylization" was discovered, the suggestive power of simple forms and the intrinsic luminosity of colours. At this moment a return to an art more honest, if not actually traditional, seemed possible; in order to understand this it is enough to recall some of Gauguin's pictures, or the reflections of Rodin on Gothic cathedrals and Hindu sculpture. But art had neither a heaven nor an earth; it lacked not only a metaphysical background but also a craft foundation, with the result that artistic development passed fleetingly over certain half-open possibilities and fell back into the domain of pure individual subjectivity, all the more deeply because the curb of a universal or collective language was no longer operative. Thrown back on himself, the artist sought new sources of inspiration. As Heaven was henceforth closed to him, and as the sensible world was no longer for him an object of adoration, he burrowed in certain cases towards the chaotic regions of the subconscious; in doing so he released a new force, independent of the world of experience, uncontrollable by ordinary reason and contagiously suggestive: *flectere si nequeo superos, Acheronta movebo*! "If I fail to move the celestial beings, I will stir up hell!"—Virgil, *Aeneid*, VII. 312). Whatever it may be that comes to the surface of the soul out of these subconscious fogs, it has certainly nothing to do with the symbolism of "archaic" or traditional arts; whatever may be reflected in these lucubrations are certainly not "archetypes", but psychic residues of the lowest kind; not symbols but spectres.

Sometimes this infra-human subjectivism assumes the "impersonal" demeanour of its congeneric antithesis, which could be called "machinism". Nothing could be more grotesque and more sinister than these machine-dreams, and nothing could more

clearly reveal the satanic nature of certain features that underlie
modern civilization!

VI

Let us now consider whether Christian art can ever be reborn,
and the conditions under which its renewal would be possible.
First let it be said that there is a certain chance, minimal though
it be, in the fact, negative in itself, that the Christian tradition
and Western civilization are moving farther and farther apart.
If it is not to be carried away in the chaos of the modern world
the Church must retire within itself. Certain of its representatives
are still trying to enlist the most modern and the most spurious
artistic movements for the purposes of religious propaganda, but
we shall see shortly that anything of that kind can only accelerate
the intellectual dissolution that threatens to engulf religion itself.
The Church must first give full value to everything that affirms
its own timelessness; then and not till then can Christian art turn
once more to its essential models, and assume the function, not
of a collective art permeating an entire civilization, but of a
spiritual support; its effectiveness as such will be proportional to
the openness of its opposition to the formal chaos of the modern
world. There are a few signs of a development tending in that
direction; the interest in Byzantine and Romanesque art now
becoming apparent in religious circles may be mentioned as one
of them. But a renewal of Christian art is not conceivable with-
out an awakening of the contemplative spirit at the heart of
Christianity; in the absence of this foundation every attempt to
restore Christian art must fail; it can never be anything but a
barren reconstruction.

What has been said above about the principles of sacred
painting makes it possible to evaluate the other condition of its
renewal. It cannot be admitted that Christian painting could
ever be "abstract", that is to say, that it might legitimately be
developed from a starting point of purely geometrical symbols.
Non-figurative art has its place in the crafts, and especially in
the art of building, where the symbolism is inseparable from the
technical procedure itself. In contradiction to a theory that may
be met with in certain quarters, the picture is not the outcome
of a "gesture" made by the artist, but on the contrary his

"gesture" proceeds from an interior image, the mental prototype of the work. Whenever a geometrical co-ordination is apparent in religious painting it has been superimposed on the image properly so called; the image remains the basis and the substance of the art, and that for all practical as well as for metaphysical reasons, since the image must not only be an anthropomorphic symbol, in conformity with "God become man", but also a precept intelligible to the people. Painting no doubt partakes of the character of a craft when considered in its technical aspects, but this does not directly concern the spectator; in its subject-matter and also in its relation to the religious community, Christian painting must always be figurative. Abstract composition occurs only—and in its proper place—in ornament, thus making as it were a bridge between conscious and quasi-theological perception on the one hand, and unconscious and instinctive perception on the other.

Some people maintain that the period during which a figurative religious art was necessary has come to an end, and that it is consequently impossible to "recapitulate" Christian medieval art; the Christianity of today, they say, has come into contact with the non-figurative or archaic arts of so many peoples that it could never recover an essential vision save in abstract forms, freed from all anthropomorphism. The answer to these people is that an "era" not determined by tradition has in any case no voice in the matter, but above all that the anthropomorphism of Christian art is an integral part of Christian spiritual means, since it springs from traditional Christology; and besides, every Christian ought to know that a new "cycle" imposed from without can be nothing but that of the Antichrist.

The character of Christian painting is essentially figurative, and not accidentally so. This means that it could never dispense with the traditional prototypes that are its safeguard from arbitrariness. These prototypes always leave a fairly wide margin for the exercise of creative genius, as well as for the special needs of times and places, in so far as they may be legitimate. This last reservation is of capital importance in a period when almost unlimited rights are attributed to "our times". The Middle Ages did not worry about being "up to date", the very notion did not exist; time was still space, so to speak. The fear of being taken for a "copyist" as well as the search for originality are very

modern prejudices. Throughout the Middle Ages, and to a certain extent even in the Renaissance and Baroque periods, ancient works regarded in each period as the most perfect were copied; and in that copying, emphasis was quite naturally placed on those that were specially impressive, or were regarded as essential; such are the means by which art is normaly kept alive. More particularly in the Middle Ages, every painter or sculptor was in the first place a craftsman who copied consecrated models; it is precisely because he identified himself with those models, and to the extent that his identification was related to their essence, that his own art was "living". The copy was evidently not a mechanical one; it passed through the filter of memory and was adapted to material circumstances; in the same way, if today one were to copy ancient Christian models, the very choice of those models, their transposition into a particular technique and the stripping from them of accessories would in itself be an art. One would have to try to condense whatever might appear to be essential elements in several analogous models, and to eliminate any features attributable to the incompetence of a craftsman or to his adoption of a superficial and injurious routine. The authenticity of this new art, its intrinsic vitality, would owe nothing to the subjective "originality" of its formulation, and everything to the objectivity or intelligence with which the essence of the model had been grasped. The success of any such enterprise is dependent above all on intuitive wisdom; as for originality, charm, freshness, they will come of their own accord.

Christian art will not be reborn unless it frees itself from all individualistic relativism, and turns back towards the sources of its inspiration, which are by definition situated in the "timeless".